MW00560167

50 Lessons to Learn from Frank Lloyd Wright

50 Lessons to Learn from Frank Lloyd Wright

Break the Box and Other Design Ideas

Aaron Betsky, Gideon Fink Shapiro

Photography by Andrew Pielage

RIZZOLI
NEW YORK

New York · Paris · London · Milan

Contents

This book began with a simple question. What lessons can designers today learn from Frank Lloyd Wright?

Unlike recent books focusing on Wright's tumultuous personal life and the Taliesin Fellowship, and equally unlike certain works that paint Wright as a mythical hero or genius, this book aims to reveal some of the design tools Wright used to create exceptional architecture, interiors, and landscapes.

The "lessons" or themes presented in the following pages—each including a quotation from Wright, a brief synopsis, and a mix of photos and drawings—are conceived as an invitation to look with fresh eyes on Wright's quintessentially modern, American work. There are more than 50 ways to learn from Frank Lloyd Wright. These are a subjective sampling to show that Wright is still relevant, and that there's a lot to learn from his work without getting bogged down in his cult of personality. For us, the place to begin was with Wright's houses, which jump-started his career in the 1880s and became his design laboratories over the next 70 years. We also paid special attention to Taliesin and Taliesin West, Wright's home and studio campuses in Wisconsin and Arizona, which are the products of decades of thinking and building by Wright and his apprentices.

The first and most important lesson of the book is "Break the box," which is not only about physical form, but also the possibility of freeing ourselves from social and mental constraints. Subsequent lessons explore Wright's cultural influences, his approach to site and landscape, the role of design in society, and the individual devices that Wright used not only to break the box, but to rethink virtually every aspect of how we inhabit space as individuals and communities. In short, Wright was on a quest to make us at home in the modern world. He believed that good design was a

Preface

shared birthright. He sometimes overreached, attempting to exert too much control over the environment, but along the way he unspooled striking insights and fabulous designs that changed the way we live.

Wright said his greatest teacher was nature, yet he was a master of artifice. He embraced modern technology, always insisting that the machine be harnessed to artistic and democratic ends. He championed "organic" architecture, all the while unleashing theatrical effects: compressing and opening space, filtering light, framing views, concealing mechanical equipment, staging communal rituals, and craftily blending experimental technology with earthy materials. He touted individual freedom but didn't think most people knew how to properly exercise their freedom. Wright's many contradictions should not stop us from learning from his thrilling designs.

— Aaron Betsky, Taliesin West
— Gideon Fink Shapiro, New York City

Our buildings are boxes that contain and sometimes even imprison us. All around us are walls, ceilings, and floors that limit what we can do and see. Each room is designed for a certain purpose, and we too easily become slaves to the social conventions of the kitchen, the dining room, or the bathroom. Each room places us, especially in the United States, in a larger grid of blocks and strips that tells us not only where, but also to a large extent, what we are. Frank Lloyd Wright believed that we need to break out of those boxes. He suggested that the rooms and buildings that fit us into our daily routines not only constrain us physically, but also limit our dreams and aspirations. To change the world, he thought, we should start at home. Specifically, a room need not be either completely closed or shaped like a box. We can slip and slide the planes around us so that light and air can come into the corner. We can lift parts of ceilings up or bring them down to sail over us and continue outside. We can change the levels of the floor to shape space without building a wall. We can add nooks and crannies that let us be by ourselves or with one or two people. We can let the landscape in through glass walls and windows and extend space out in the same way. We can use terraces and porches to the same effect. We can explode our sense of who and where we are just by getting rid of the idea that space has to come packaged in a box. Break that container, and the world outside and in yourself opens up.

"I think I first *consciously* began to try to beat the box in the Larkin Building—1904. I found a natural opening to the liberation I sought when (after a great struggle) I finally pushed the staircase towers out from the corners of the main building, made them into free-standing, individual features.... Unity Temple [shown on following pages] is where I thought I had it, this idea that the reality of a building no longer consisted in the walls and roof."
— From an address to the Junior Chapter of the American Institute of Architects, New York City, 1952

"The walls themselves cease to exist as either weight or thickness. Windows become in this fabrication a matter of a unit in the screen fabric, opening singly or in groups at the will of the occupant."
—"In the Cause of Architecture, VIII: Sheet Metal and a Modern Instance," 1928

1. Break the box

Fallingwater (Liliane and Edgar J. Kaufmann House), Mill Run, Pennsylvania, 1935–1938

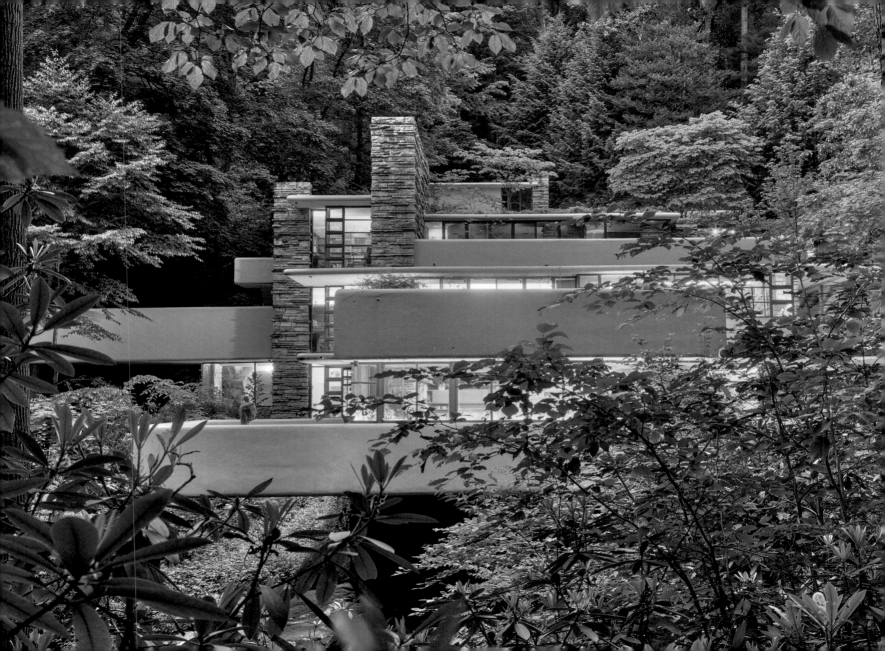

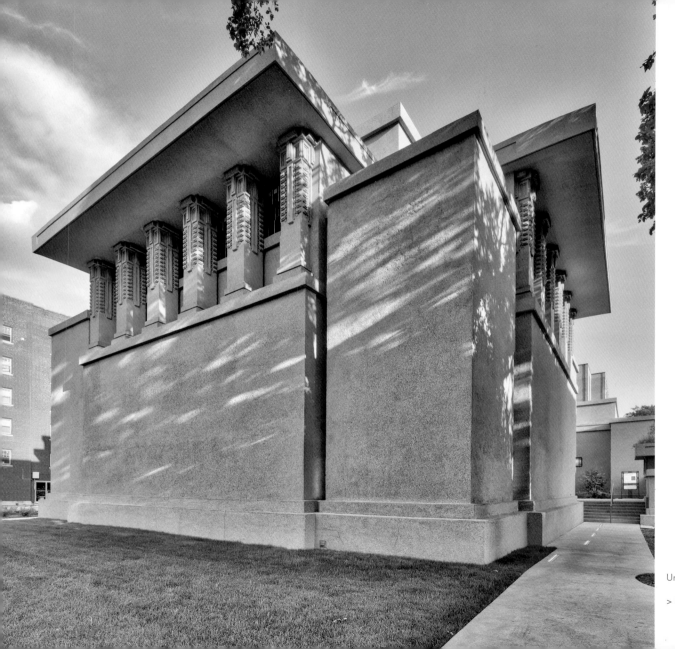

Unity Temple, Oak Park, Illinois, 1904–1908

> Unity Temple, Oak Park, Illinois, 1904–1908

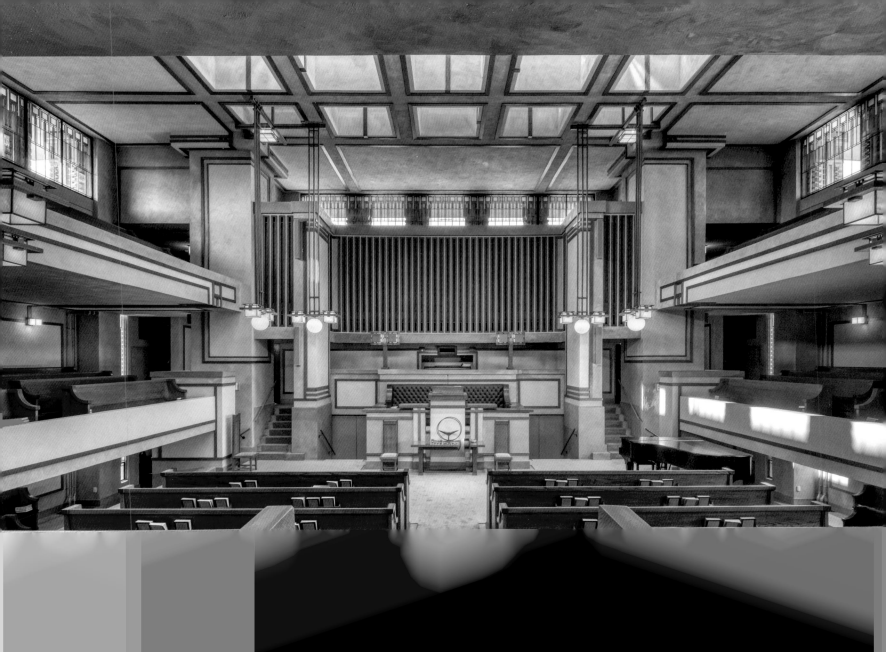

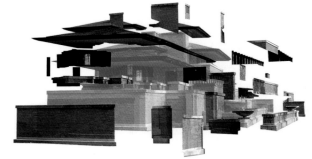

Cloverleaf Quadruple Houses (unbuilt project),
Pittsfield, Massachusetts, 1942, interior view. FA

Richard Quittenton, *Break the Box*, 2020

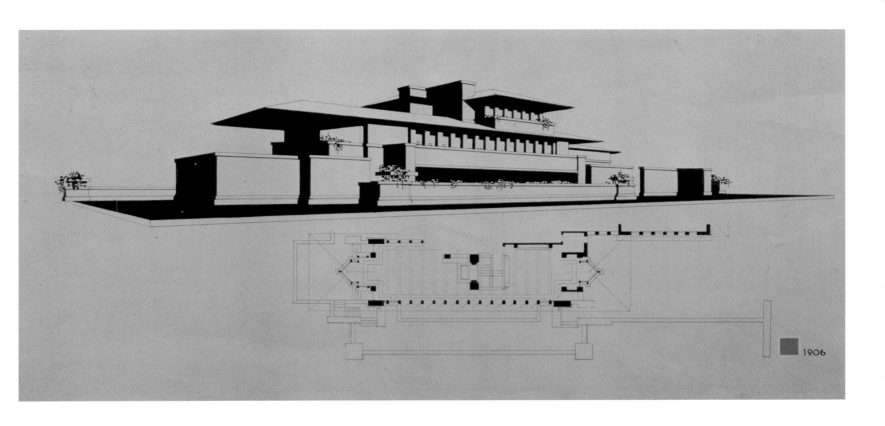

Frederick C. Robie House, Chicago, Illinois,
1908–1910. Private collection. FLWF

2. Let nature inspire you

3. Reinterpret familiar forms

4. Learn from indigenous design

5. Look to Asia

6. Make the room dance

INFLUENCES and INSPIRATION

One of Frank Lloyd Wright's central ideas was that architecture should be organic. What he meant by that term changed over the many decades that he lived and worked, but it always referred to the idea that we should learn from and follow nature. As a child, Wright loved wandering through the fields of his native Wisconsin, and fell in love with flowers, animals, and the rolling hills of the valley where he grew up. He felt inspired by the forms, colors, and spaces of the landscape, and began to search for its underlying structures and growth patterns in the abstract language of geometry. When he moved to Chicago in 1887, he learned from the architect Louis Sullivan, his employer, who brought nature onto and into his buildings by designing ornaments that combined references to flowers, water, wind, and other natural phenomena. As Wright developed his own sense of architecture, he came to believe that nature had to be ingrained in each project from the start, woven into the very bones of what we build, and only then given outward expression. He wanted to build with the land, not on it. He wanted his structures to work the way trees did. He wanted to create a flow of spaces in his buildings like what he found by wandering around the countryside. More than that, he came to believe that everything had to flow from everything else, not just in the spaces and forms of buildings, but also from the subconscious upwelling of a design in his mind all the way to its completion.

—Organic architecture meant not so much copying the forms of nature, nor disappearing into the landscape, but taking inspiration from the principles at work in the natural world—and making those hidden forces evident in the world human beings make for themselves.

"A building should appear to grow easily from its site and be shaped to harmonize with its surroundings if Nature is manifest there, and if not try to make it as quiet, substantial and organic as She would have been were the opportunity Hers."
—"In the Cause of Architecture," 1908

"Nothing is more difficult to achieve than the integral simplicity of organic nature, amid the tangled confusions of the innumerable relics of form that encumber life for us. To achieve it in any degree means a serious devotion to the 'underneath' in an attempt to grasp the *nature* of building a beautiful building beautifully, as organically true in itself, to itself and to its purpose, as any tree or flower."
—"In the Cause of Architecture," 1914

2. Let nature inspire you

Fallingwater (Liliane and Edgar J. Kaufmann House), Mill Run, Pennsylvania, 1935–1938

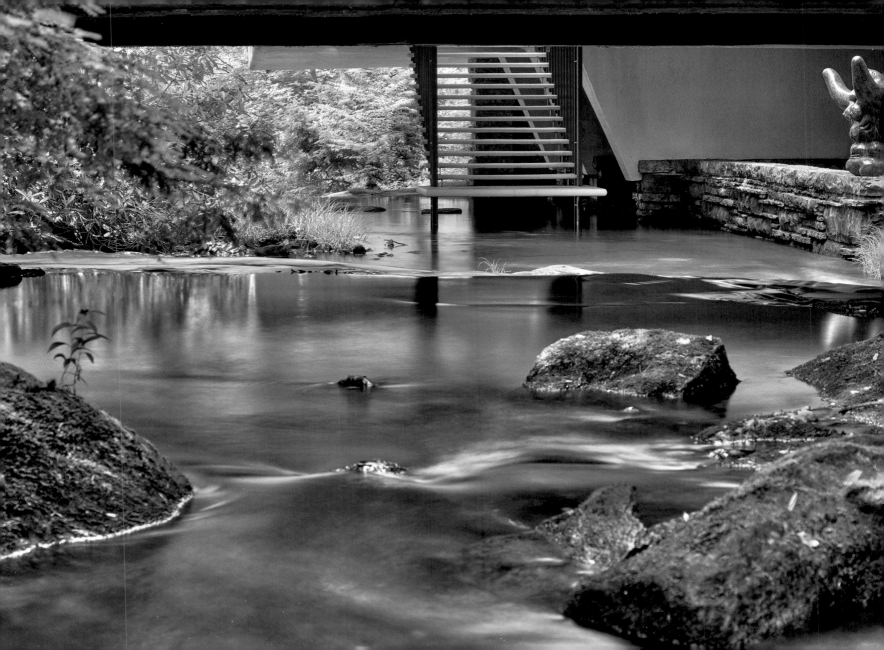

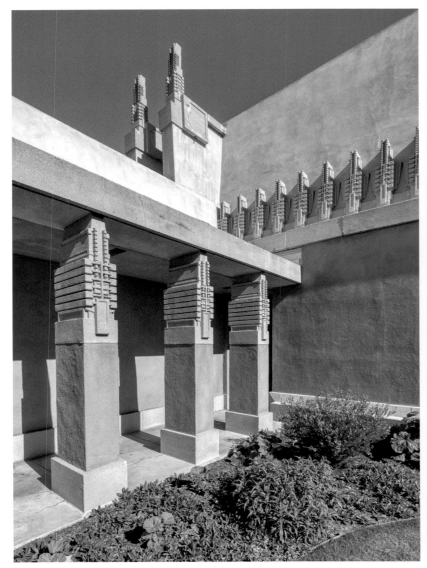

Hollyhock House (Aline Barnsdall House), Los Angeles, California, 1917–1921

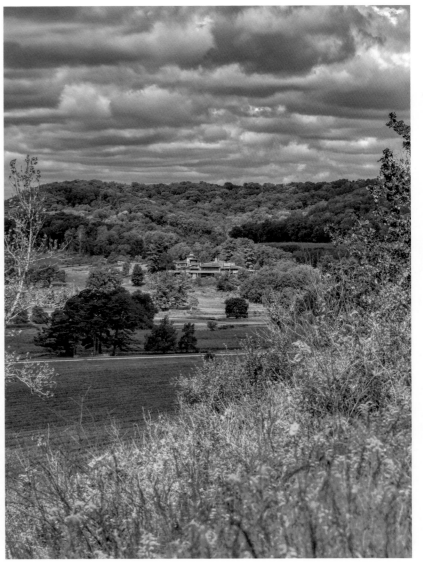

Taliesin III, Spring Green, Wisconsin, 1925–1959

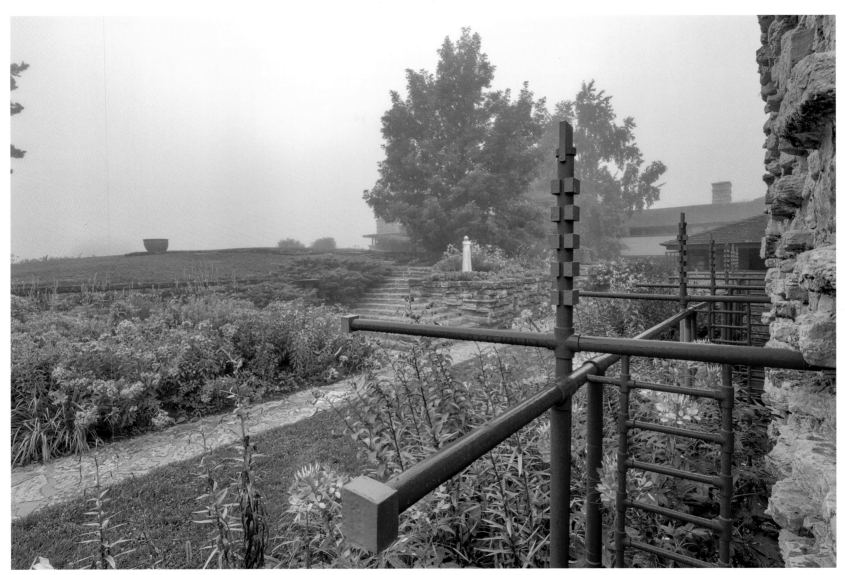

Taliesin III, Spring Green, Wisconsin, 1925–1959

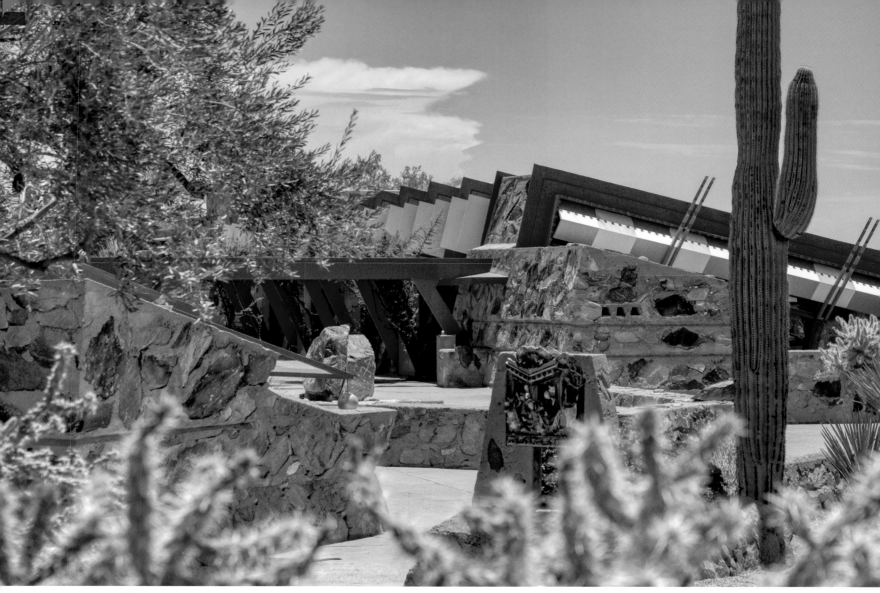

Taliesin West, Scottsdale, Arizona, 1937–1959

Richard Quittenton, Site 182 (student-designed
shelter), Taliesin West, Scottsdale, Arizona,
2018

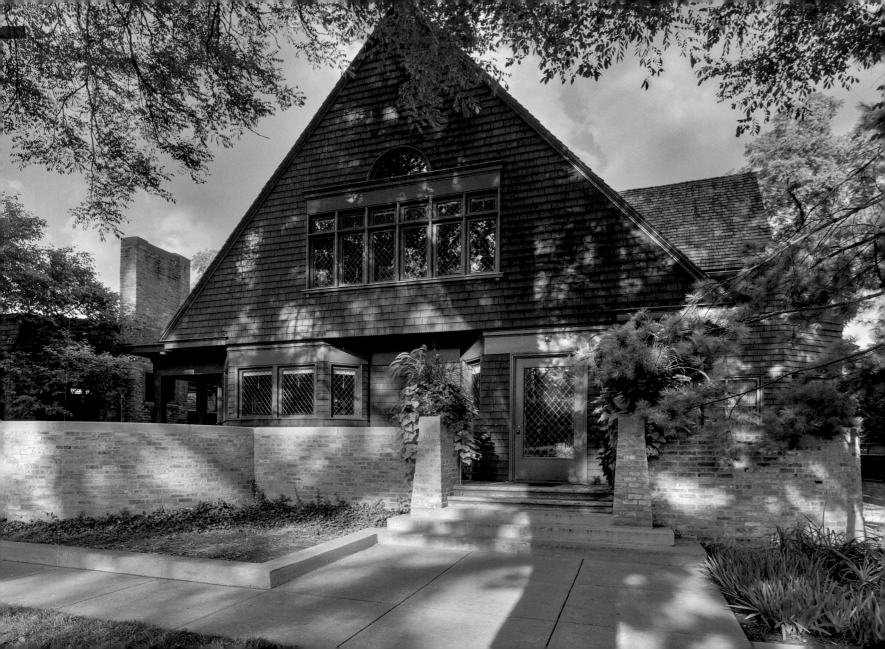

Although Frank Lloyd Wright saw himself as a great inventor who had a style and way of doing things that was all his own, his work reveals a deep understanding of what architects call the vernacular. This rather fraught term usually denotes the practices that have grown up in a given place through continued use and refinement by one group of people. In architecture, it usually means a particular way of using the landscape, local materials, and methods of construction based on what is available. The issue with such a definition is that almost every vernacular is an adaptation of a methodology or manner of appearance that comes from elsewhere. The vernacular in which Frank Lloyd Wright started working when he opened his practice in Oak Park was that of the American Victorian-era house, a type that Wright soon began to abstract and simplify to become more open, flexible, and horizontal. It was not until he received larger commissions in other locations that he started to develop forms that were truly novel, though even then, as in the Imperial Hotel design (see pp. 66–69) in Tokyo, he relied on local crafts, materials, and building methods. For all his desire to be modern and innovative, Wright maintained a keen eye and a deep admiration for tried-and-true forms of architecture, which he was often able to push beyond their conventional limits. This was true even when he started to work in more exotic locations such as the high Sonoran desert, where he looked towards the ways in which the Pueblo and Hohokam built with that often harsh and dramatic landscape, and to the ways in which it was transformed and tamed by the Spanish missions and haciendas. In all these cases, Frank Lloyd Wright learned by looking at how things had been done and how things had looked, even if he hid his knowledge behind forms that had the appearance of being new. It was the ghost of the past, though, that made his buildings work, both in terms of how they were built and in how they were received, while it was his innovations that, though exhilarating, often created the biggest expenses and problems.

"The true basis for any serious study of the art of Architecture still lies in those indigenous, more humble buildings everywhere that are to architecture what folklore is to literature or folk song to music and with which academic architects were seldom concerned."
—Wasmuth Portfolio ("Ausgeführte Bauten und Entwürfe von Frank Lloyd Wright"), 1910

Frank Lloyd Wright House, Oak Park, Illinois, 1889–1895

3. Reinterpret familiar forms

Drawing for Louis H. Sullivan (residential portfolio project), 1887. FA

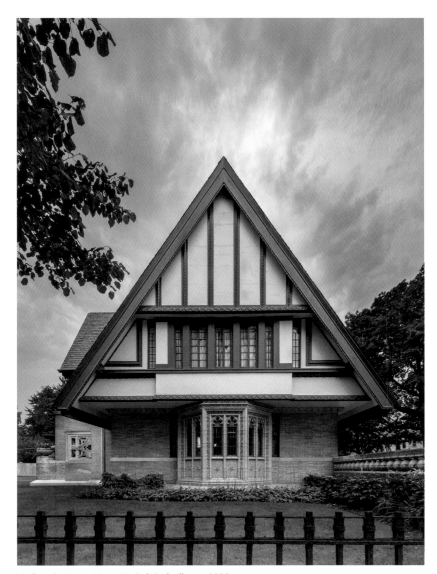

Nathan G. Moore House II, Oak Park, Illinois, 1923

From early in his career, Frank Lloyd Wright found inspiration in Native American forms and motifs. He went on to appropriate and reinterpret these "primitive" elements and references in his work. He had little interest in what these signs and symbols, or patterns and compositions, might have meant originally, but he thought that the people who had made them must have had an admirable connection with nature and a strong sense of community. At first, his sources were depictions of North America's indigenous people by Western observers, such as displays at the World's Columbian Exposition of 1893 in Chicago and prints in magazines. The result was stylized versions of his own plant- and animal-based ornament, as well as sculptural figures in the form of "sprites" and stereotyped Native Americans. In his design for the Nakoma Country Club in Wisconsin, he conflated teepee with wigwam, despite the fact that these came from different native cultures. It was not until he began to work in the Southwest that he came into direct contact with the weaving, pottery, and painting of the tribes inhabiting what is now Arizona, California, and New Mexico, and he encountered the petroglyphs at Death Valley and at what was to become Taliesin West. Native Americans, he believed, had as much reverence for the land as he did. Wright's "borrowing" from the peoples of the Southwest ranged from the spirals that influenced both the plans of his buildings and his "Whirling Arrow" logo (see p. 229), to the staccato rhythms and bold colors he found in the implements that were being sold at tourist shops. Wright never collected much of this work, preferring instead to assimilate what he saw into friezes, decorative patterns, and even whole building elements: the buildings at Taliesin West include a "kiva" —traditionally a windowless, sacred gathering space, entered from above—in this case a cozy, cavelike room that was originally a place to watch movies (see p. 35). Wright's appropriation of Native American elements lent his work an aura of authenticity, but it's not clear that the elements he used kept their significance when taken out of context. He called himself an "indigenous Architect" who practiced "Native architecture," but this was a conceit. What Wright's work did accomplish in the desert Southwest was to respond to the natural forms of the mesas, cliffs, boulders, and sloping planes in a manner that echoed, though indirectly, the work of the Hohokam, Anasazi, and Pueblo people who were the last to build permanent urban structures there.

4. Learn from indigenous design

"I remember how as a boy, primitive American architecture — Toltec, Aztec, Mayan, Inca — stirred my wonder.... Those great American abstractions were all earth architectures: gigantic masses of masonry raised up on great stone-paved terrain, all planned as one mountain... These were human creations, cosmic as sun, moon, and stars!"
—A Testament, 1957

Taliesin West, Scottsdale, Arizona, 1937–1959

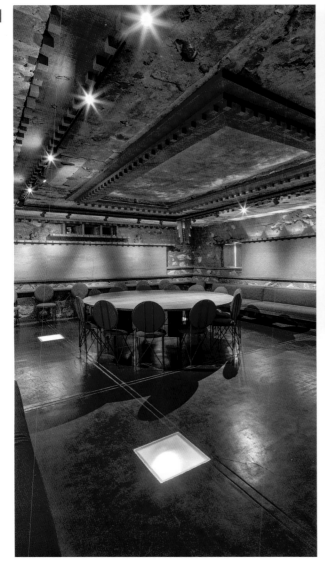

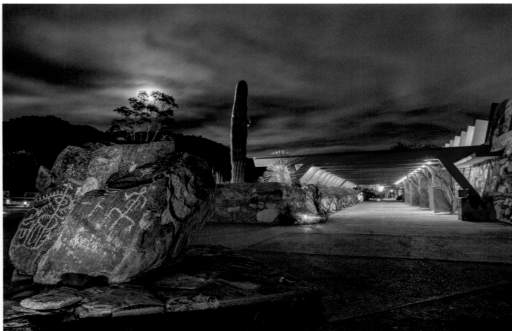

Taliesin West, Scottsdale, Arizona, 1937–1959

Taliesin West, Scottsdale, Arizona, 1937–1959

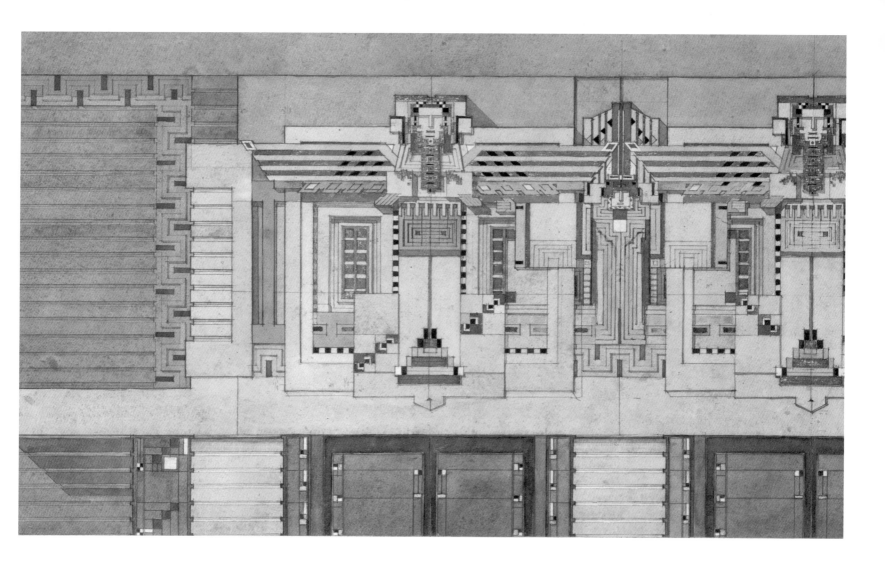

Frederick C. Bogk House, Milwaukee,
Wisconsin, 1916–1917, detail of stone lintel. LC

From the moment Frank Lloyd Wright came into contact with Japanese art and architecture at the 1893 World's Columbian Exposition in Chicago (and perhaps even before that), he was fascinated by the forms and images he saw. Starting with his first visit to Tokyo in 1905, he built up several collections of art from Asia, the most notable of which consisted of Japanese woodblock prints from the eighteenth and nineteenth centuries, hundreds of which now reside in the collections of the Metropolitan Museum of Art, the Art Institute of Chicago, and many other institutions. Wright's architecture and drawings acquired some of the qualities that he admired in the imagery he collected. Unlike some of his contemporaries, he rarely copied formal elements directly. Rather, the art and the architecture he saw while living in Japan for the construction of the Imperial Hotel in Tokyo (1916–1923; see pages 66–69) nurtured his notion that the rooms of a house should not be separate cells, but should flow into each other past screens; that the inside and the outside should frame each other; that movement through a building was analogous to a path through a series of scenes; that architecture was tactile as well as visual; and that buildings can be open pavilions that add up to seemingly rambling complexes spreading through a carefully curated natural setting. Wright's interest in Chinese art, on the other hand, appears to have been more directed toward its decorative forms and its penchant for luxurious materials. He never visited the country, but collected various art objects second-hand, and used many of them to punctuate the rooms and the curves of his designs. What Wright learned from the arts of East Asia, above all else, was a mode of representing his work graphically. From his earliest published renderings, all the way to the late perspectives, many of which were produced by his collaborator Ling Po, he adopted the forced perspective, the delicate brushwork, the extended lines, the collapsed perspective, and the scenographic sweep he saw in that art. If Frank Lloyd Wright had a drawing style, it was *Japonesque*.

"Both China and Japan have preserved a great deal of their native sense of beauty and artistry. True, too, the Japanese have from their first knowledge of us regarded us as vulgar barbarians. From their standpoint I suppose we are."
— *An Autobiography*, 548

"The first and supreme principle of Japanese aesthetics consists in stringent simplification by elimination of the insignificant, and a consequent emphasis of reality."
— "The Japanese Print: An Interpretation," 1912

5. Look to Asia

Taliesin II, Spring Green, Wisconsin, 1914. FA

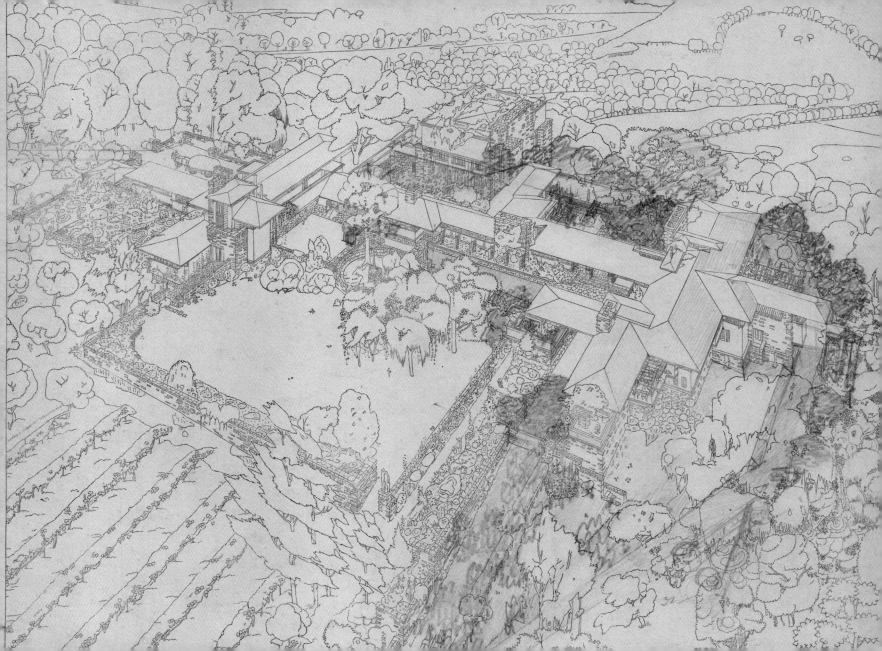

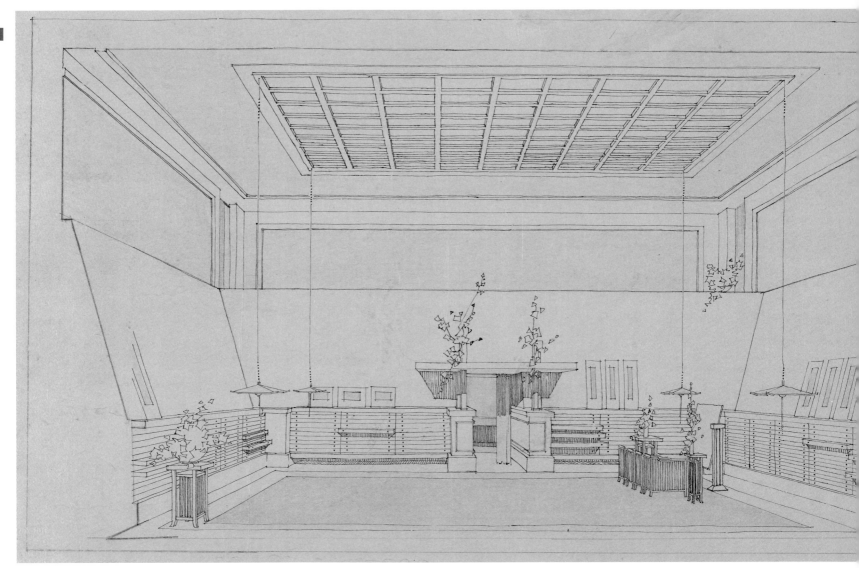

W. S. Spaulding Gallery for Japanese prints (unbuilt project), Boston, Massachusetts, 1919, interior view. FA

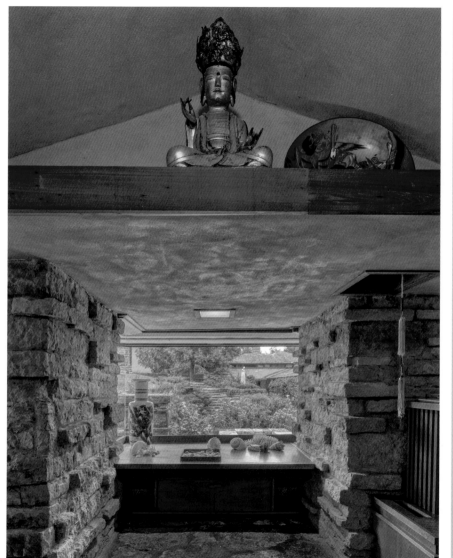

Taliesin III, Spring Green, Wisconsin, 1925–1959

Thomas P. Hardy House, Racine, Wisconsin, 1905, view from the lake. FA ^

Frank Lloyd Wright was born into a musical family, with a father who was a music teacher and composer. Throughout his life, he loved classical music, although he never seems to have cottoned onto more contemporary forms of musical expression, and even the work of Claude Debussy was banned from his home. Wright valued music both as a way to draw a family or a community together, and as an artistic analogue to the rhythms and motifs he sought to create in his architecture. He never made the mistake of trying to directly apply this aural ornament to the "frozen music" of his buildings, but rather appreciated music and other performing arts as a way to approach the essence of nature and the potential of human imagination. His third wife, Olgivanna, brought a kind of rhythmic dancing to Taliesin and Taliesin West. She had learned these "moves," as she called them, from her guru, the Georgian mystic George Gurdjieff, who believed these dances connected you to a larger spiritual truth. Wright made sure that there were multiple performance spaces for dance and music at all of his homes, and many of the rooms he designed have very good acoustics. Several large-scale theaters that he designed were never built. It is interesting that Frank Lloyd Wright also loved that most modern form of culture, movies. He built a screening room at Taliesin West and showed avant-garde films he brought from Chicago. The 1933 prospectus for Taliesin calls for screening films by "Eisenstein, René Clair, Murnau, Chaplin, Disney, Pabst and other productions of fine character" and providing a good sound system, dressing rooms, and stage facilities. Architecture, however, remained the mother of the arts. For Wright, architecture was the frame or veil that brought all the arts together, returning them to the community and culture that made them.

"The Taliesin Sunday evenings are made by music for music and enter into the spirit of the occasion as if the Fellowship was made for music. Eye music and ear music do go together to make a happy meeting for the mind. This happy union charms the soul."

"The striving for entity, oneness in diversity, depth in design, repose in the final expression of the whole—all these essentials are there in common pattern between architect and musician. So I am going to a delightful, inspiring school of architecture when I listen to Beethoven's music..."
— *An Autobiography*, 1943

6. Make the room dance

Cabaret theater, Taliesin West, Scottsdale, Arizona, 1949

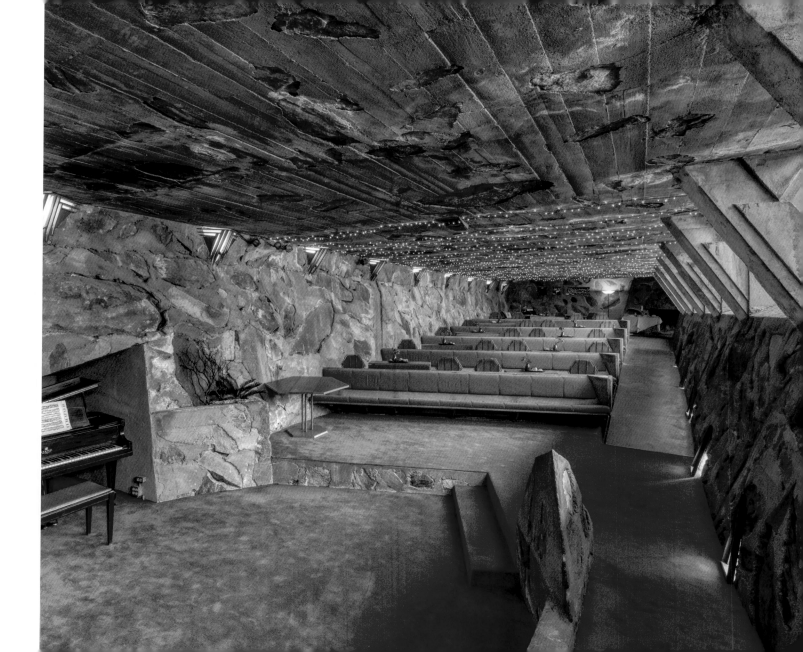

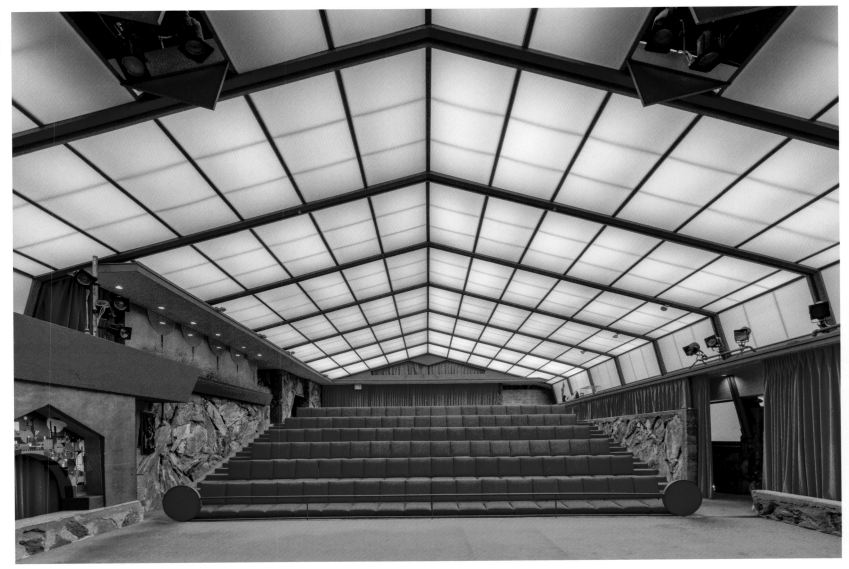

Music pavilion, Taliesin West, Scottsdale, Arizona, 1956

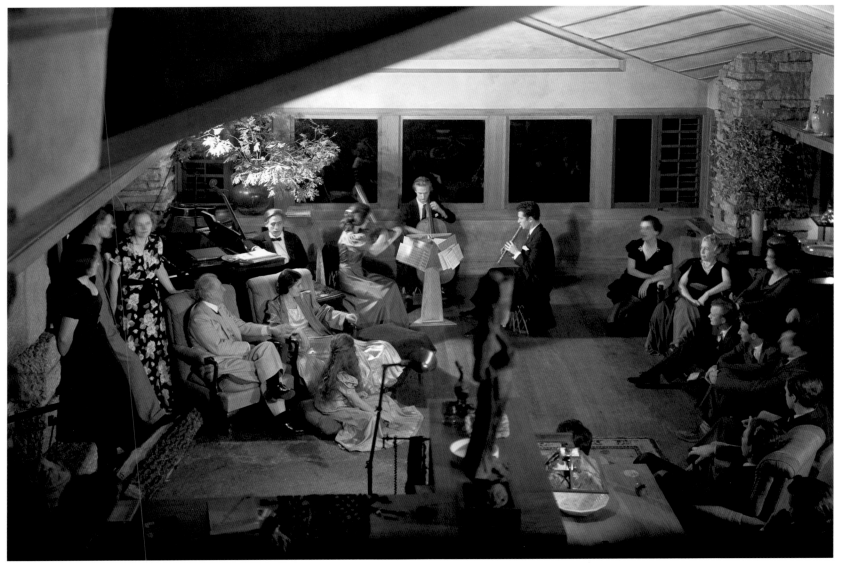

Concert at Taliesin, Spring Green, Wisconsin, 1937. CHM

> Hillside Theater (Taliesin playhouse, long section), Spring Green, Wisconsin, 1952–1955. FA

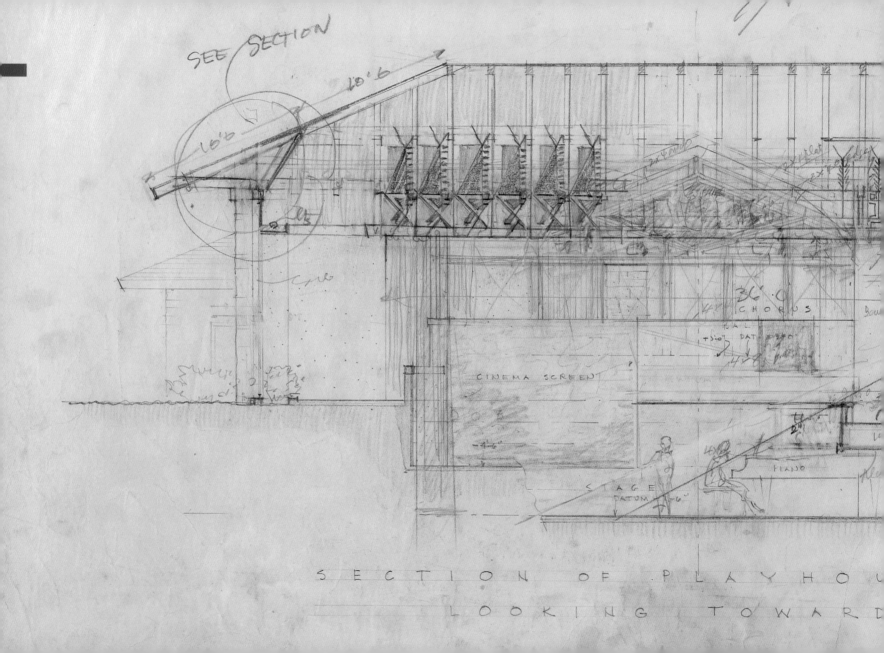

SEE SECTION

CINEMA SCREEN

CHORUS

STAGE
DATUM

PIANO

SECTION OF PLAYHOU

LOOKING TOWARD

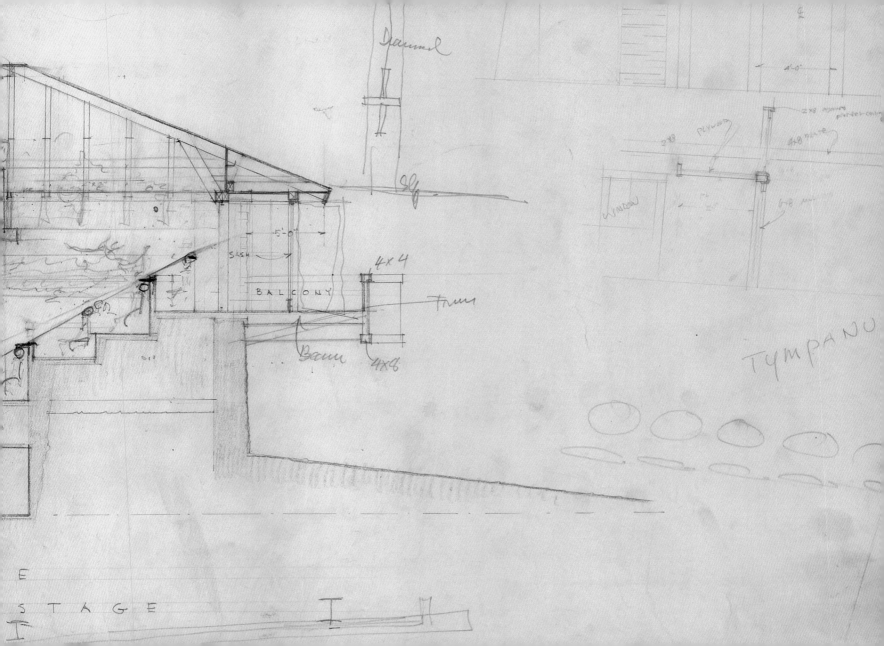

Diamond

sash

5'-0"

SASH

BALCONY

4 x 4

Truss

Beam

4 x 8

TYMPANU

2x8 plywood

Window

STAGE

7. Spread across the prairie

8. Adapt to the desert

9. Build with the land, not on it

10. Build on the brow

11. Frame the landscape

12. Design for resilience

13. Dream of better worlds

SITE and LANDSCAPE

Frank Lloyd Wright was a man of the prairie, and proudly so. Though his roots were in the so-called Driftless Region, an area of rolling hills and fertile fields in southwestern Wisconsin, the first part of his career unfolded in Chicago, the city that was not only built on the prairie, but that rose as a monument to the agricultural wealth of the vast, flat plains stretching across much of the continent. It is no coincidence that Wright came into prominence as one of the leading architects of the so-called Prairie School. What he and the other members of that group did was to assimilate the notion of flatness and turn it into a virtue—at times stacking multiple horizontal layers in long, low compositions. While downtown Chicago became famous for turning the bounty of the prairies into the vertical grids and spires of skyscrapers, Wright and his peers chose to develop the look and feel of the suburbs. Wright saw the flat landscape not as featureless or monotonous, but as the fertile ground of democracy and community. The neutral grid offered the freedom to go anywhere and make a place for yourself. Despite Wright's constant glorification of the individual (man, rarely woman), his idealized prairie society appears conformist in its layout, not very open to difference. For Wright the individual was always part of the family and the community, and his prairie architecture was meant to shelter them underneath elongated roof planes in houses with great fireplaces that reflected the lay of the land and a harmonious way of life. The midwestern landscape meant horizontality, democracy, family, community, and possibilities. His architecture was an attempt to articulate how all the qualities and phenomena came together to make a claim for a new kind of American place.

"I loved the prairie as a great simplicity—the trees, flowers, sky itself, thrilling by contrast. I saw that a little height on the prairie was enough to look like much more—every detail as to height becoming intensely significant, breadths all falling short. Here was tremendous spaciousness…"

"The new buildings were rational: low, swift and clean, and were studiously adapted to machine methods. The quiet, intuitional, horizontal line (it will always be the line of human tenure on this earth) was thus humanly interpreted and suited to modern machine-performance."
— *An Autobiography*, 1943

7. Spread across the prairie

Still Bend (Bernard Schwartz House), Two Rivers, Wisconsin, 1939–1940

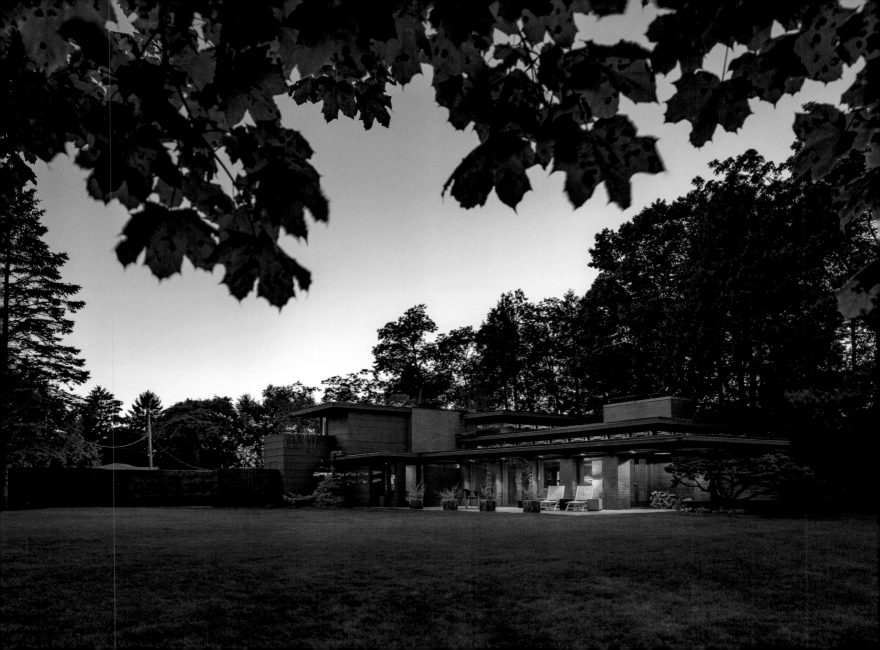

Robert and Elizabeth Muirhead House, Plato Center, Illinois, 1950–1953

Midway barns and farm, Taliesin Fellowship Complex, Spring Green, Wisconsin, 1938

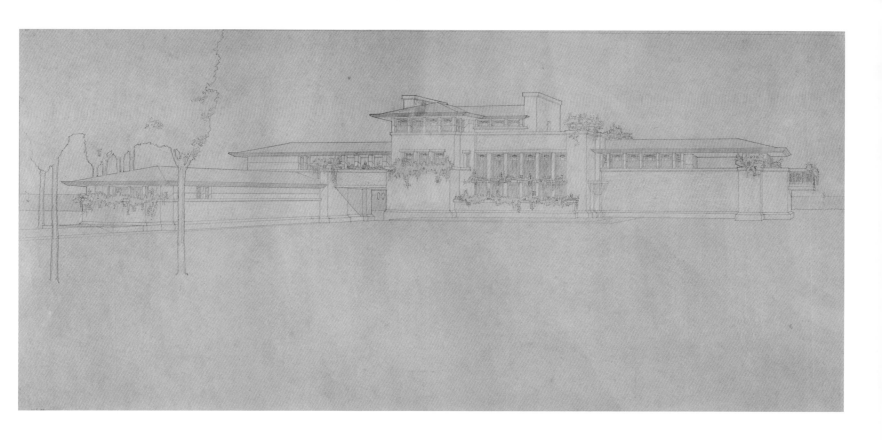

Edward Schroeder House (unbuilt project), Milwaukee, Wisconsin, 1911. FA

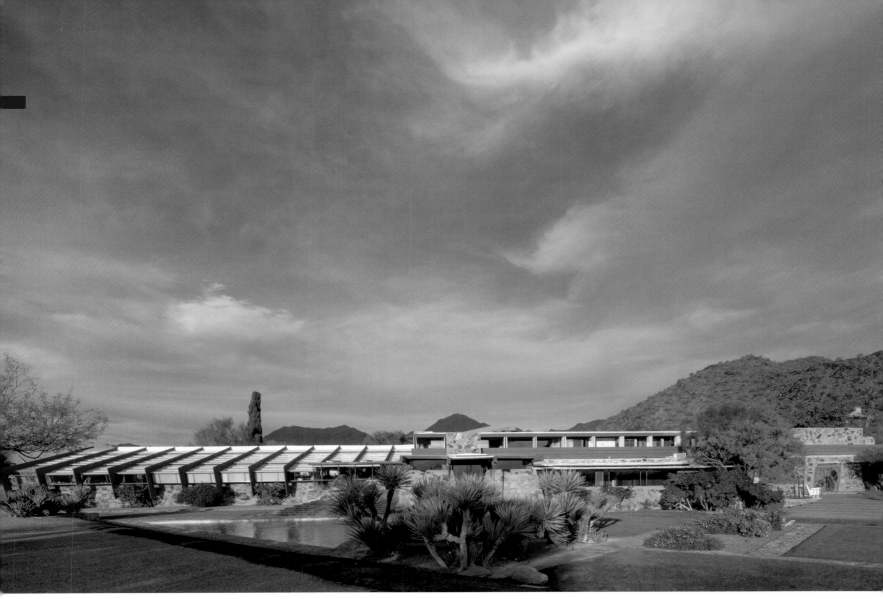

Taliesin West, Scottsdale, Arizona, 1937

During his productive final decades, Frank Lloyd Wright spent half of every year in the high Sonoran Desert outside of Phoenix, Arizona. His fascination with the area dated to his work during the late 1920s on a never-built resort project, following a previous desert commission in Death Valley, California. Wright responded to both the human-made and the natural forms he found in such places. The vastness and seeming emptiness of the landscape, the very opposite of the environments most people inhabit, called for an architecture that was more like a "dotted line" than a solid object. He wanted to capture the sense of expansiveness, the vistas that opened up in the folds of the land, and the clarity of the landmarks he found there. He loved the forms of the boulders and rocks, the topography of slopes giving way to cliffs and mesas, and the inner structure of the saguaro cactus, which he called a "perfect example of reinforced building construction." He also came to respect how the ancestors of Native American communities, such as the O'odham, Piipaash, Hopi, Yavapai, and Apache, had adapted to the desert by building cool, cave-like rooms, by mimicking the rocks and cliffs in their pueblos. He took a special interest in how they had marked the landscape with figures, or petroglyphs, that tied specific places both to their daily lives and their spiritual beliefs. One such sign, a rectilinear spiral, inspired his signature "whirling arrow" logo (see p. 229) for the Taliesin Fellowship, and perhaps helped spur his later designs for spiral buildings. Meanwhile, Wright learned how to make his own architecture out of ever simpler forms — incorporating the local stone to build thermally massive walls — and to become ever more resourceful in adapting to the desert environment. He aligned buildings with the slopes and vistas, designed sharp angles to reach out to the horizon, and built combinations of cool caves, breeze-catching crevasses between rocks, and lightweight tents. From the desert, Frank Lloyd Wright learned how to make architecture more basic and abstract, more tied to the land, and more connected to a wider cosmos.

"Arizona character seems to cry out for a space-loving architecture of its own. The straight line and flat plane must come here — of all places — but they should become the dotted line, the broad, low, extended plane textured, because in all this astounding desert there is not one hard undotted line to be seen. The great nature-masonry we see rising from the great mesa floors is … not architectural at all, but it is inspiration."
— *An Autobiography*, 1932

8. Adapt to the desert

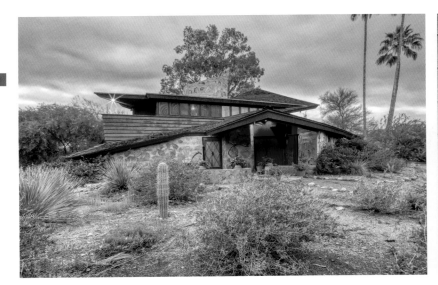

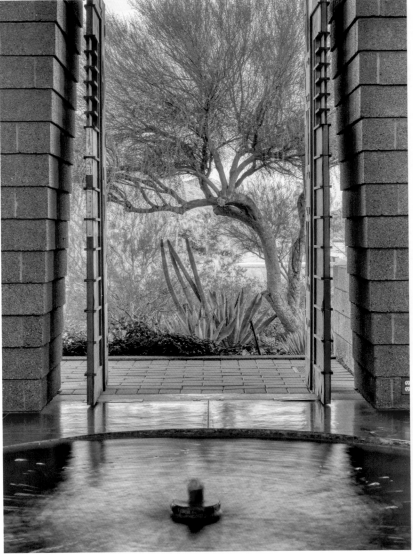

Jorgine Boomer Cottage, Phoenix, Arizona, 1953

Harold C. Price Sr. House, Paradise Valley, Arizona, 1954–1955

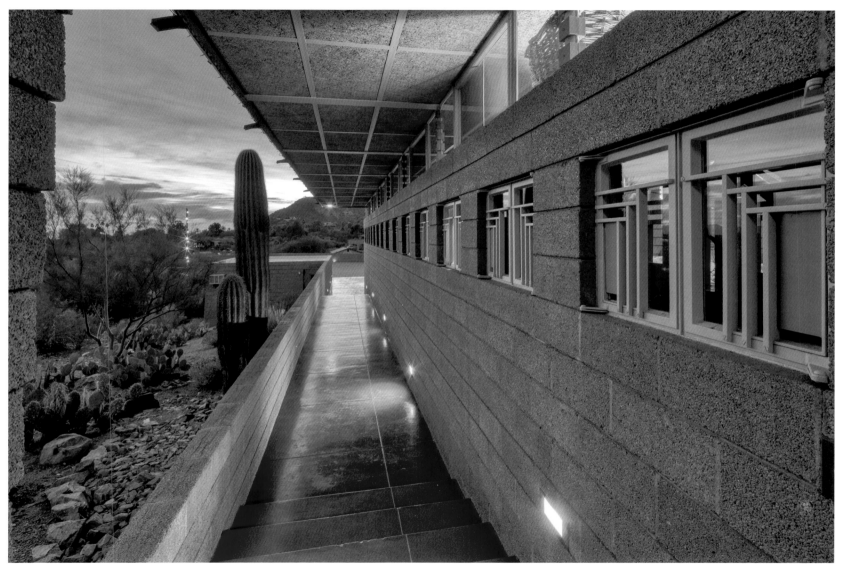

Harold C. Price, Sr. House, Paradise Valley, Arizona, 1954–1955

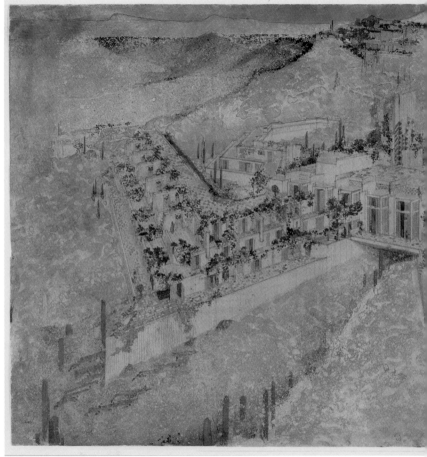

Alexander Chandler House, (unbuilt project), Chandler, Arizona, 1928. FA

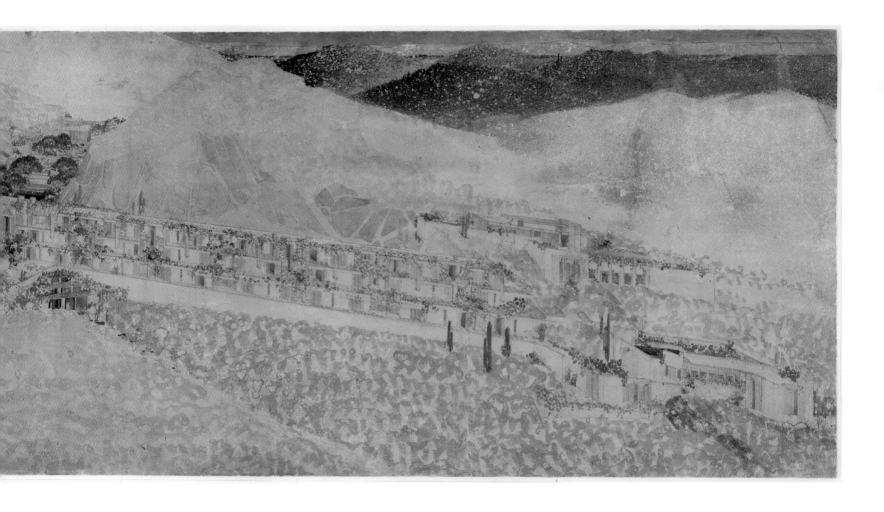

San Marcos-in-the-Desert resort for Alexander Chandler (unbuilt project), Chandler, Arizona, 1928–1929. FA

Long before the modern environmental and green building movements, Frank Lloyd Wright pioneered ways to make his buildings more energy-efficient. Most of these methods come out of his desire to use nature to do the work of keeping a house warm or cool, and in one case—the waterfall at the base of Taliesin that housed a small dynamo—even powered. Wright's preference for rotating plans and placing windows at corners helped promote air circulation, while his skylights and clerestories worked to bring natural daylight into the depths of his buildings. His deep overhangs allowed winter sunlight to come in, but blocked heat gain in the summer, when the sun was high above. At Taliesin West and several other buildings in hot climates, he created covered breezeways whose configuration promoted the "Venturi effect," a cooling effect as the wind rushed through these gaps in the line of the building. That does not mean all Wright's buildings were perfect from an environmental perspective. His love of a contrast between low areas and tall rooms meant that the heat would gather at the top of the latter spaces, while the many hearths he placed in his houses did little to heat them while using up a great deal of wood. On the other hand, his use of abundant shrubs and flowers around the edges of the building and his dislike of planting beds turned their immediate surroundings into swales that would catch the runoff from the eaves. And, though he never built a green roof as we know it today, he did propose a "berm type" flat roof with soil and plants growing on it, and he let plants and vines grow over many of his flat roofs. He also experimented with berm-type dwellings in cold climates to provide natural insulation. Frank Lloyd Wright's desire to make an environment in which everything, in appearances and use, flowed into each other, led him to design buildings that are what we call "passively" sustainable, and showed that ecological sensibilities in architecture can express themselves in an organic and beautiful manner.

"The berm-type house, with walls of earth, is practical ... for here you have good insulation—great protection from the elements; a possible economy too, because you do not have to finish any outside below."
—*The Natural House*, 1954

9. Build with the land, not on it

Taliesin West, Scottsdale, Arizona, 1937

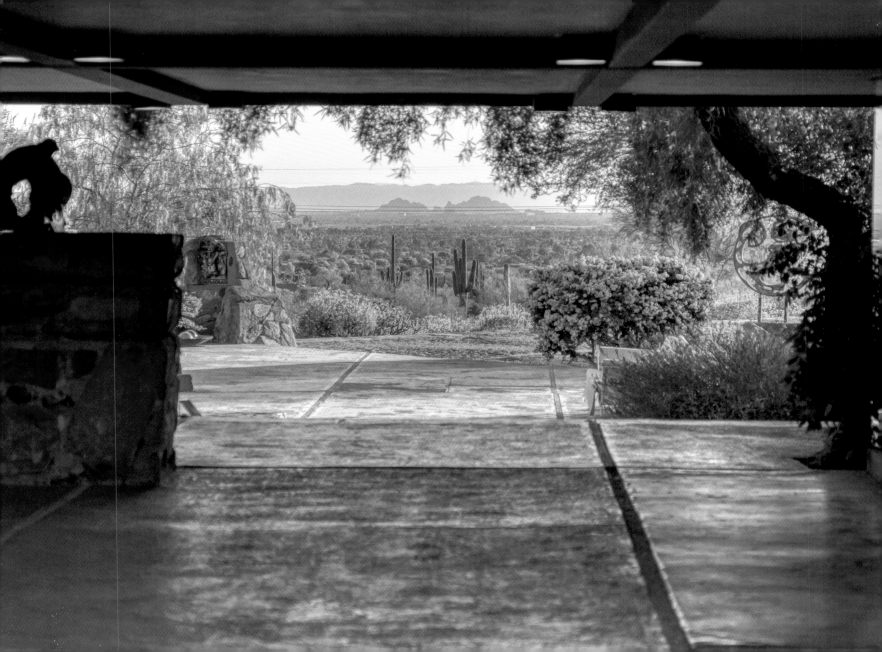

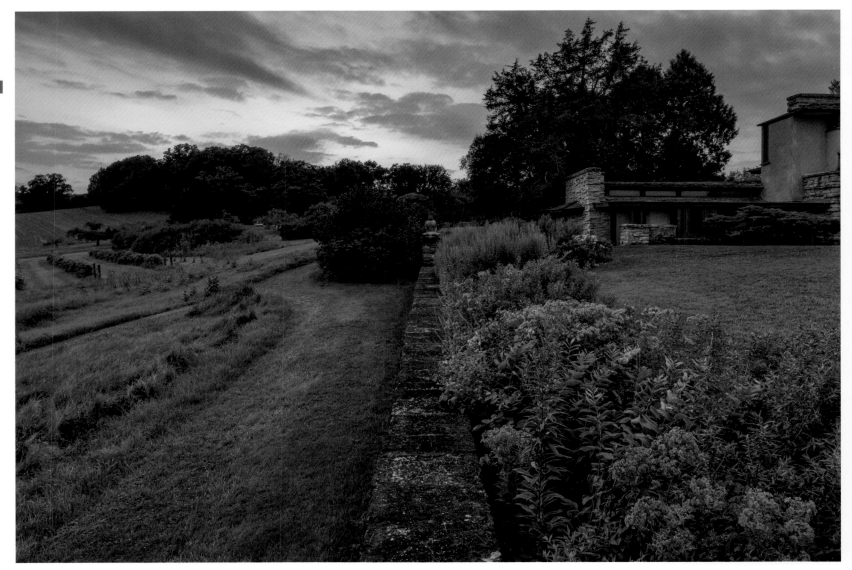

Taliesin III, Spring Green, Wisconsin, 1925–1959

Cooperative Homesteads (unbuilt project), Detroit, Michigan, 1942, exterior view (top) and section through living room. FA

SECTION THROUGH LIVING ROOM

SUNK GARDEN

DRAIN TILE

Given a hilly site, Frank Lloyd Wright loved to build on the "brow" of the hill, partway up the slope. When clients asked him to create a home on the highest point of their property, he would talk them out of it. He felt that the summit should be respected and left open for all to enjoy—nature, after all, came first. Moreover, by building in between, on a ledge, valley, or saddle between hills, you could nestle into the site, fitting in and extending the natural properties into built form. Wright most famously showed how to do it at Taliesin (see following pages, right), the home he built for himself beginning in 1911 when his mother bought back his family's farm near Spring Green, Wisconsin. There, he sought to express a natural limestone outcropping on a series of hills that that measured the valleys around the house, running perpendicular to the adjacent Wisconsin River. The house's site is halfway up the hill, and the structure consists of a series of levels, each of which respond to the existing site and all of which serve to let you explore the hill and the different views it affords. Wright, in other words, made the hill his own by hooking onto its most prominent location he could find, while letting his structure blend in with the surroundings. Taliesin was also the name of a famous Welsh bard (Wright's mother's family, the Lloyds, came from Wales) and means shining brow. Wright produced some of his best architecture on such sloping sites, where he could show off both the building and the landscape to maximum effect while hiding utilities and service spaces in the back. From the inside, a building on the brow gives you a sense of both shelter and expansion. It is an architecture seen through the eyes of a bard trying to sing alive the landscape and the community that inhabits it.

"It was unthinkable to me, at least unbearable, that any house should be put *on* that beloved hill. I knew well that no house should ever be on a hill or on anything. It should be *of* the hill. Belonging to it. Hill and house should live together each the happier for the other.... The hill-crown was thus saved and the buildings became a brow for the hill itself."
— *An Autobiography*, 1932

10. Build on the brow

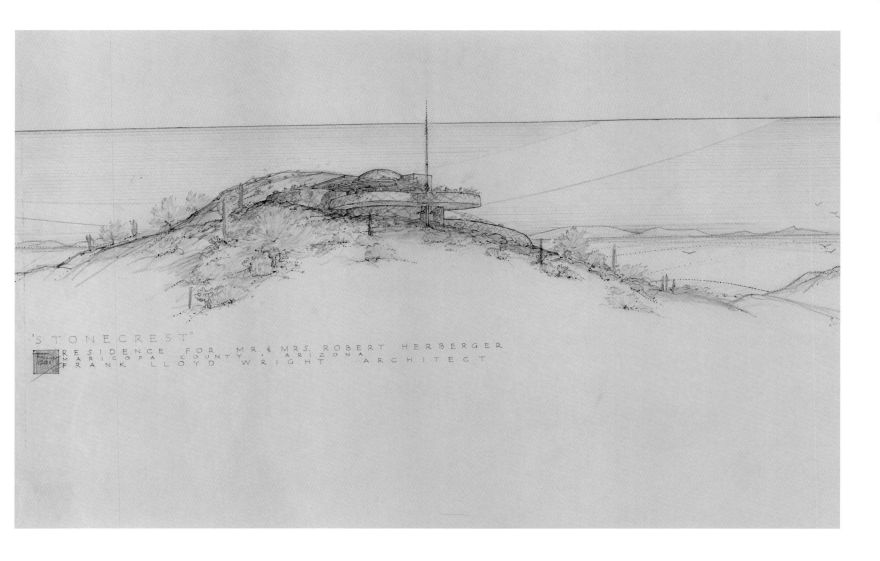

"STONECREST"
RESIDENCE FOR MR. & MRS. ROBERT HERBERGER
MARICOPA COUNTY · ARIZONA
FRANK LLOYD WRIGHT ARCHITECT

Stonecrest (Robert Herberger House, unbuilt project), Maricopa County, Arizona, 1955. FA

> Norman and Aimee Lykes House (completed by
John Rattenbury), Phoenix, Arizona, 1959–1968
>> Taliesin III, Spring Green, Wisconsin, 1925–1959

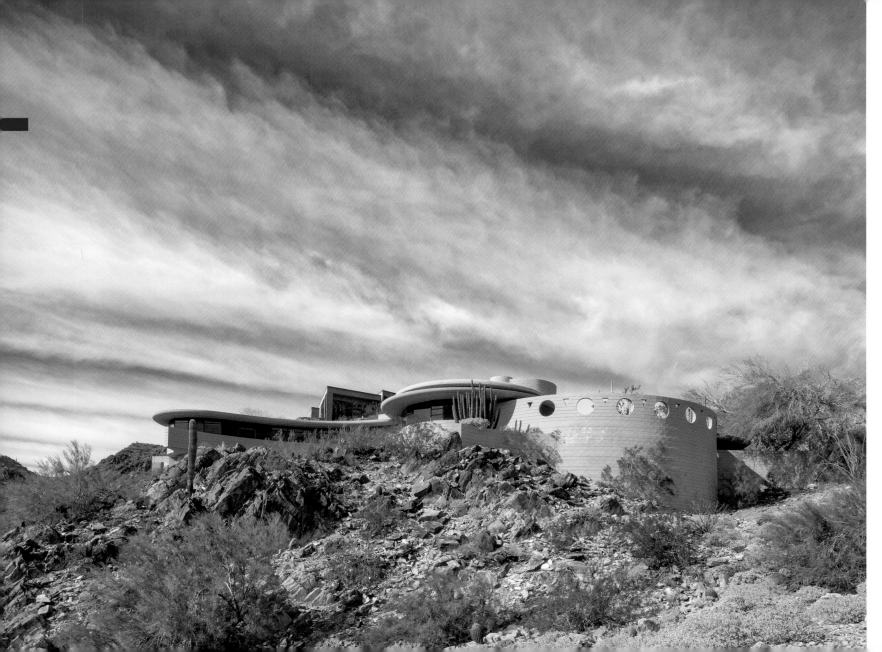

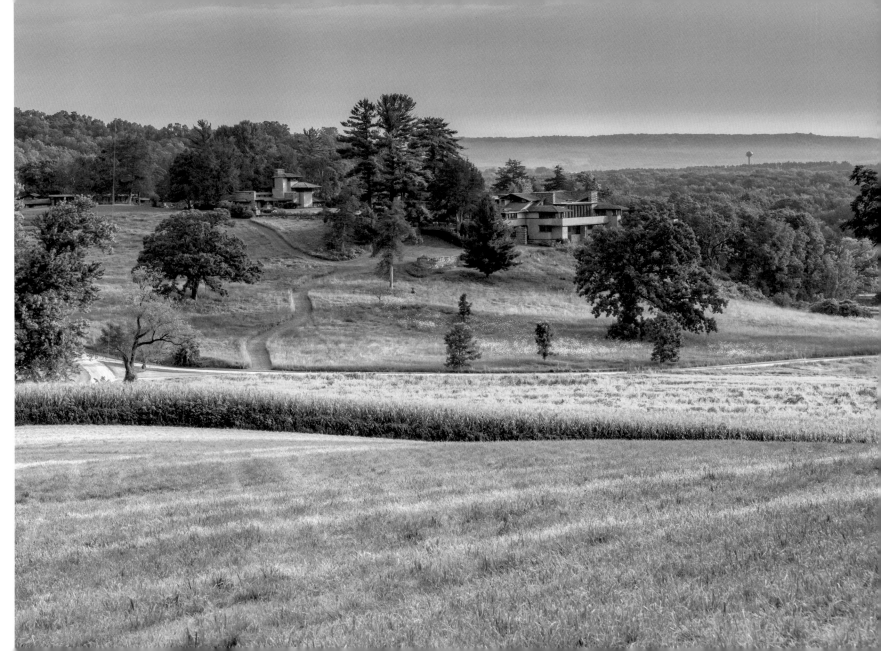

Though Frank Lloyd Wright emphasized the precedence of nature and his desire to work with it, he did so in a manner that showed that he was truly in charge of how you experienced it. This "framing" of the landscape through architecture is most striking from inside the building. Sitting in one of his rooms, you see the surroundings either through large panes of glass that are not unlike the frames of traditional landscape paintings, or through long bands of windows. The lintels and all the other parts of that surround are heavy and often multi-layered; sometimes two panes of glass meet to form a frame that magically wraps around a corner. At times, Wright would mask parts of the view with colored or translucent glass and, in some urban settings, he would hide all of the view while letting light filter in. When he wanted you to see the landscape as a series of vignettes or a scroll painting, he might let you look out through bands of small panes. Wright was also careful to screen off the near foreground with shrubs, planters, or terraces, and to mark its edges with urns or other ornamental fixtures. This outer frame then released your gaze "out there" toward the horizon. From the outside, it is the landscape that frames the building. When he had enough room, Wright controlled the way you would approach his buildings so you would glimpse them from afar, punctuating the rolling hills or swaths of flat land, their edges blurring into the vegetation, but their geometries rising clearly and cleanly above that. As you came nearer, those human-made forms and the essential lines would dominate. Frank Lloyd Wright showed that the best way to enjoy nature was to own it, both as property and through the controlling lines and framed vistas of a masterful architecture.

"Landscape seen through the openings of the building thus placed and proportioned has greater charm than when seen independent of the architecture. Architecture ... [can be] a great clarifier and developer of the beauty of landscape."
—*The Architectural Forum*, 1938

"The site was not at all stimulating before the house went up—but like the developer poured over a negative, when you view the environment framed by the Architecture of the house from within, somehow, like magic—charm appears in the landscape and will be there wherever you look. The site seemed to come alive"
—*An Autobiography*, 1943

11. Frame the landscape

Taliesin West, Scottsdale, Arizona, 1937

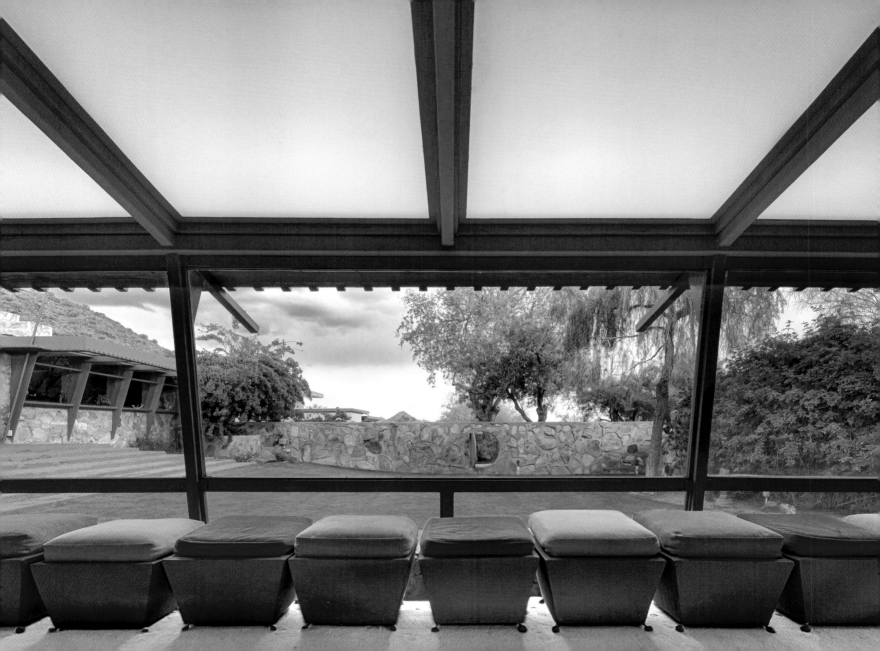

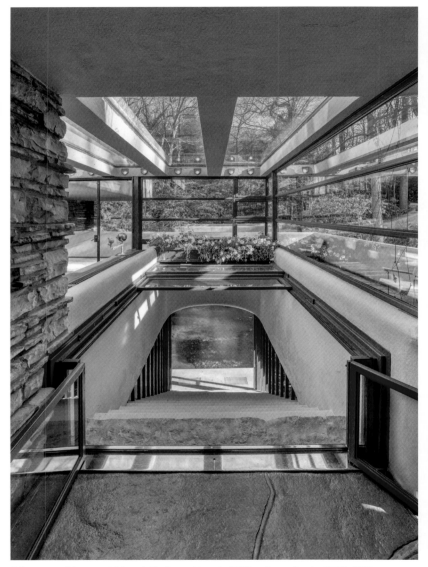

Fallingwater (Liliane and Edgar J. Kaufmann House), Mill Run, Pennsylvania, 1935–1938

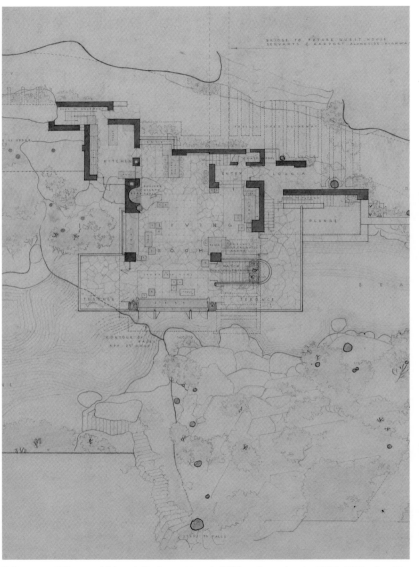

Fallingwater (Liliane and Edgar J. Kaufmann House), Mill Run, Pennsylvania, 1935–1938, plan. FA

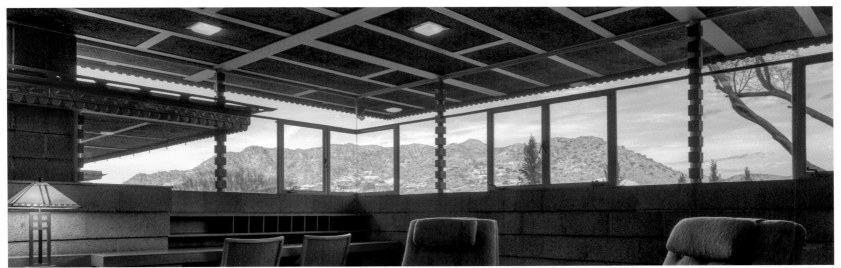

Harold C. Price Sr. House, Paradise Valley, Arizona, 1954–1955 Wyoming Valley School, Wyoming Valley, Wisconsin, 1956–1957

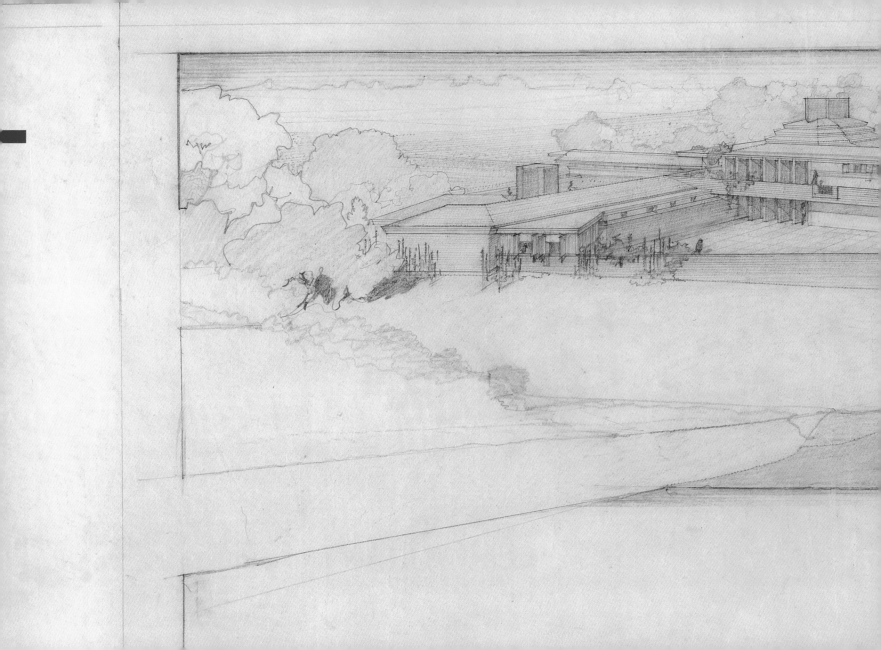

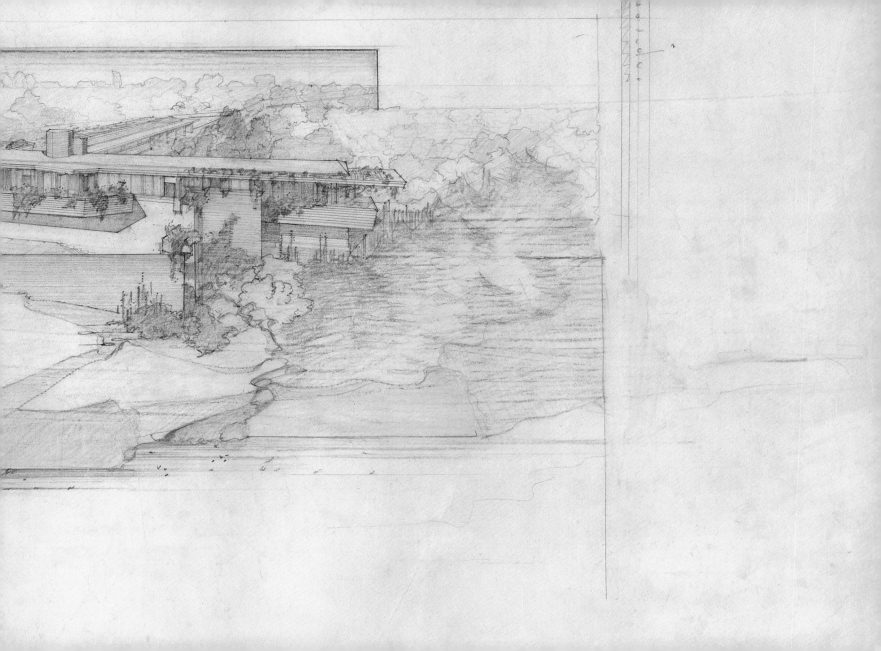

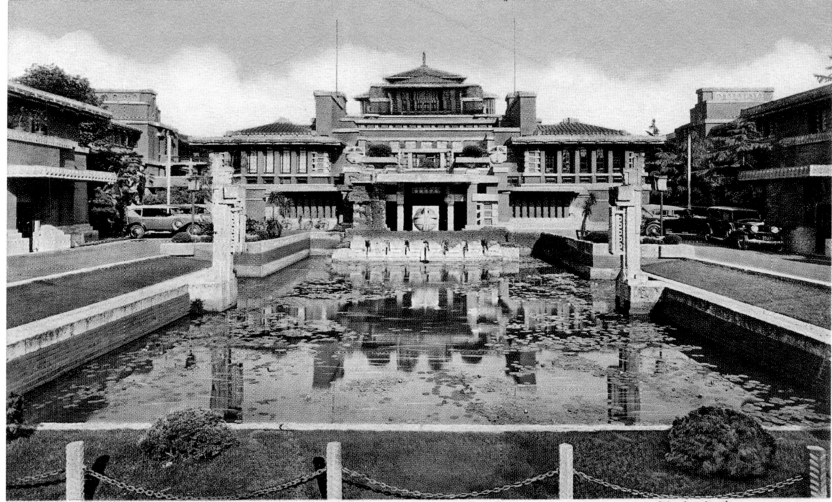

IMPERIAL HOTEL, TOKYO, JAPAN.　　　　　東京帝國ホテル

< Wingspread (Herbert F. Johnson House), Wind Point, Wisconsin, 1937–1939. FA

Imperial Hotel, Tokyo, Japan, 1915–1923. PD

One of the great triumphs of Frank Lloyd Wright's career was the manner in which the Imperial Hotel in Tokyo, which he designed in 1916, survived the 1923 earthquake there with very little damage, even as other structures crumbled all around its intersecting planes and low-slung volumes. Wright was no expert on earthquake resilient design, but he was willing to learn from what had worked in the past. That, in Japan, meant not only keeping his buildings low, but also weaving them together with both horizontal and vertical walls that intersected and braced each other, even while they allowed for powerful vibrations and movement. For once, Wright's dislike of heavy foundations also stood him in good stead, as the hotel was able to sway with the quaking earth, rather than trying to resist its overwhelming forces. Similarly, most of Wright's work in California has withstood earthquakes, though at least one structure, the Freeman House in Hollywood, was significantly damaged in a 1994 temblor. For Wright, though, resistance to earthquakes and other natural threats was less an explicit goal than a happy result of hunkering down low and weaving all the parts of a building together with interlacing joinery. He was certainly not loath to take chances with his structures, and loved extreme cantilevers and other devices that put a great deal of stress on his buildings. Still, Wright's idea of building with the land included the need to accommodate natural forces, opening up to the same nature that at times could be so threatening.

"What saved the Imperial was the principle of flexibility: flexible foundations, flexible connections, flexible piping and wiring systems, flexible continuous slabs cantilevering over supports, passing clear through the outer walls to become balconies or projecting cornices—and an exaggeration of all vertical supporting members, center of gravity always kept low as possible."
— Letter to Lieber Meister, September 26, 1923

12. Design for resilience

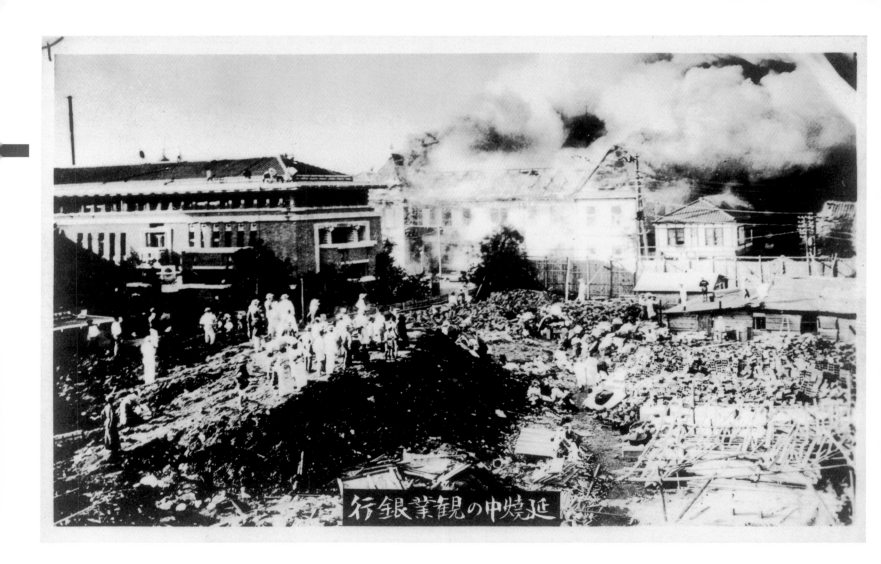

行銀業観の中焼延

The Imperial Hotel, Tokyo (left), survived the Great Kantō Earthquake of 1923. WHS

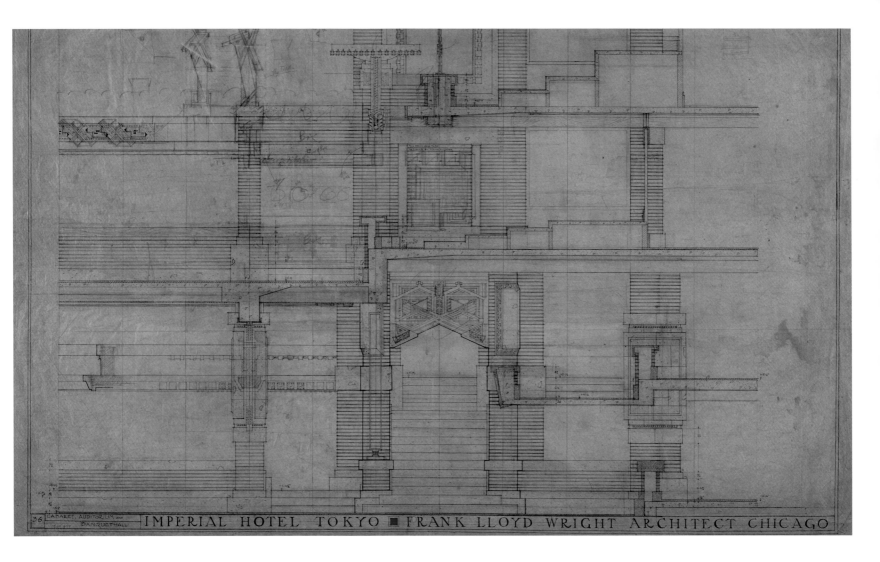

36 CABARET, AUDITORIUM AND BANQUET HALL — IMPERIAL HOTEL TOKYO ■ FRANK LLOYD WRIGHT ARCHITECT CHICAGO

Imperial Hotel, Tokyo, Japan, 1915–1923, section through cabaret. FA

Frank Lloyd Wright claimed that his designs sprang to life in his mind before he drew them. And some of his best drawings have the qualities of a dream—pure architecture and environment, unencumbered by the mundane realities of building. They arise on the page from indistinct borders, coming together with lines that move towards the middle of a plan, perspective, or cut through the building, where the core of the design remains somewhat veiled. The borders of the drawings are all shrubs, vines, trees, or flowers. When the site was urban, he declined to show the actual buildings around his proposed structure, at most indicating the vague outline of something around the edge of the lot. There, as if emerging from the foliage and the raw fiber of the paper itself, his design would offer a vision of the future you could have, either as a client or as an admirer, and one that is somehow directly, "organically" connected both to the past and the site. In some of Frank Lloyd Wright's most seductive work, he imagined whole landscapes dotted with his architecture. This was the case when he imagined urban or suburban communities in Oak Park or Marin County, or in his presentation of Usonia and Broadacre City (see pp. 80–81). In designs for groups of buildings in Los Angeles, both for Aline Barnsdall near Hollywood (see pp. 188–189), and for a resort development at Doheny Ranch (see following pages), he imagined architecture, flora, and hills merging. The same was true when he came to draw a group of vacation homes in Lake Tahoe. In one of his last projects, a new civic center for Baghdad (unrealized; see pp. 238–239), he evoked a fairy-tale scene that deliberately recalled *A Thousand and One Nights*. What all this work had in common was Wright's desire not just to design for a specific function or solution, but to present a vision of a complete place in which you would dissolve, along with everybody and everything around you, into a better version of yourself.

"Before the plan is a plan it is a concept in some creative mind. It is, after all, only a purposeful recording of that dream, which saw the destined building living in its appointed place."
—"In the Cause of Architecture, I: The Logic of the Plan," 1928

13. Dream of better worlds

Sherman Booth House, scheme 1 (unbuilt project), Glencoe, Illinois, 1911. FA

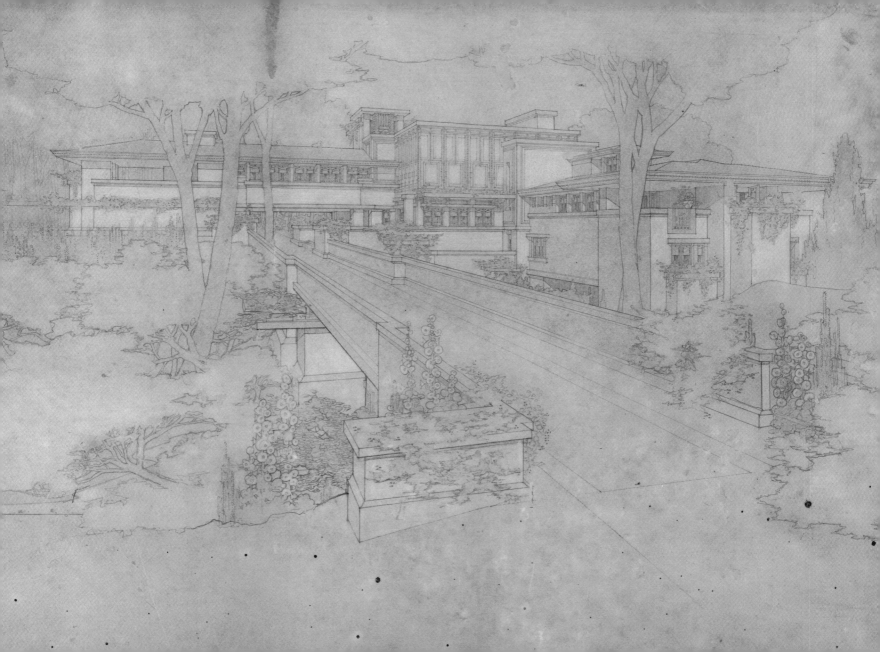

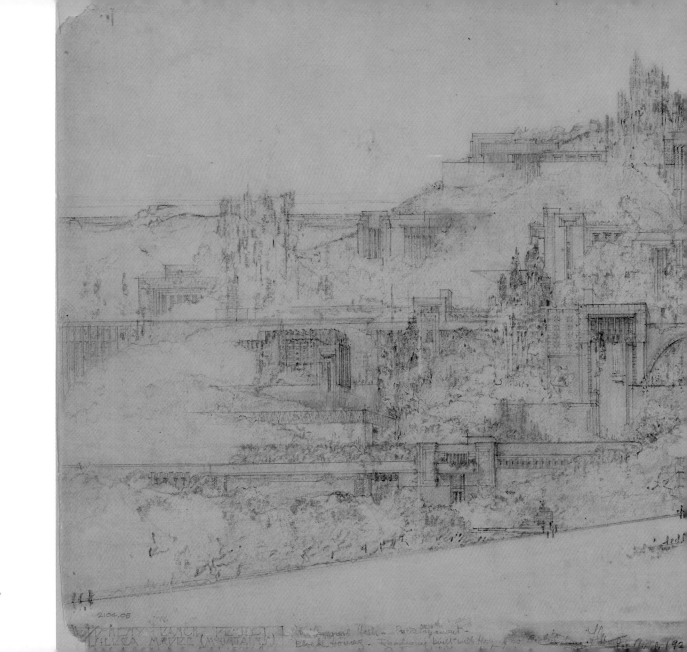

Doheny Ranch Resort (unbuilt project),
Los Angeles, California, 1923. FA

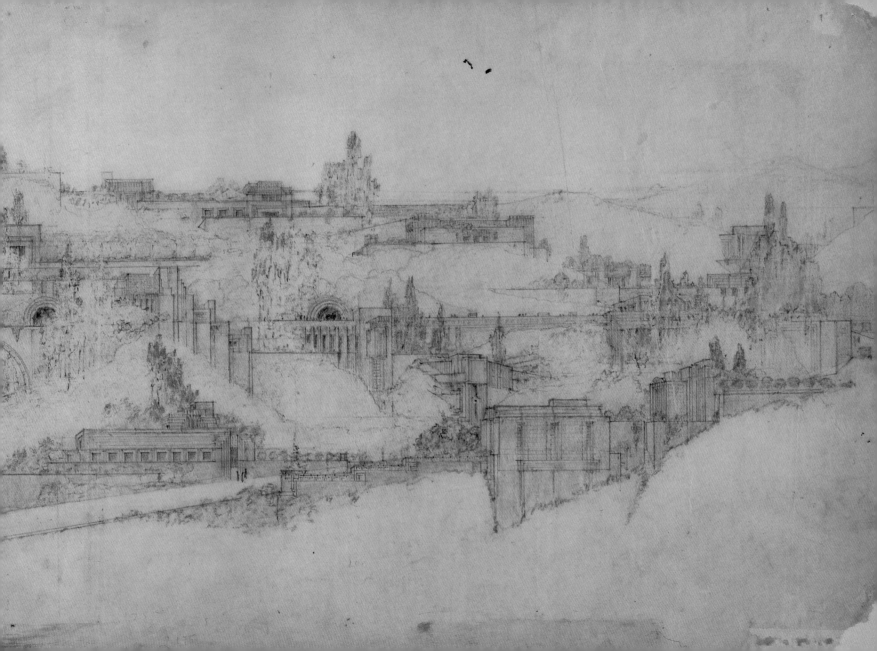

14. Create communal environments

15. Make the landscape democratic

16. Learn from the city

17. Give suburbia a soul

18. Design castles for the people

19. Be functional and artful

20. Dwell in the living room

21. Express the room within

22. Embrace the future

DESIGN and SOCIETY

Though Frank Lloyd Wright exalted the notion of the individual, he almost always designed for a community, whether real or imagined. That group might be as small as a nuclear family and as large as a corporation or congregation, but he always saw it as an assembly of freely associating individuals whose bonds he strengthened through his architecture. In his scaled conception of community, individual homes sheltering nuclear families coalesced into neighborhoods, such as the one he inhabited in Oak Park, Illinois, for several decades. He experimented over the years with opening up the individual homes to each other and creating shared spaces. Then there were looser congregations, including religious communities, but also those of music lovers coming together in auditoria and revelers at the Midway Gardens (see pp. 96–97). Such a group could also be one of work, such as at the Larkin Building, Johnson Wax, or the Marin County Civic Center (see p. 80). To these communities he gave shared spaces suffused with light from above, melding them together in a scene transformed by his architecture and caught within his structures. Finally, he dreamed of turning all of society into a textile of social connections laid out over the landscape, focused on civic monuments. What all these social designs had in common was a desire to bring people together not in front of an altar or in a strict hierarchy, but around a shared place of warmth and purpose, such as the hearth in the home, in democratic circles or grids, which remained open both to the outside and to an abstract sense of a higher essence. To design for a community, Wright felt, you had to design a place, a reason, and a way for gathering. Your only other tasks were to make sure that the members of that group were sheltered and contained, but not imprisoned, and would feel that there was something higher than themselves to which they should collectively aspire.

"[The Broadacre citizen] will have true form or he will have none. And this goes out from him to establish itself in his relations with others in the communal life. The communal life, too, must rest squarely and naturally with the basis for all human life."
—*The Disappearing City*, 1932

14. Create communal environments

Johnson Wax (S. C. Johnson Co.) Administration Building, Racine, Wisconsin, 1936–1939

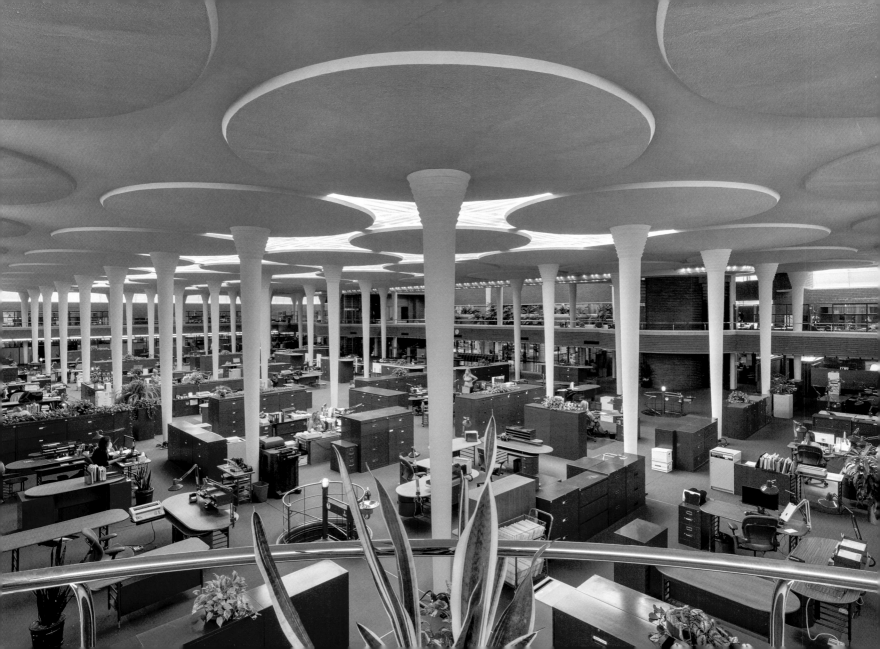

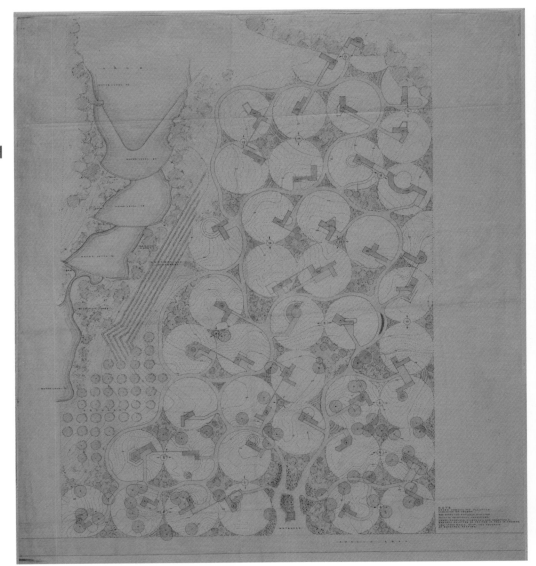

Galesburg Country Homes master plan, Galesburg, Michigan, 1947–1948. FA

Unity Temple, Oak Park, Illinois, 1904–1908. FA

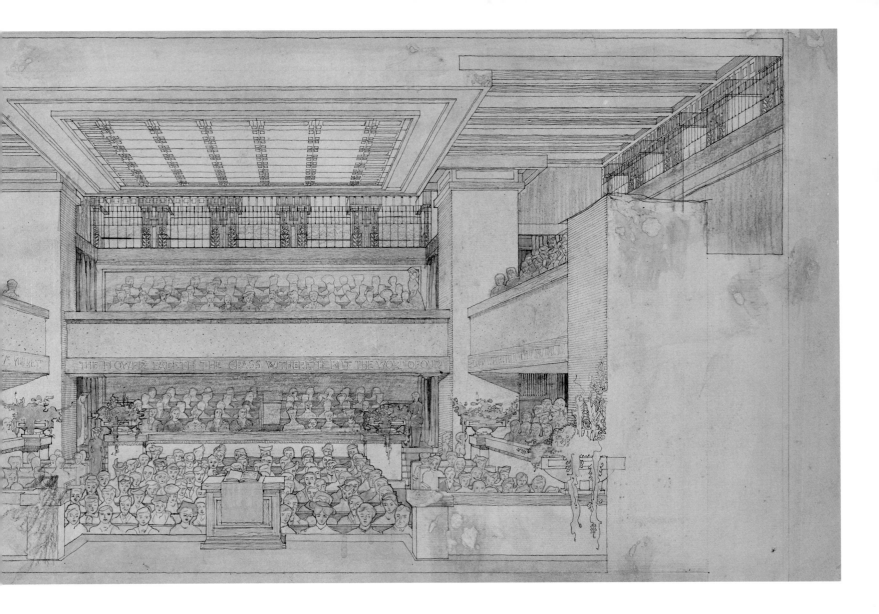

Marin County Civic Center, San Rafael, California, 1957–1962

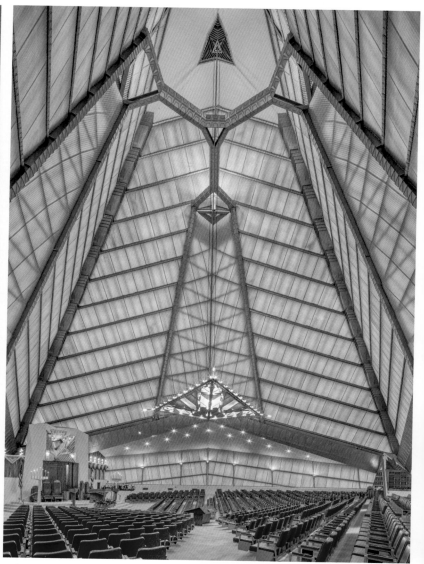

Beth Sholom Synagogue, Elkins Park, Pennsylvania, 1954–1959

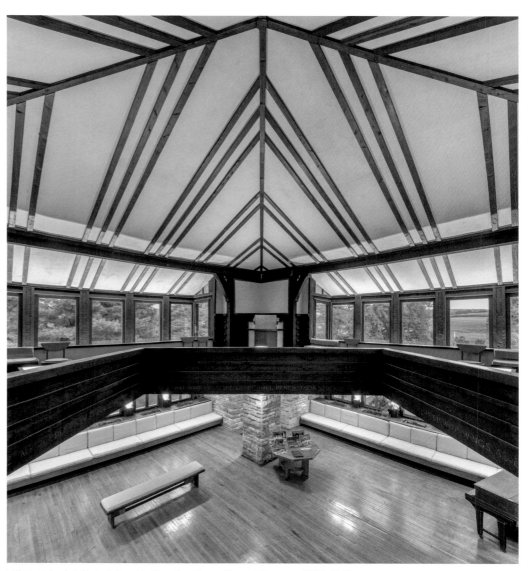

Hillside School, Taliesin Fellowship Complex, Spring Green, Wisconsin, 1902–1903

Democracy was Frank Lloyd Wright's greatest political ideal. He meant different things by the term at different points in his life, but his notion of democracy was always tied to the human-made landscape—he thought it was crucial for each person to cultivate a connection to the land. Early in his career, Wright believed that machines, which could make many things for large groups of people at the same time and bind them together through the process of industrial production and the vast factories, warehouses, and department stores it produced, could be the engine of democracy. Later, he looked toward political systems ranging from communism to fascism for ideas about democracy in an industrial age. In the end, he thought that architecture could quite simply build democracy. His model was the so-called "Jeffersonian grid," the 1813 measuring-out of the United States west of the Alleghenies in mile-square grids. Wright wanted to take that abstract set of relations within which the farms and townships of his youth in Wisconsin had grown up, and transform it into an alternative to the seemingly chaotic growth of cities and suburbs. He believed people should live on lots large enough to farm, with modern roads giving quick access to nodes of culture, care, education, and government, distributed evenly across the American continent. Wright saw no paradox in his notion that the architect would not only design this neo-agrarian space of democracy, which he called Broadacre City, but that he would run it, too. Together with his apprentices, beginning in the 1930s Wright built a working model for this space and, although flawed in key respects, it did offer an inspired alternative to ordinary suburban development in the form of a community of collective making dedicated to and guided by architecture—a building block for a Wrightian democracy.

"... The new will pass from the possession of kings and classes to the everyday lives of all ..."
—"The Art and Craft of the Machine," 1901

"When this *unfolding* architecture as distinguished from *enfolding* architecture comes to America... *That* is the character the architecture of democracy will take and probably that architecture will be an expression of the highest form of aristocracy the world has conceived.... Architecture must now unfold an inner content—express 'life' from the 'within.'"
—"Modern Architecture" (The Kahn Lectures), 1931

15. Make the landscape democratic

Living City (unbuilt project), 1958. FA

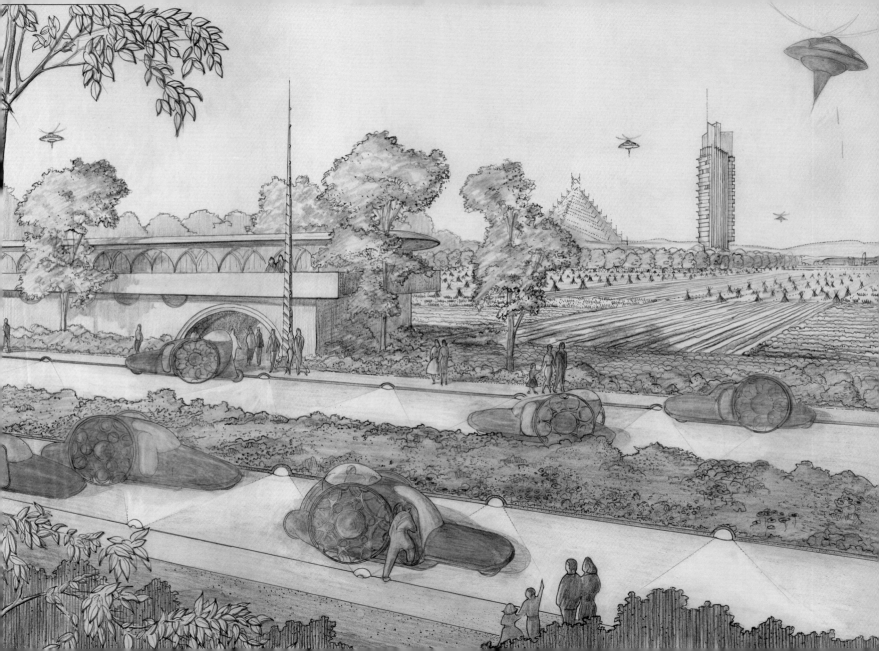

Marin County Civic Center, San Rafael, California, 1957–1962

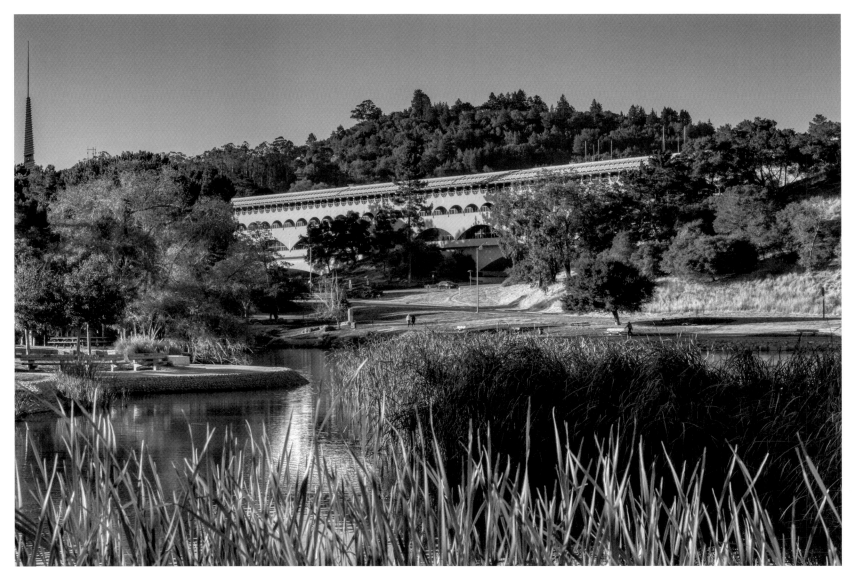
Marin County Civic Center, San Rafael, California, 1957–1962

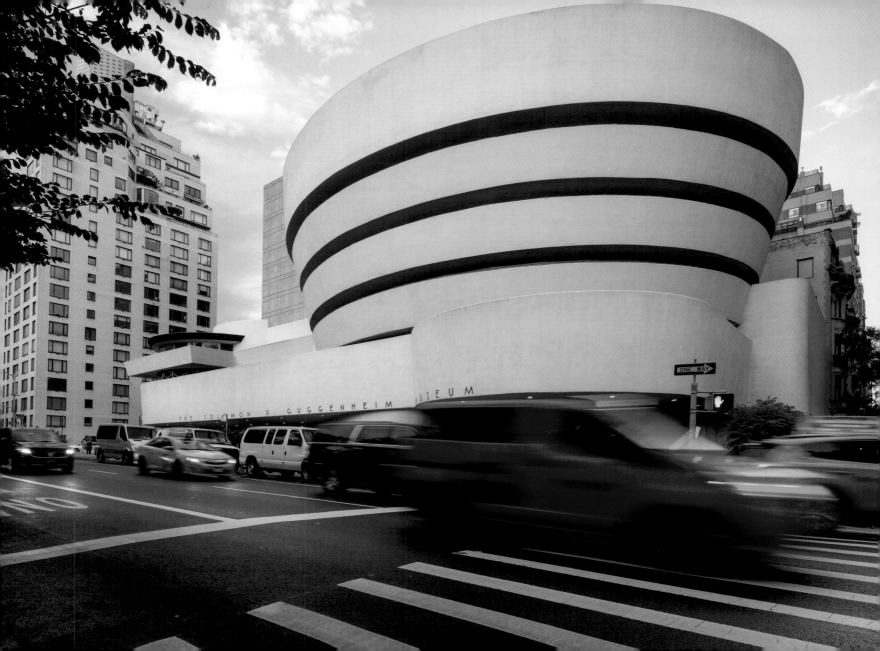

There is no doubt that Frank Lloyd Wright had a difficult relationship to the city, and in particular to the two that most shaped his life, Chicago and New York. Wright came to Chicago as a young man seeking his fortune and found there all the excitement of one of the fastest-growing and wealthiest metropoles in the world. He thrilled at its density, its skyscrapers, its technology, and its culture. He dreamed, in his 1901 talk, "The Art and Craft of the Machine," of fusing the metropolis together into a giant machine that would transform all the wealth of the American landscape into a democratic entity in three dimensions. It was not to be. Frank Lloyd Wright built countless structures in the suburbs, but in Chicago's downtown all he could point to were interior remodels. Meanwhile, he saw the city becoming not only ever larger but, in his opinion, ever uglier and more oppressive. Living and working in the suburbs, he became an alien to downtown Chicago, venturing in to find clients, to board a long-distance train, or to enjoy opera and the arts. Turning to New York, he proposed several projects and eventually built the Solomon R. Guggenheim Museum and a car showroom on Park Avenue. He loved the apartment he designed and occupied for part of every year in one of the city's fanciest hotels. The city was a place of thrusting and competing verticals that he wanted to link together into human-made mountains that were at the same time machines at a giant scale. Wright was exhilarated by Manhattan, but also disturbed by some of the same qualities he saw in Chicago. The city was all artifice and ambition, whereas the suburb could be a place of community and equality, and the countryside a place of spirituality grounded in a relationship with the land. Wright felt most at home at his spacious Wisconsin and Arizona compounds—or driving between them, traversing the open country together with his family and apprentices—but he kept coming back to the great metropoles, not just Chicago and New York, but also Los Angeles and Tokyo. He proposed skyscrapers that would sum up their possibilities, including one that would have been a mile high. But ultimately Frank Lloyd Wright stuck to architecture that was open, organic, and horizontal. His last urban designs dreamed of spreading out the city and wiping out its verticality to create a never-ending suburb.

"And the heavy breathing, the murmuring, the clangor, and the roar! — how the voice of this monstrous thing, this greatest of machines, a great city, rises to proclaim the marvel of the units of its structure..."
—"The Art and Craft of the Machine," 1901

"I believe that the American city as we know it today is not only to die but dying of acceleration. [...] Yet there is hope that our American civilization may not only survive its great cities but eventually profit by them because the death of these cities—now conceivable—will be the greatest service the machine has ultimately to render the human being."
—An Autobiography, 1943

Solomon R. Guggenheim Museum, New York, New York, 1943–1959

16. Learn from the city

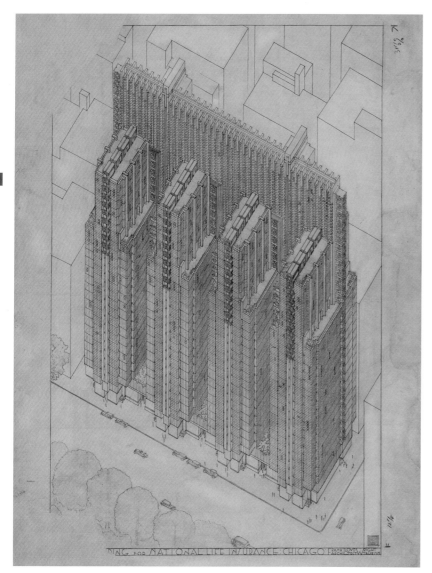

National Life Insurance Company Building (unbuilt project), Chicago, Illinois, 1924–1925. FA

> Solomon R. Guggenheim Museum, New York, New York, 1943–1959

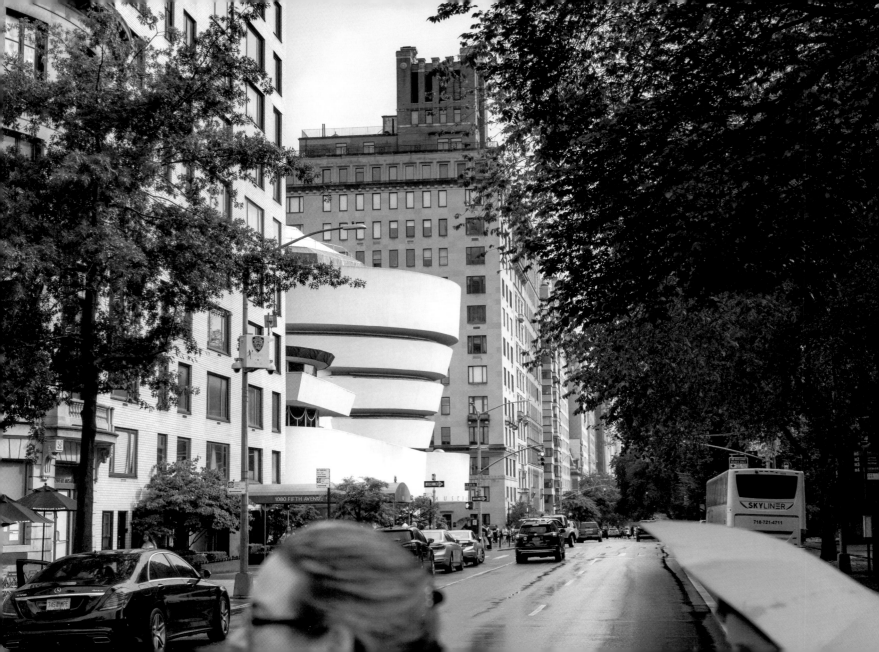

The closest Frank Lloyd Wright came to creating mass-produced homes that would be affordable yet beautiful—a dream he had harbored from the days when he started his practice—was with his "Usonian Automatic" series of concrete-block houses. He used the term, which he coined in 1954, to describe single-family dwellings with a more or less standard floor plan that could fit into a suburban lot, but that you could adapt to the particularities of a site. Most of the house could be built, he proposed, by using a version of the textile-block system he had developed in the 1920s. He wanted homeowners to be able to construct their home themselves, relying on sand and aggregate found on-site, local lumber, and other materials, so that the house would fit into its surroundings. Wood and glass components available in standard sizes would flesh out the structure. Tradespeople would be needed only to install such systems as electrical wiring and plumbing. The floor plan, of which his office produced dozens of variations throughout the 1950s, was based on that of the 1937 Jacobs House, a small home in suburban Madison, Wisconsin. The idea was that you would park your car under a carport (another one of his inventions, which he preferred over the enclosed garage that hid the car and made the house into a box) and enter diagonally into the main living space. The bedrooms would then form a train of cabins leading away from the communal areas. By using not just a standard building block, but also a grid out of which each room would be composed, Wright sought to standardize all the house's parts. He did not just make a series of boxes, though. He and his office were careful to slide all the planes apart, letting light pass in through clerestory windows to make the roofs seem to float, and opening the main room to the backyard with floor-to-ceiling glass. Over the years, the system relied more and more on modules that consisted of hexagons, so that the plan of the houses resembled beehives. Wright held onto the idea of organizing the house around a hearth, even though he recognized that most people would not use it. Though the houses were often more expensive than their neighboring structures, the variety of spaces and experiences they provided within what was becoming the standard living environment for middle-class Americans made them alternatives to the soulless imitations of Colonial houses that surrounded them—and make them valuable and beloved homes to this day.

"The house of moderate cost is not only America's major architectural problem but the problem most difficult for her major architects."
—*Architectural Forum*, 1938

17. Give suburbia a soul

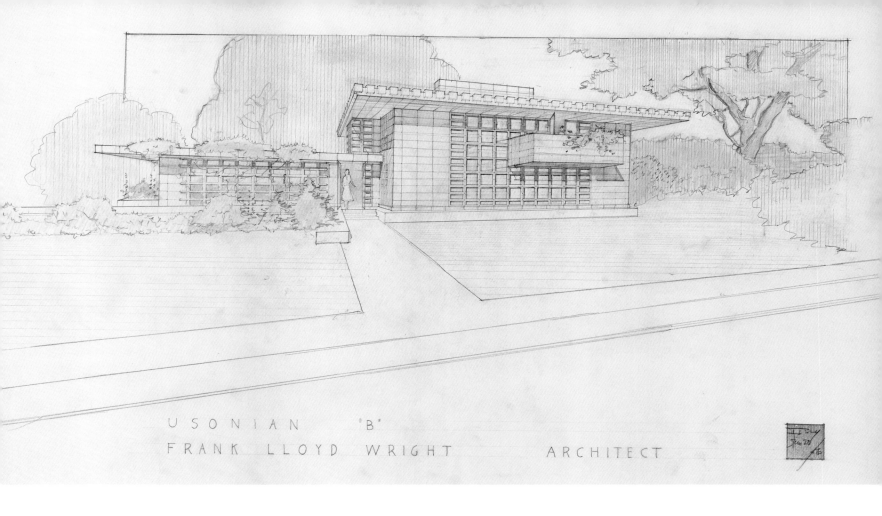

USONIAN 'B'
FRANK LLOYD WRIGHT ARCHITECT

Usonian automatic housing for Walter Bimson (unbuilt project), Phoenix, Arizona, 1949. FA

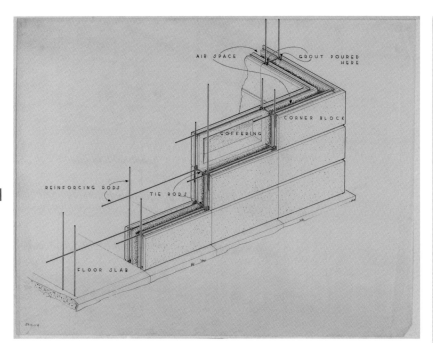

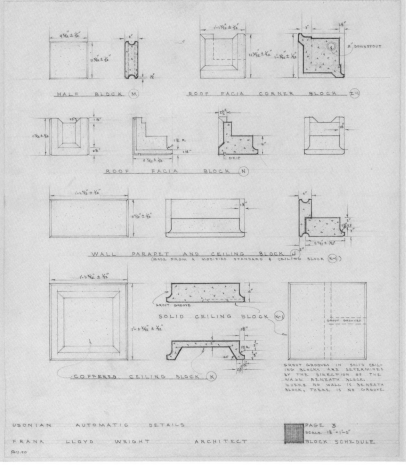

Usonian Automatic housing for Walter Bimson (above and right; unbuilt project), Phoenix, Arizona, 1949. FA

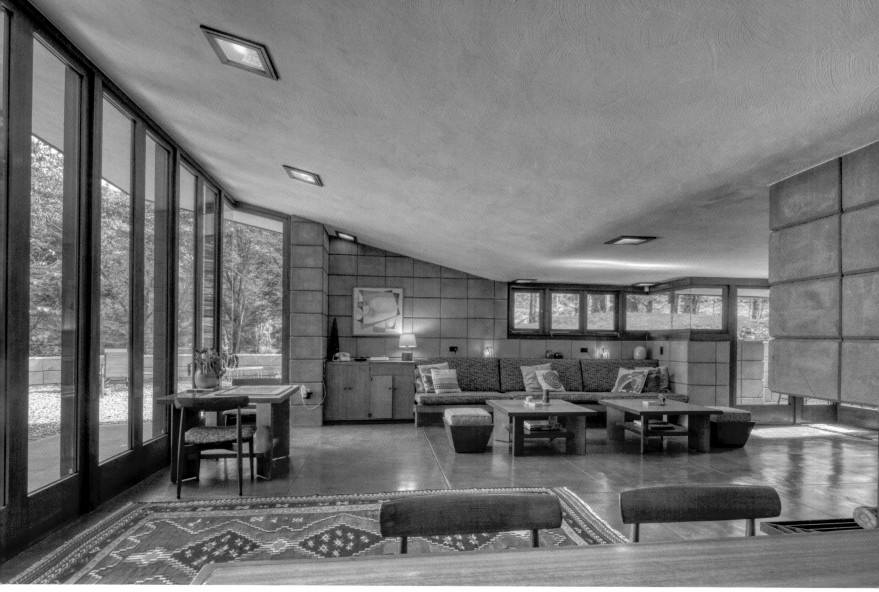

Samuel Eppstein House, Galesburg, Michigan, 1948–1949

Frank Lloyd Wright believed that he was middle class, that he designed for the middle class, and that the middle class were the natural inhabitants of the United States. He identified with this growing class of capitalist democracy in the U.S. despite dabbling in socialism, communism, fascism, and cultural elitism. He wanted to provide the middle class with architecture that met their needs and expressed their values "organically," as it were, from the inside out, unburdened by inherited customs and quirks. The places where they lived, worked, and played should make them feel at home and confident in the world they increasingly dominated. To Wright, the modern middle class were the descendants of self-sufficient farmers of yore. The middle class generally meant people who owned property, did not work in factories, and who were not aristocrats living in downtown penthouses or lakeshore mansions—though many of his clients were quite wealthy. Wright believed that "ordinary" people—those who worked, but not necessarily for wages, who were educated and educable, and who were active citizens of the nation—formed the social bedrock of America. They would typically be white and have a decent income, and came in family units of one father, one mother, and several children. In this, he conformed to common beliefs at the time, despite experiencing public censure and ostracism over his own broken (first and second) marriages, and despite his stated wish to live an "unconventional life" as the founder of the Taliesin Fellowship. Whether or not the principles applied to either Wright's own life or that of nonconforming social groupings, his best buildings, whether homes or places for religious or social communities, were such gathering places. Their solidity and monumentality, along with their sense of openness and accessibility, their didactic qualities, and the ways they created places for communal activity, represented the values he wanted to affirm as proper to the middle class.

"Not every man's home is his castle, that was a feudal concept. No, every man's home is his sunlit strand and no less, but more than ever, a refuge for the expanding spirit that is still his."
— The Disappearing City, 1932

American System-Built duplex housing, Milwaukee, Wisconsin, 1915–1917

18. Design castles for the people

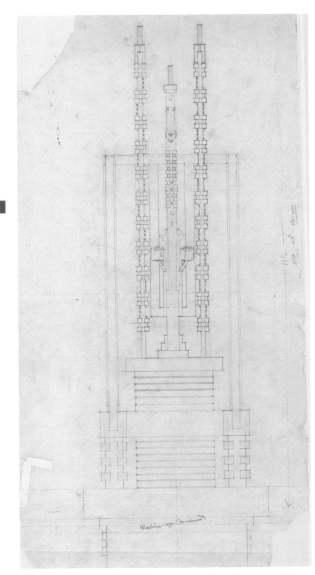

Midway Gardens, Chicago, Illinois, 1913. Sculptural ornament. FA

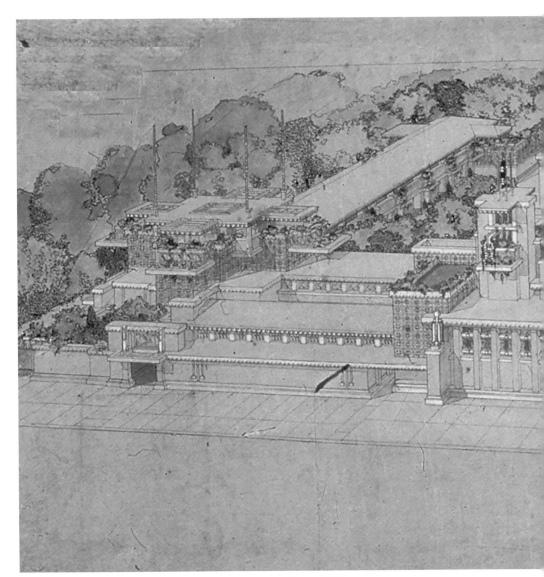

Midway Gardens, Chicago, Illinois, 1913. Aerial view. Private collection. FLWF

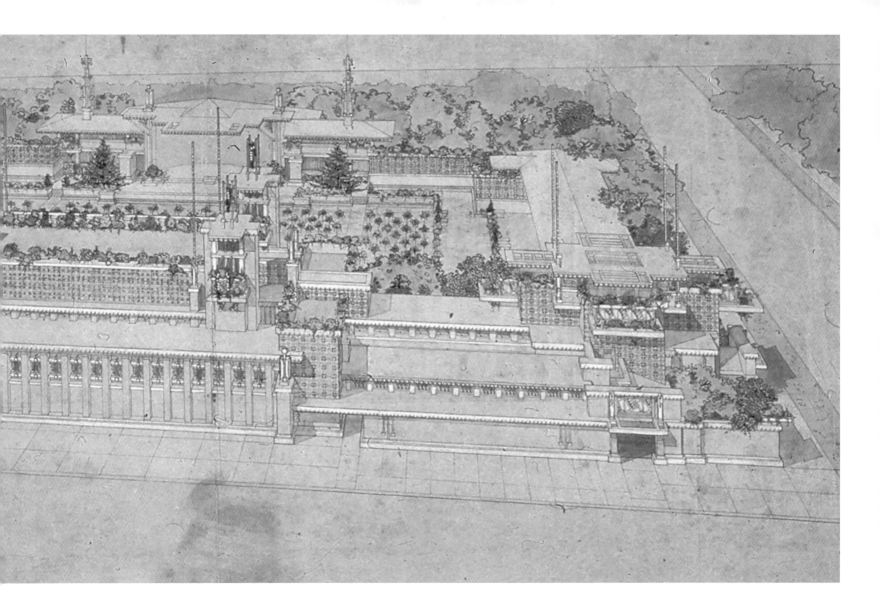

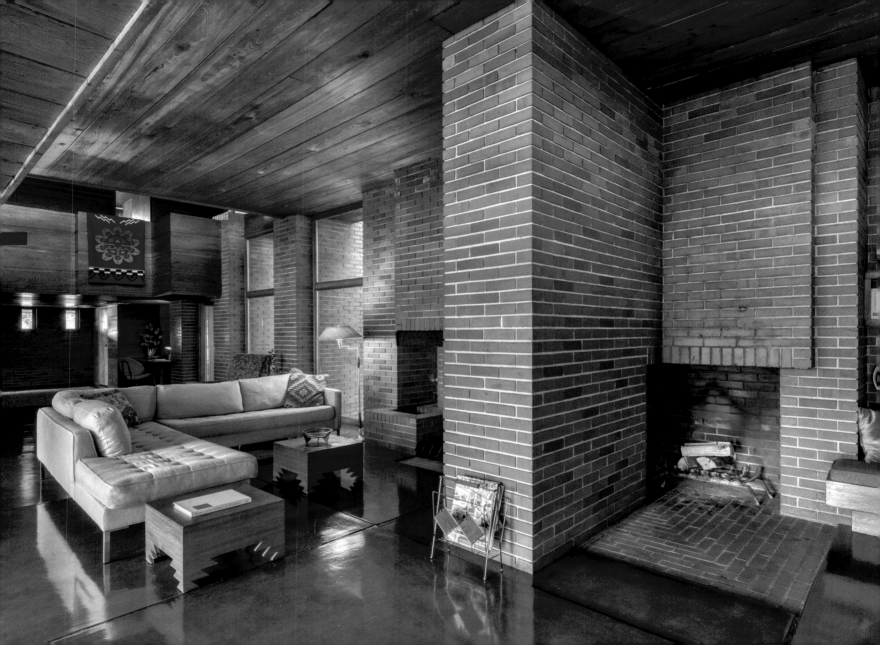

Building a better America meant designing high-quality homes for the middle class, Frank Lloyd Wright believed. He came to see his single-family house designs—which remained the mainstay of his practice for most of his life—as building blocks for larger communities. In 1936, he brought his experiments together in an effort to make moderately priced homes without basements or attics, prefiguring the postwar popularity of the ranch home. These Usonian homes of wood, glass, and concrete, with large windows and open plans, were conceived as both functional and artful. Wright also saw them as homegrown, as reflected in his borrowing of the term "Usonia," a variation of USA signifying United States of North America and for him, shades of unity and perhaps utopia. Most had a flat roofs, built-in furniture, unpainted walls, radiant floor heating, and a carport instead of a garage. In the 1950s Wright introduced the Usonian Automatic, a system for a home that his clients could (theoretically) construct out of modular materials themselves, with minimal help from tradespeople. It turned out that the construction process was more complex than Wright thought, and few clients were able to complete their own houses. Still, the nearly 150 Usonian houses that were eventually built, including the 47-home community of Usonia in Pleasantville, New York, testify to Wright's desire to make suburban living more affordable and more responsive to the landscape.

"A modest house, this Usonian house, a dwelling place that has no feeling at all for the 'grand' except as the house extends itself in the flat parallel to the ground. It will be a companion to the horizon."
—*The Natural House*, 1954

Still Bend (Bernard Schwartz House), Two Rivers, Wisconsin, 1939–1940

19. Be functional and artful

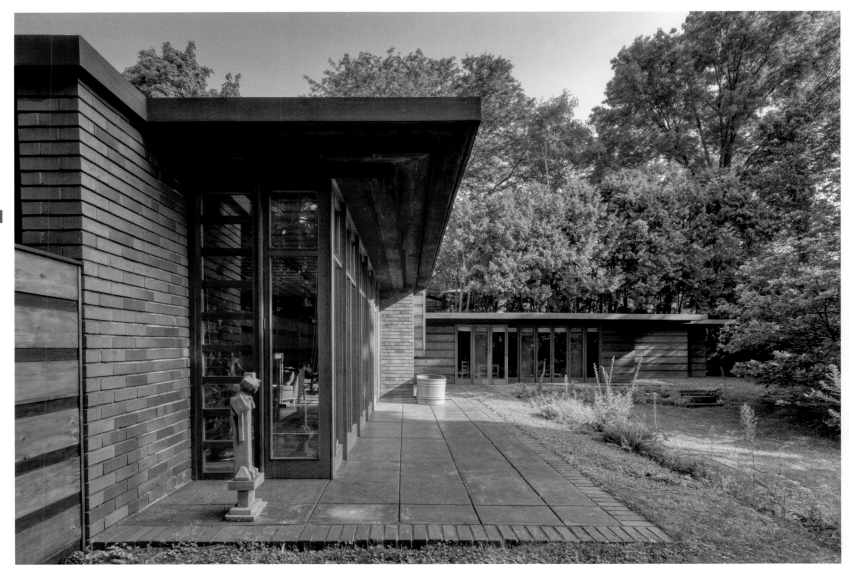

Jacobs I (Katherine and Herbert A. Jacobs House), Madison, Wisconsin, 1936–1937

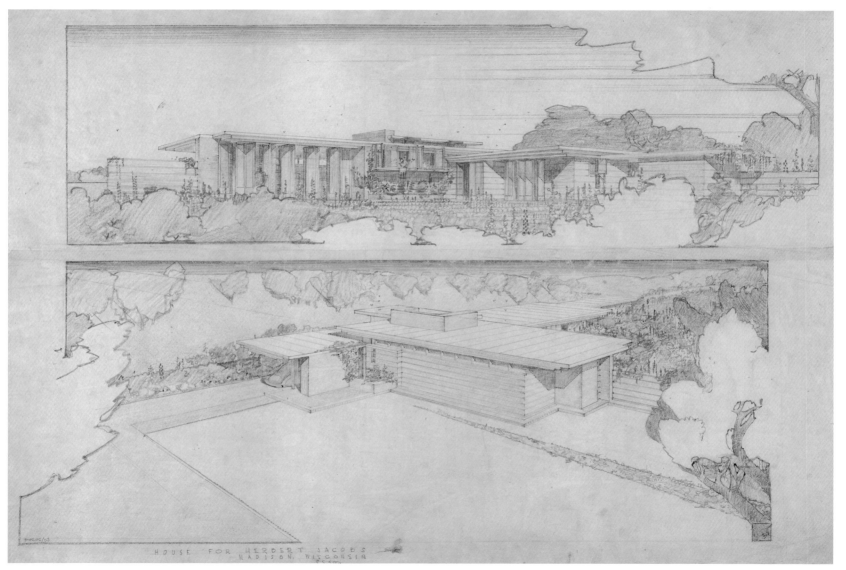

HOUSE FOR HERBERT JACOBS
MADISON, WISCONSIN

Jacobs I (Katherine and Herbert A. Jacobs House), Madison, Wisconsin, 1936–1937. FA

The living room is the reason for the existence of any Frank Lloyd Wright home, and its most alluring space. He once wrote that "really there need be but one room, the living room" on the ground floor of any house; all else was a concession to practical requirements. The living room was a relatively new phenomenon when Wright started designing in the 1880s. While rich people had various salons, receiving rooms, and withdrawing chambers, and poor people just had a few rooms in which to do everything, the living room emerged as the place for the middle-class nuclear family and their close friends to relax together. Its whole point was to bring people together to enjoy music, reading, gossiping, or educating each other in conversation. Wright perfected this idealized space of mutual acculturation in his early work, gathering the family around the symbolic and sometimes physical warmth of the hearth, while individual members could also withdraw to nooks or benches along the windows to read. Many of the spaces have a full and rich acoustics, enveloping you in music. Too large for one person to feel comfortable, but also too small to work for larger parties, Wright's typical living rooms work best with a small group of people. But Frank Lloyd Wright did not stop there. He extended the lessons he had learned from designing such spaces to making everything from hotel lobbies to office buildings have areas where small to large groups of people could have such a moment of shared focus. This kind of enforced (or at least encouraged) sociality then became the basis of the way in which he developed the baronial living rooms at his two homes, Taliesin and Taliesin West. These large spaces only work when populated by a sizable group, such as the apprentices who made up the Fellowship he founded in 1932. They came together for salon-style performances at least once a week while Wright was alive, turning these rather grand spaces into the social hub of a community. Such larger living rooms, Wright believed, could serve as prototypes for how we can create places of social connection and bonding embedded in the places we live, work, and play.

"Winter nights—all frosty white or deep snow—icicles hanging from the eaves outside—we love to build great blazing fires in the big stone fireplaces, closing the inside shutters of the whole house, and lie there story-telling, arguing or reading until we fall asleep."

"The most desirable work of art in modern times is a beautiful living room. Or let's say a beautiful room to live in."
— *An Autobiography*, 1943

20. Dwell in the living room

Charles F. Glore House, Lake Forest, Illinois, 1951–1954

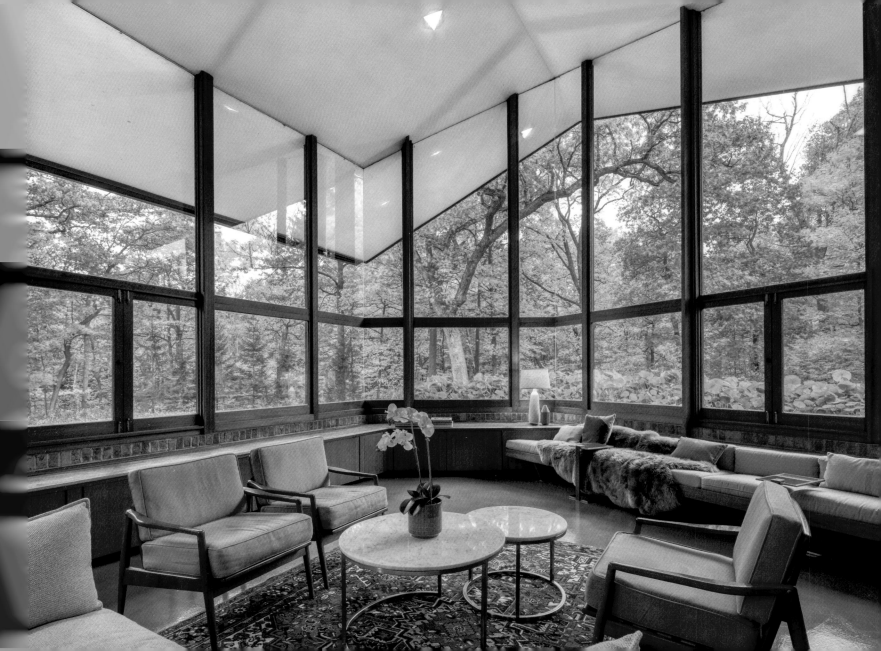

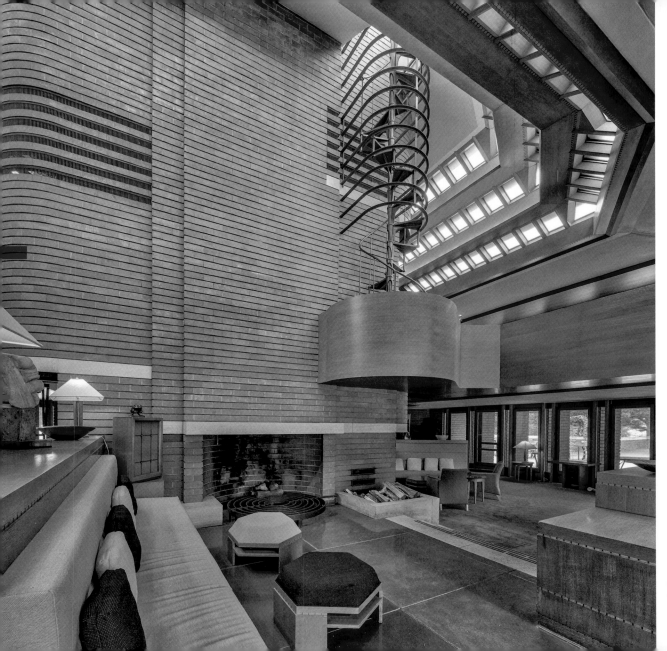

Wingspread (Herbert F. Johnson House),
Wind Point, Wisconsin, 1937–1939

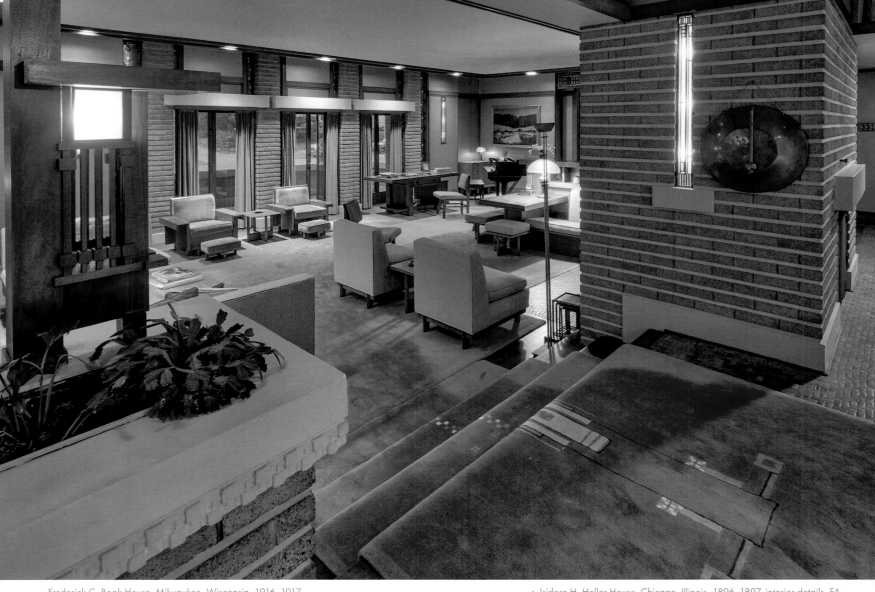

Frederick C. Bogk House, Milwaukee, Wisconsin, 1916–1917

> Isidore H. Heller House, Chicago, Illinois, 1896–1897, interior details. FA

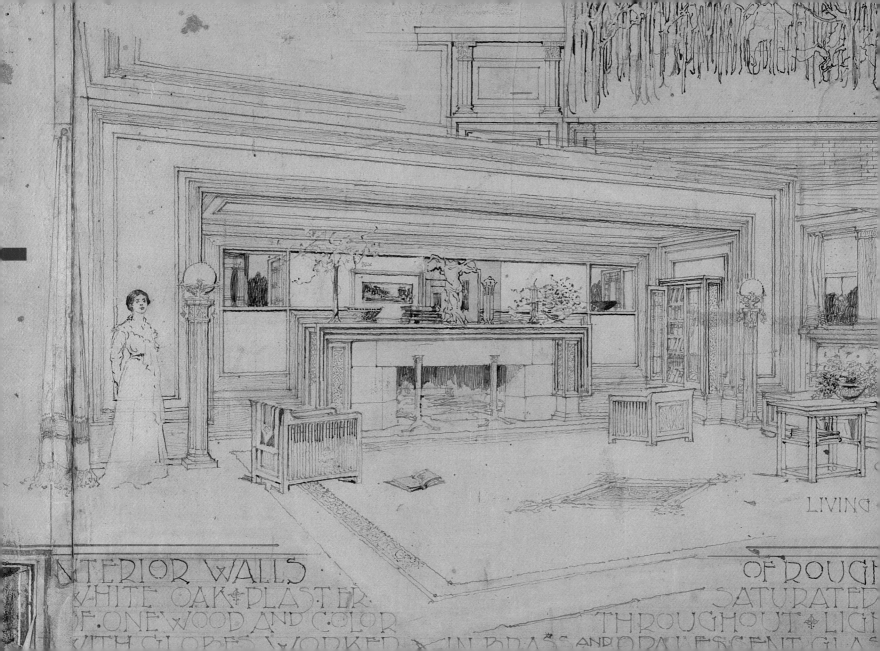

LIVING

INTERIOR WALLS OF ROUGH
WHITE OAK PLASTER SATURATED
OF ONE WOOD AND COLOR THROUGHOUT LIG
WITH GLOBES WORKED IN BRASS AND OPALESCENT GLA

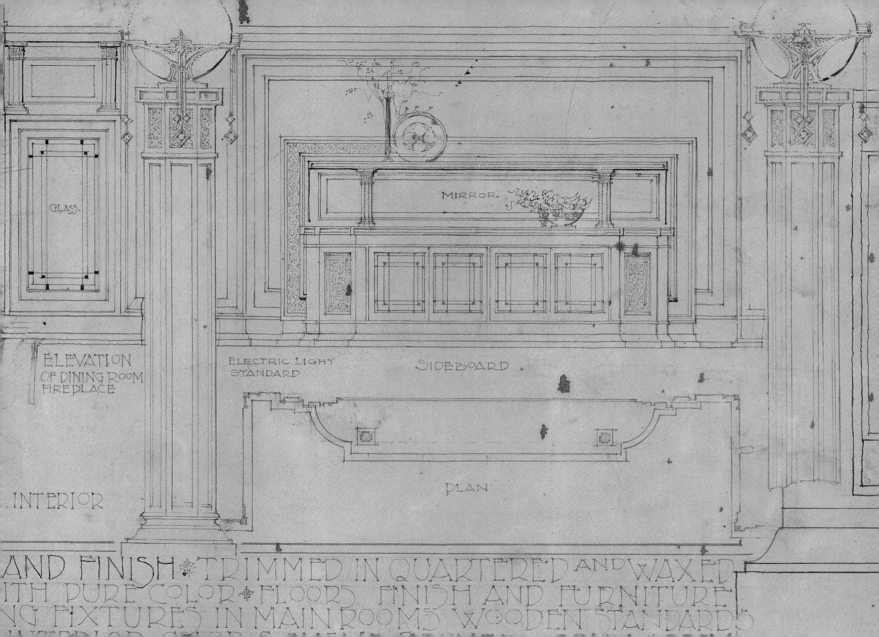

GLASS.

ELEVATION
OF DINING ROOM
FIRE PLACE

ELECTRIC LIGHT
STANDARD

MIRROR.

SIDEBOARD

PLAN

INTERIOR

AND FINISH TRIMMED IN QUARTERED AND WAXED
ITH PURE COLOR FLOORS FINISH AND FURNITURE
NG FIXTURES IN MAIN ROOMS WOODEN STANDARDS

Jorgine Boomer Cottage, Phoenix, Arizona, 1953

"The first idea was to keep a noble room... in mind, and let that sense of the great room shape the whole edifice. Let the room inside be the architecture outside."
— *An Autobiography*, 1932

"The room within is the great fact about the building—*the room* to be expressed in the exterior as *space enclosed*. This sense of the *room* within, held as the great *motif* for enclosure, is the advanced thought of the era in architecture, and is now searching for exterior expression."
—"In the Cause of Architecture II: What 'Styles' Mean to the Architect," 1928

When you look at a building Frank Lloyd Wright designed, you almost immediately understand what the most important space is and where it is located. In most but not all cases, you can quickly pick out the living room, the main work area, the chapel, or the main atrium from the rest of the mass. This was the "noble room," as Wright called the sanctuary of Unity Temple in Oak Park. He sometimes made his major space eccentric, siting a living room or a worship room off to the side or the back. In that case, it is the height or breadth of that space, or a dramatic roof that sailed over the space toward you, that shows you its importance. Additionally, Frank Lloyd Wright went to great pains to articulate the smaller rooms so that you can distinguish them, too, from the outside. He then repeated that same act of articulation with the building's structure. Yet each of these pieces also served to buttress, in terms of visual composition, that dominant space or room. What's more, they all had to hang together as a whole. Frank Lloyd Wright neither hid what his buildings were about, nor did he undress them so that they stood naked on the street. Instead, his architecture was a veil that clad and intimated what was inside, making it beautiful and seductive, while letting you know that only on the inside would that which was sheltered become fully revealed.

21. Express the room within

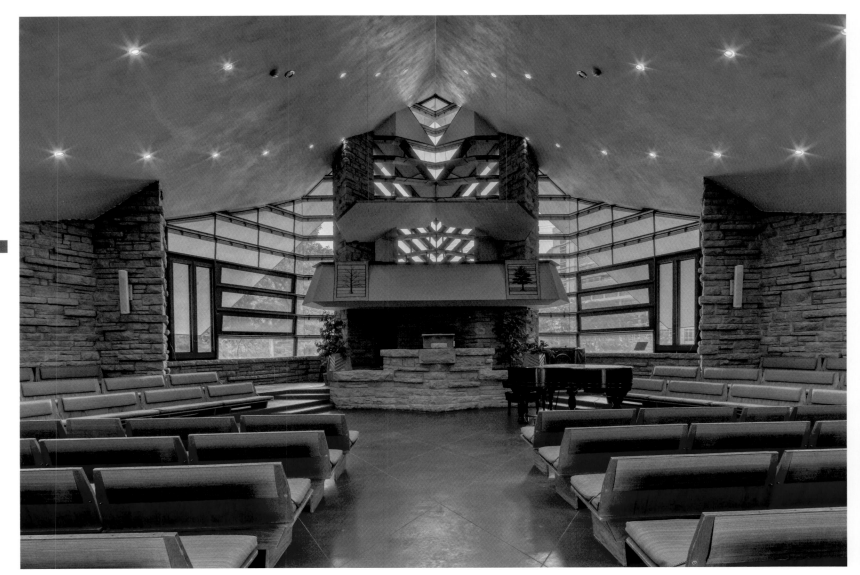

Unitarian Meeting House, Shorewood Hills, Wisconsin, 1947–1951

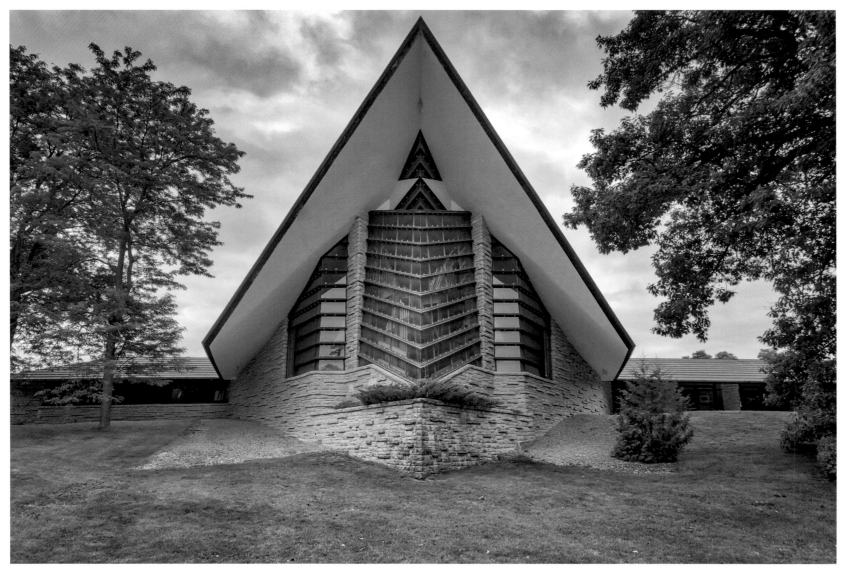

Unitarian Meeting House, Shorewood Hills, Wisconsin, 1947–1951

Frank Lloyd Wright experimented with new technologies and materials throughout his life. In his final decade, he applied some of the innovations in manufacturing that had emerged from the Second World War to housing and building construction. He also embraced the increasing mobility of American society, envisioning not just the triumph of automobiles, but also personal aircraft parked outside the home, and new possibilities like mobile resort hotels. Fascinated with the possibilities of structure and materials, Wright used aluminum and prefabricated elements in his buildings, and even designed a "Dinky Diner" that resembled an Airstream trailer for his twice-yearly migration between Taliesin and Taliesin West. In 1956 Wright worked with the U.S. Rubber Company to propose inflatable huts that could be easily put up and just as easily deflated, packed up, and moved. Wright was by then using many circular forms in his architecture, and the method suited him well. He proposed compounds of these Fiberthin structures grouped in a radial pattern. While he was proposing such radical departures from traditional building methods, he was also arguing for the standardization of the building trades and materials, which he hoped would help his "Usonian Automatic" houses become more affordable. This work, in turn, harked back all the way to his experiments in prefabrication with the American System-Built homes of 1917 and his textile-block system of the following decade. What all this work had in common was Wright's belief that the future of architecture lay in harnessing the power of technology for practical and artistic innovation, and that we should always look for new materials that were cheaper, easier to use and maintain, stronger, and more beautiful.

"Multitudes of processes are expectantly awaiting the sympathetic interpretation of the mastermind."
—"The Art and Craft of the Machine," 1901

"Time was when the hand wrought. Time is here when the *process* fabricates instead."
—"In the Cause of Architecture, IV: Fabrication and Imagination," 1927

22. Embrace the future

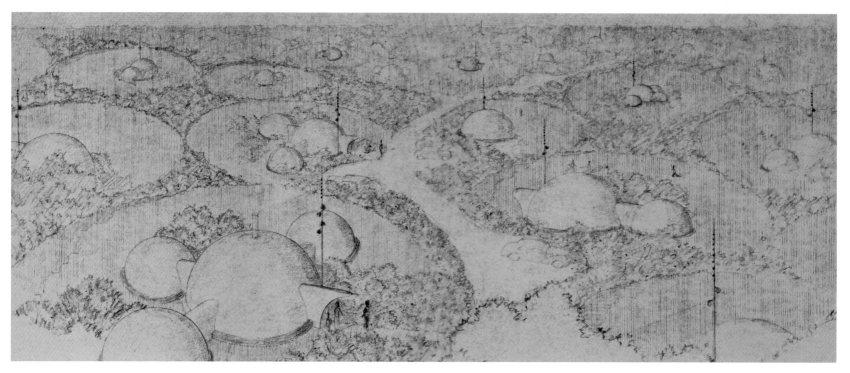

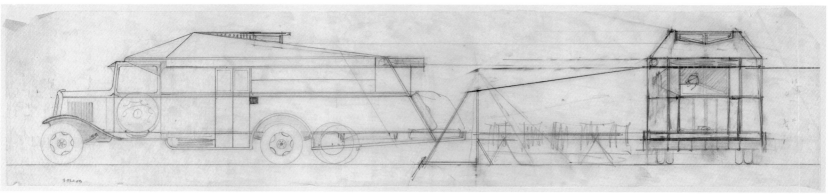

Rubber Village (Fiberthin air houses), Mishawaka, Indiana, 1956. FA Dinky Diner mobile kitchen unit (unbuilt project), 1939. FA

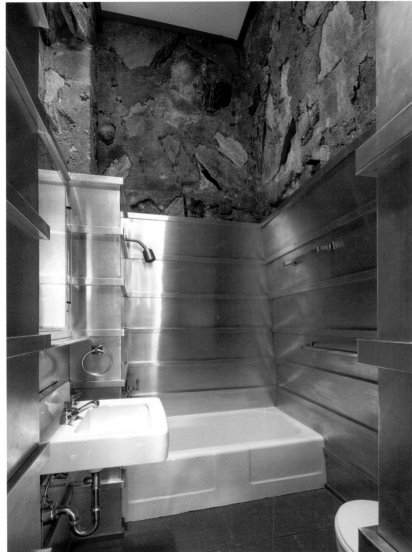

Taliesin West, Scottsdale, Arizona, 1937

S. C. Johnson Research Tower, Racine, Wisconsin, 1944–1950

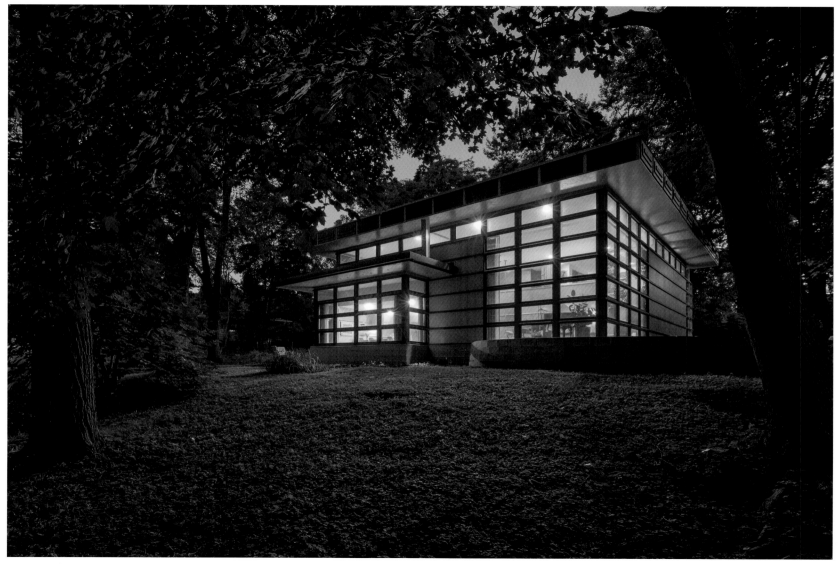

Walter and Mary Ellen Rudin House (prefabricated house #2 for Erdman Homes), Madison, Wisconsin 1957–1959

23. Compress and release

24. Open the corner

25. Shelter with overhangs

26. Reach out beyond

27. Screen, don't close

28. Mold with light

SPACE and EXPERIENCE

At Unity Temple, one of Frank Lloyd Wright's first nonresidential designs, you come off the street at a right angle, walk all the way past the main sanctuary, make a ninety-degree turn, enter into a very low and dark space, walk through it, open another set of doors, and then suddenly find yourself overwhelmed by a triple-height space with light flooding in from clerestory windows all around you. One critic has called this the "death-and-resurrection trick": you are taken out of the path of everyday life, led through a passage that resembles a tomb or a cave, and then released into a breathtaking realm of light and space that is radically different from the world you have left behind. The experience at Unity Temple is religious, and so the metaphor would seem apt. But Wright used the same "trick," also known as compression and release, in many different buildings, ranging from single-family homes to office buildings and museums. To some extent, he was trying to sanctify the core functions that these structures house. At the Larkin Building, the headquarters for a soap manufacturer in Buffalo, New York, the big reveal was the main office floor, a 76-foot-tall skylit interior court surrounded by tiers of more offices. Inscriptions and artworks extolled the virtue of work. Wright also saw the experience of viewing "nonobjective art," which is the sort of spiritually infused painting for which he designed the Solomon R. Guggenheim Museum (see pp. 234–235) in New York, as a religious one. However, the true significance of the death-and-resurrection move, in these and other cases, was not the purpose of the big room you find after you have been buried by the low vestibule; it is the experience itself. Wright wanted you to be reborn into the scene he had built for you. The very composition of the space, its light, and the ornament that told you what the place was all about, was meant to make you realize something with your eyes and your body that was beyond the ordinary, beyond the use of the space, and beyond the material out of which he had the structure built. That experience was meant to make you realize that there was something larger than you, both literally and metaphorically, and that it was abstract, accessible to humans, and brought people together to strive towards some greater good.

23. Compress and release

"Now he went through the moist woods that in their shade were treasuring the rainfall for the sloping fields below or to feed the clear springs in the ravines, wending his way along the ridges of the hills gay with Indian-pinks or shooting-stars, across wide meadows carpeted thick with tall grass on which the flowers seemed to float."
—*An Autobiography*, 1932

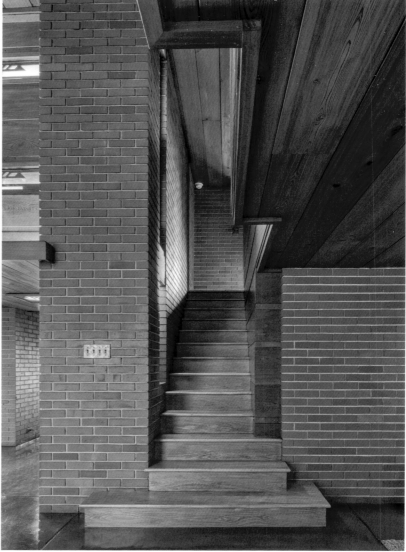

Richard Quittenton, *Death and Resurrection*, 2020

Still Bend (Bernard Schwartz House), Two Rivers, Wisconsin, 1939–1940

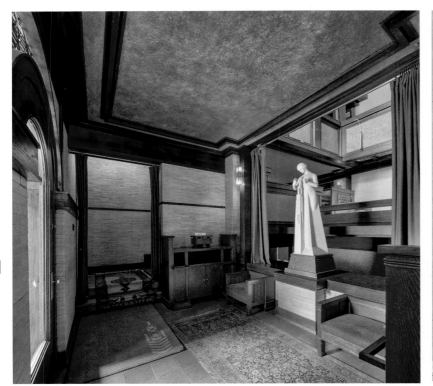

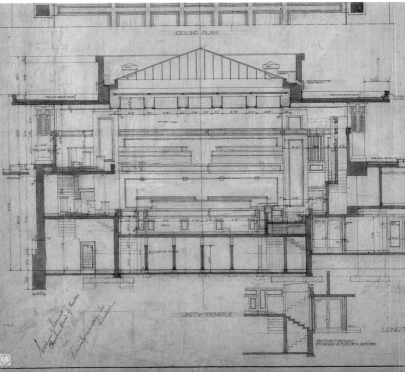

Susan Lawrence Dana House, Springfield, Illinois, 1900–1902

Unity Temple, Oak Park, Illinois, 1904–1908, section. FA

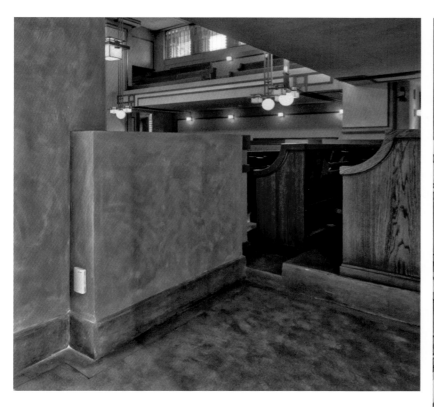

Unity Temple, Oak Park, Illinois, 1904–1908

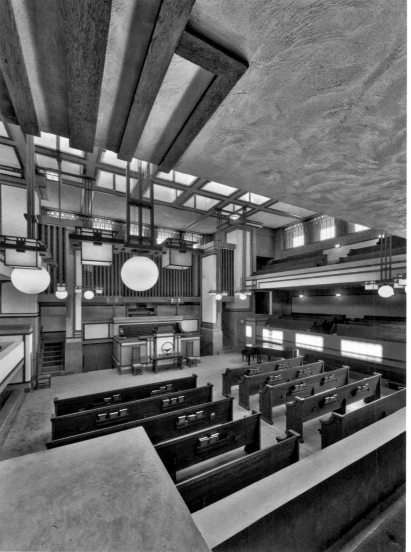

Unity Temple, Oak Park, Illinois, 1904–1908

The corner window, for Frank Lloyd Wright, was more than just a window in the corner of a room. It was a dramatic way of dissolving the corner to "break the box" and release space right where you would expect solid walls to meet. Sometimes by taking advantage of steel-frame construction to eliminate the need for corner posts, Wright used mitered glass panes to "wrap" the window seamlessly around corners. Even more astonishingly, at Fallingwater and elsewhere, he designed operable windows that invite the user to make corners disappear: go to the corner, undo the latches, push the frames open, and feel the space instantly transform. The room expands outward, while the outside rushes in. Instead of planes joining together to enclose a room, or some sort of column to support the weight above, a void now opens up. Above and below the window, everything is normal, and you feel enclosed. But at eye height, the corner window calls into question the difference between inside and outside, the logic of structure, and the sense of enclosure. As the corner window became a common feature of modern architecture across the world, Wright claimed that most architects did not understand how to use it correctly. Frank Lloyd Wright might not have invented this particular way of opening space, but he perfected it as one of the hallmarks of his architecture, which always seeks to balance a sense of shelter with a recognition that you are part of a wider world out there. The corner window is an opening into that continuous reality.

"I soon realized that the corners of the box were not economical or vital bearing points of structure. The main load of the usual building, I saw, was on the walls and so best supported at points some distance back from the corner. Spans were then reduced by cantileverage. So I took the corners out, put in glass instead: the corner window. I gave a real blow here to all boxing up or boxing in."
—*Architectural Forum*, 1951

24. Open the corner

Fallingwater (Liliane and Edgar J. Kaufmann House), Mill Run, Pennsylvania, 1935–1938

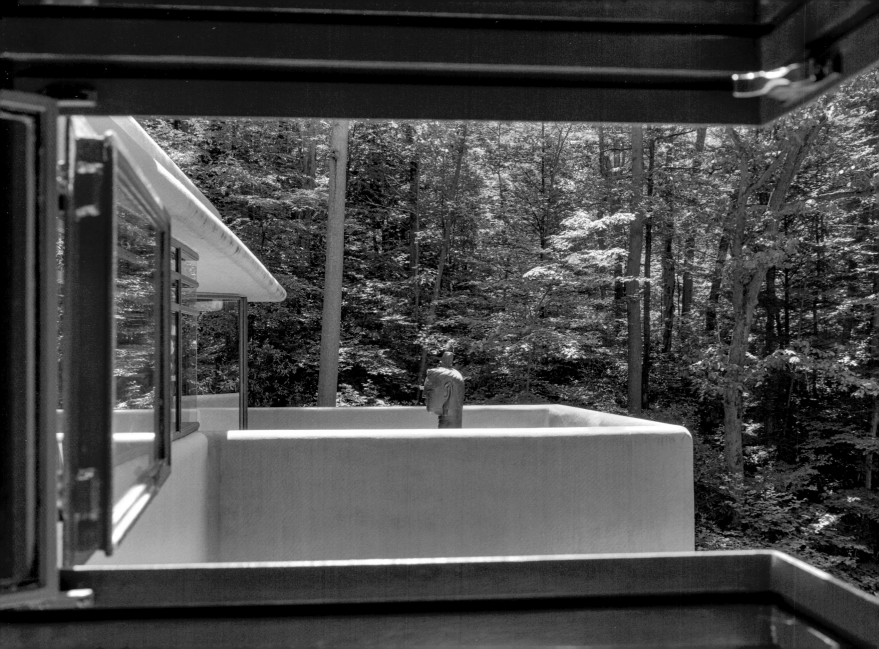

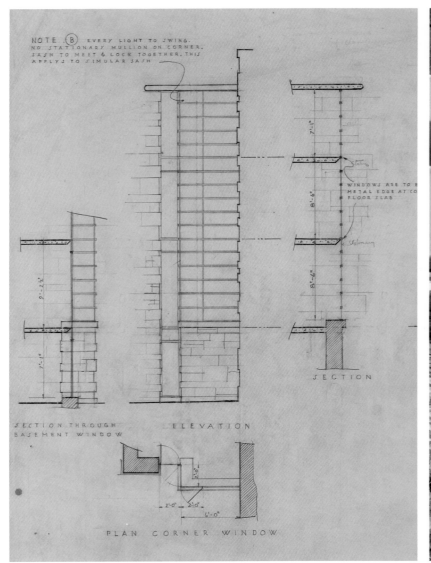

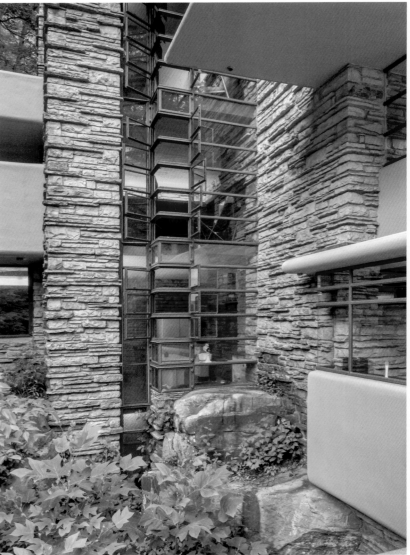

Fallingwater (Liliane and Edgar J. Kaufmann House), Mill Run, Pennsylvania, 1935–1938. FA

Fallingwater (Liliane and Edgar J. Kaufmann House), Mill Run, Pennsylvania, 1935–1938

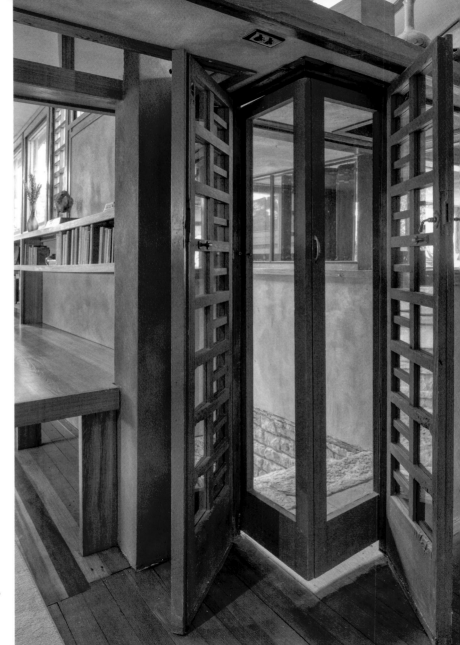

Taliesin III, Spring Green, Wisconsin, 1925–1959

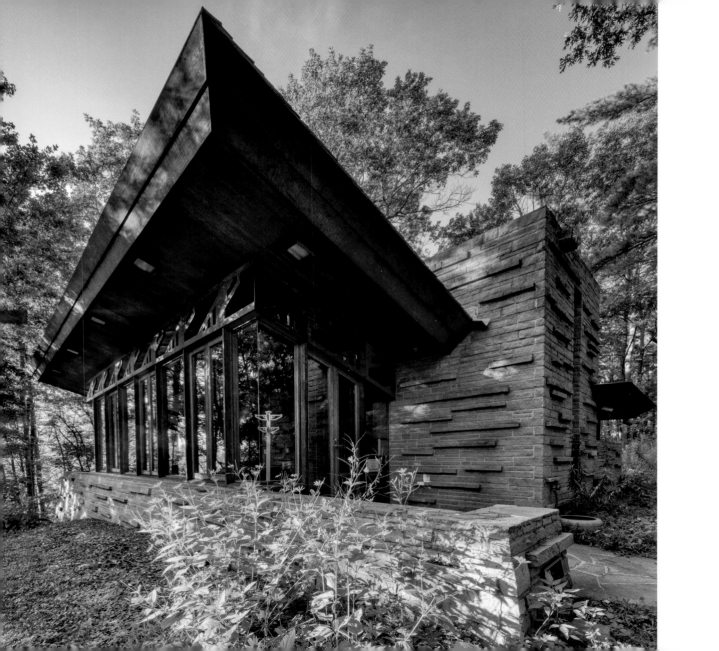

Wright used broad overhangs to great effect. Continuing the roof past where the walls end makes the whole structure appear lower and more horizontal, and thus more "grounded" in its site. The spreading roof also gives you a sense that something inside is being sheltered. The line of the eaves, which ends that covering, catches your eye and becomes a unifying stroke across the building. Its strength lets the rooms below it push and pull in whatever direction they need to accommodate the functions inside or to bring light in without disturbing the overall mass. The shadow of the overhang hides the different shapes while also protecting the spaces inside from sun, rain, or snow. From the inside, the overhang seamlessly continues the lines of the ceiling, drawing your eye out to the surrounding landscape. At the same time, the dark band of the eaves helps to frame your views of what is outside. Overhangs might seem wasteful, using material and space that has no particular function, or they may seem like liabilities for roof maintenance, but Frank Lloyd Wright used them skillfully in designing livable and energy-efficient homes. The subtle ways in which overhangs create a relationship between inside and outside, smoothing the transition between the two, and protect you from the elements, make them valuable.

"Overhangs had double value: shelter and preservation for the walls of the house, as well as this diffusion of reflected light for the upper story through the 'light screens' that took the place of the walls and were now often the windows in long series."
— *The Natural House*, 1954

25. Shelter with overhangs

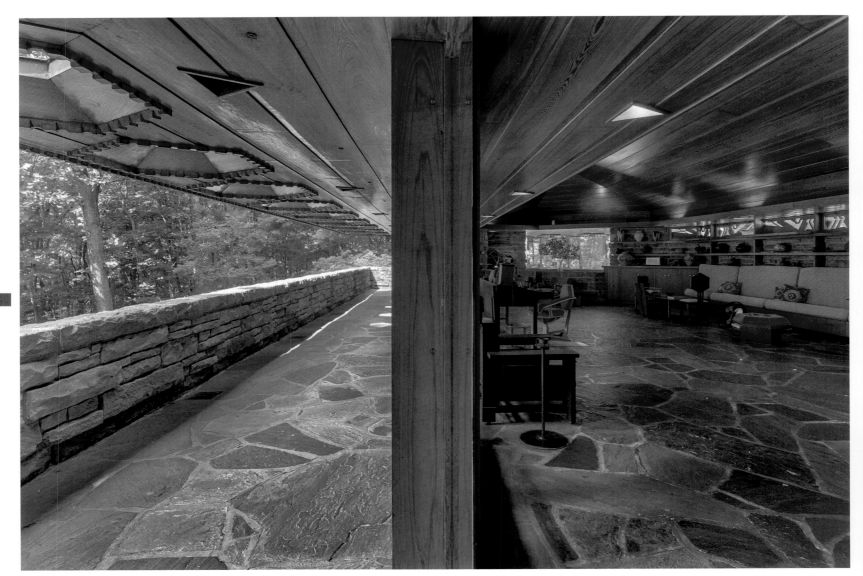

Kentuck Knob (I. N. Hagan House), Chalkhill, Pennsylvania, 1954–1956

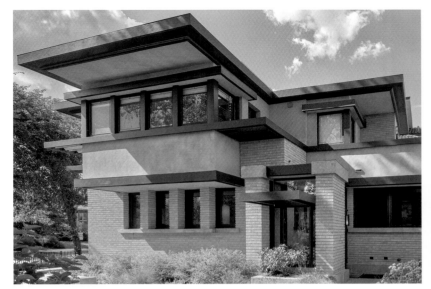

Emil and Anna Bach House, Chicago, Illinois, 1915

Pettit Memorial Chapel, Belvidere, Illinois, 1906–1907

Frank Lloyd Wright wielded the cantilever as a device to "break the box." Extending his buildings out beyond their foundations or letting terraces and even whole rooms reach out beyond the floors below them was his way to not only gain more space, but also to make his buildings float over the landscape. Wright always launched the cantilevered horizontal plane from a strong vertical element, like the structural core of the Johnson Wax Research Tower (see pp. 164–165) or the fireplace boulder at Fallingwater. Because of that, the buildings appear to be rooted in the ground, reaching out into the landscape like a dancer (or a waiter) extending their arms or legs. The cantilever was the ultimate human-made space in Wright's architecture. Made possible by modern structural technology, the cantilevered space, hovering off the earthy core of the building, expresses the idea of freedom, inviting people to move beyond the edge of gravity and community while opening themselves up to nature. Wright wanted his cantilevers to be as light as possible, leading him to push the boundaries of structural engineering as well as space. In Wright's hands, the cantilever helped liberate both the architect and the inhabitant from the constraints of building and dwelling as conventionally understood. The cantilever allowed architecture to open up directly into its surroundings.

"Steel gave rise to a new property: I call it tenuity. Tenuity is simply a matter of tension (pull), something never before known in the architecture of this world…. This pull permits free use of the cantilever, a projectile and tensile at the same time, in building-design. The outstretched arm with its hand (with its dropping fingers for walls) is a cantilever. So is the branch of a tree."

"Floor slabs stiffened and extended as cantilevers over centered supports, as a waiter's tray rests upon his upturned fingers… I now began to use in order to get planes parallel to the earth to emphasize the third dimension."
— The Natural House, 1954

26. Reach out beyond

Fallingwater (Liliane and Edgar J. Kaufmann House), Mill Run, Pennsylvania, 1935–1938

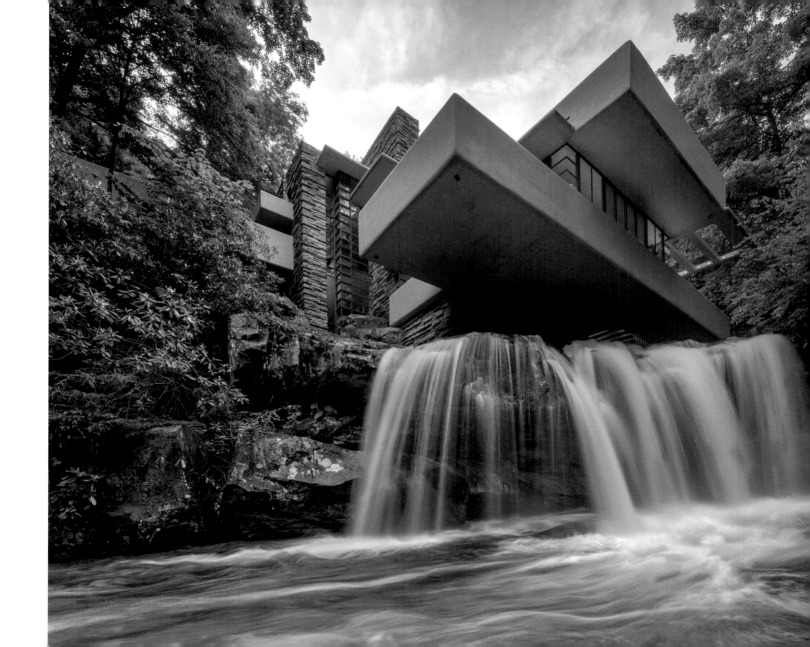

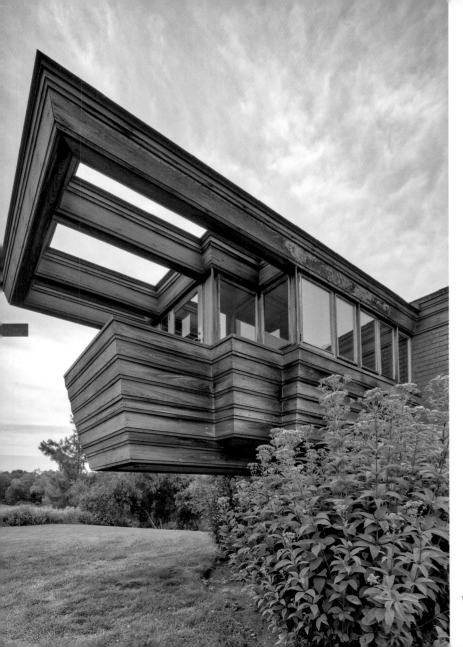

Wingspread (Herbert F. Johnson House), Wind Point, Wisconsin, 1937–1939

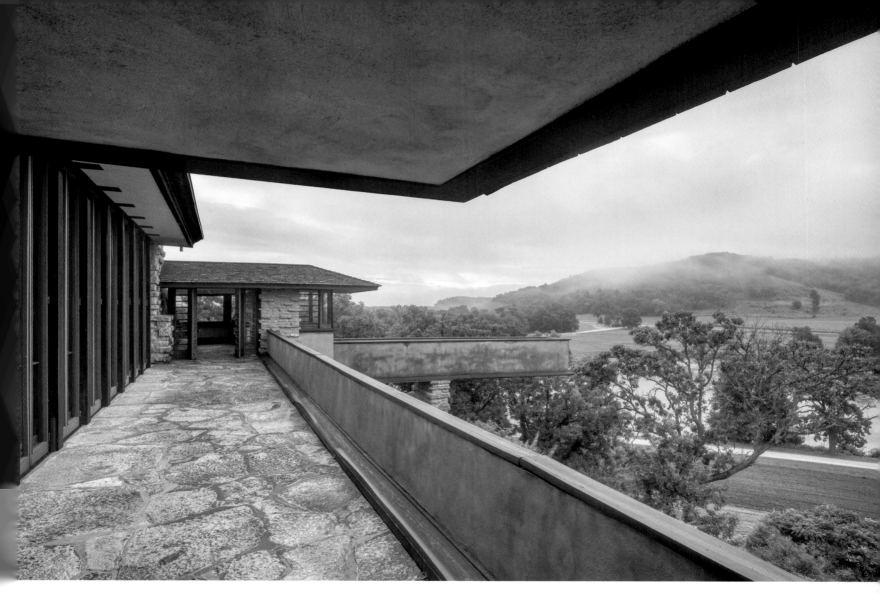

Taliesin III, Spring Green, Wisconsin, 1925–1959

To make a room flexible, you can use screens. Frank Lloyd Wright recognized that the places where we gather together, like a living room, need to be able to change depending on how many people are there, what they are doing, or even what time of day or year it is. Sometimes you just want to have a few friends over, and the large living room that works perfectly for a party can feel overwhelming. Sometimes all the stuff that you have collected can feel like too much. In such situations you can hide what you don't need, either of the room or of your furniture and possessions, behind screens that are low enough to still give a sense of the larger space, and which also let light and air flow by. Sometimes screens can also work between rooms. Rather than cutting off one room from another with a wall and door, you can place a screen (fixed or movable) between the two, so that the space beyond subtly beckons, but reveals itself only once you move past it and, once you are there, you don't have to look back at an entrance or closet. Any nonbearing wall can be a screen, especially when filled with glass. Interior screens also provide a surface for art and decoration that complements the architecture. Screens are the lightest part of house architecture, and the architecture part of furniture. They bring space down to your scale without boxing you in.

"The building now became a creation of interior-space in light. And as this sense of the interior space as the reality of the building began to work, walls as walls fell away. The vanishing wall joined the disappearing cave. Enclosing screens and protecting features of architectural character took the place of the solid wall."
—"Two Lectures on Architecture," 1931

27. Screen, don't close

Marin County Civic Center, San Rafael, California, 1957–1962

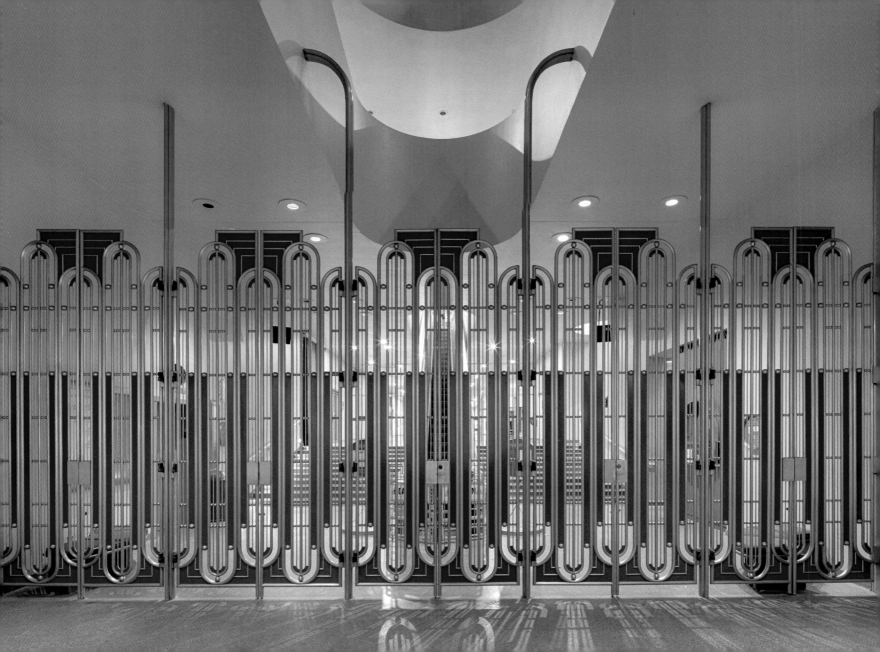

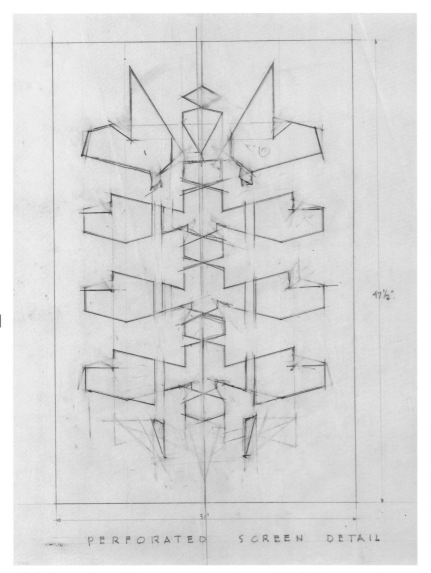

Hillside Theater (Taliesin playhouse), Spring Green, Wisconsin, 1952–1955, screen detail. FA

PERFORATED SCREEN DETAIL

47½"

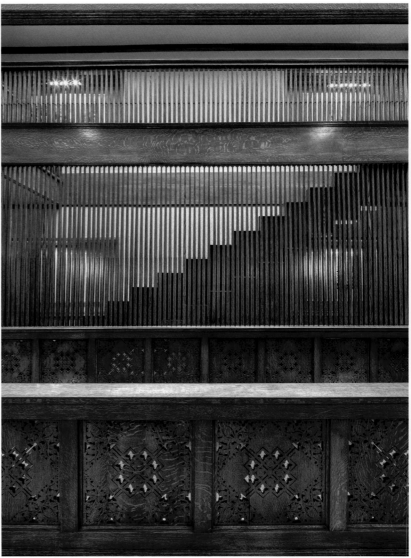

Charnley-Persky House, 1365 N. Astor St., Chicago, Illinois, 1891–1892, by Louis Sullivan and Frank Lloyd Wright

Taliesin West, Scottsdale, Arizona, 1937–1959

Frank Lloyd Wright's buildings come alive in sunlight. Though he was a master at using artificial light, he designed most of his buildings to be experienced in natural illumination. To create the fullest and most delicate effects, he filtered sunlight through the architecture. Unadulterated sunlight belonged on the outside; on the inside, light was something to be captured and molded by human beings. If light did come in directly, especially from skylights or clerestories, he either filtered it through translucent glass to create a soft glow, or bounced it off a wall before it could hit your eyes. Many of Wright's early homes were quite dark, but he soon introduced long bands of windows and clerestories shaded by an overhang, providing views without the glare of direct sunlight. Rays of sunlight might penetrate as highlights that would pick out a bit of stonework and slide across the room in an indication of the time of day and the seasons. His public buildings brought in light from above, both for efficiency and to give you a sense that you had entered another, more rational and ethereal world. In religious and quasi-religious structures that he designed, this overhead light took on a spiritual quality as it filled the communal room. Artificial light was similarly diffused: Wright hid most of his lights in coves and, when he did design freestanding lamps, he made sure that the source was always hidden and the light was filtered. On the outside, Wright also manipulated light to serve his purposes. For example, he designed overhangs to create shadows strong enough to model the structure so that you could understand it in space. Frank Lloyd Wright did not worship sunlight the way he did most natural phenomena. He put it to work for him.

"I flooded these side-alcoves with light from above to get a sense of a happy cloudless day into the room. And with this feeling for light the center ceiling between the four great posts became skylight, daylight sifting through between the intersecting concrete beams, filtering through amber glass ceiling lights. Thus managed the light would, rain or shine, have the warmth of sunlight. Artificial lighting took place there at night as well. This scheme of lighting was integral, gave diffusion and kept the room-space clear."
—An Autobiography, 1932

"As for all artificial lighting, it too should be an integral part of the house—be as near daylighting as possible ... placing [the source] in recesses in such a way that it comes from the building itself."
—The Natural House, 1954

28. Mold with light

S. C. Johnson Research Tower, Racine, Wisconsin, 1944–1950

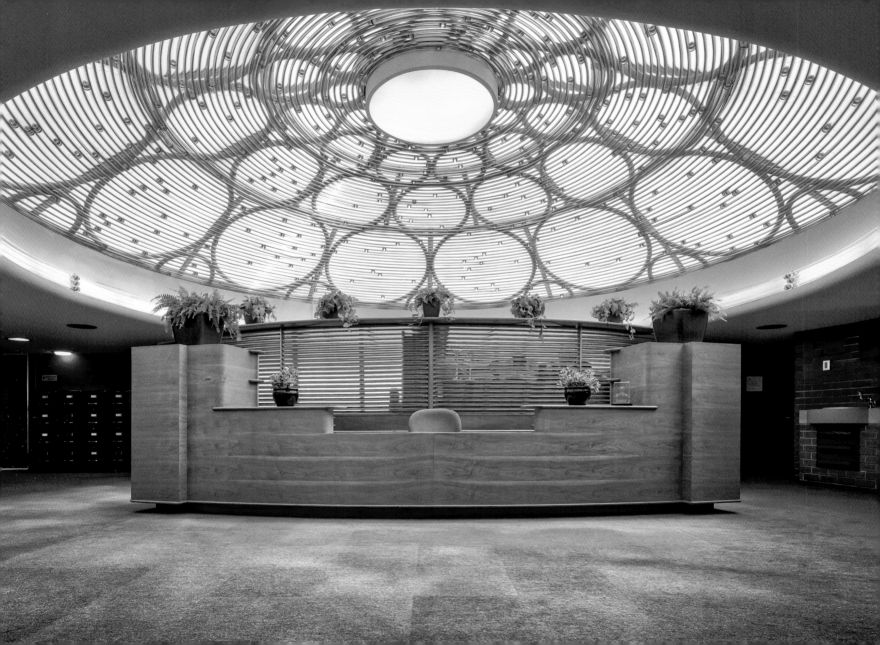

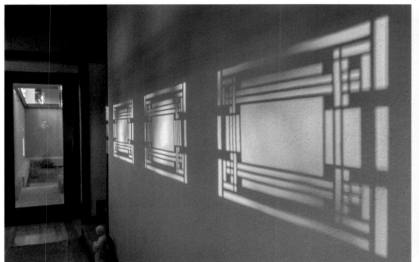

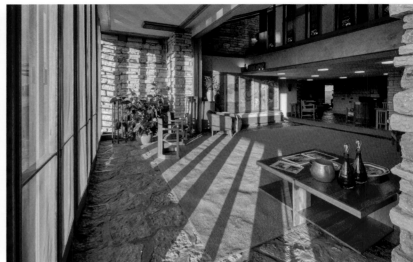

Thomas P. Hardy House, Racine, Wisconsin, 1905

Taliesin III, Spring Green, Wisconsin, 1925–1959

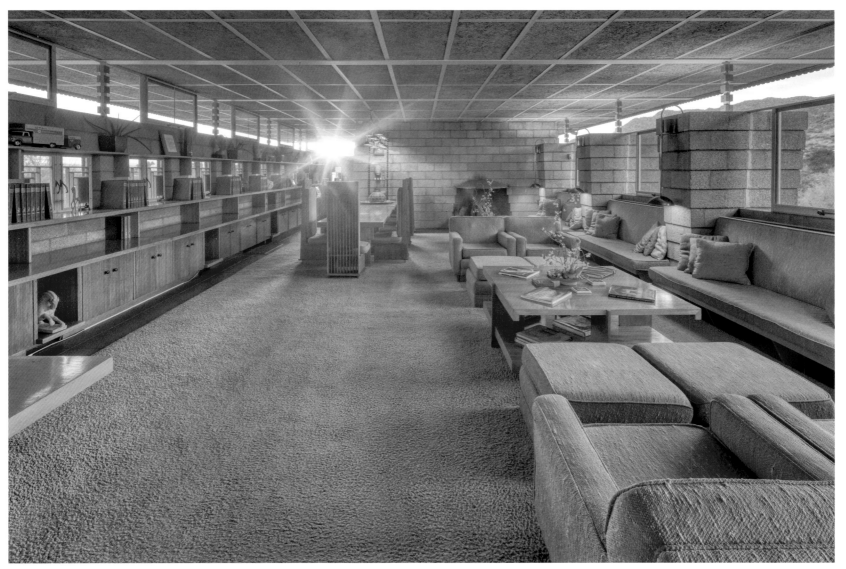

Harold C. Price, Sr. House, Paradise Valley, Arizona, 1954–1955

29. Balance the whole

30. Activate the angle

31. Rotate and lock

32. Let "X" mark the spot

33. Turn and turn again

34. Make it flow

35. Bring the household together

36. Celebrate work—sometimes

37. Embrace simple materials

38. Make concrete beautiful

COMPOSITION and MOVEMENT

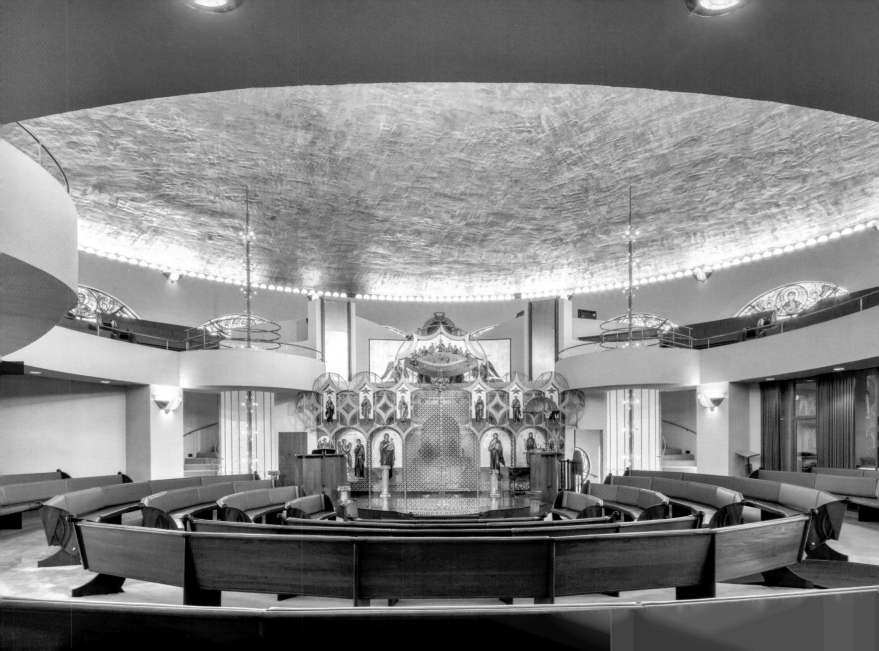

One of the marks of a good piece of architecture—or of any work of art, for that matter—is the sense of the whole. Beyond the old cliché that a piece is finished when you cannot take anything away or add anything without making it worse, this means that a building makes sense from every angle, both inside and out, from the big idea down to the smallest details. Frank Lloyd Wright was remarkably good at achieving that sense of a whole while working in complex circumstances and with budget constraints. The main tool he used to create what another architect called "the difficult whole" was geometry. Symmetry is the classic tool to create harmony and balance, and that compositional ability cascades all the way from overall organization to the building blocks, the rooms, and the ornament that fill out the basic shape.

Wright, like many good architects, cleverly accommodated the inconsistencies that creep into any design concept as it becomes a building: the fact that you need a front door and a back door, that there are service areas and main areas, that most sites are not perfectly flat or the same on every side, to name a few. Wright preserved the integrity of the whole by balancing different pieces with each other: horizontal to vertical, one block to another, ledge to eave, patio to room, turret to vase, chair to chimney. In his earlier work, particularly at Unity Temple (see pp. 10–11), he wove spaces and surfaces together with wood slats that were more than picture frames and less than lattices; they wrapped around corners and surrounded parts of walls painted in contrasting colors. It was the syncopated rhythms, the layering of geometries, and the call-and-response of each piece to the other that made the whole work. His sense of the whole continued to his use of materials in the ways in which he employed wood and brick, stone and concrete, or glass and metal, to complement and balance each other. He also tried to control all of the interior furnishings, from furniture to textiles and glass ornament, so that the patterns he developed for the structure would repeat themselves at the scale of the human body. Frank Lloyd Wright did not design static structures. He made a whole that only made sense as you moved around and through it, experiencing it in space and time.

"In organic architecture, then, it is quite impossible to consider the building as one thing, its furnishings another and its setting and environment still another. The spirit in which these buildings are conceived sees all these together *as one thing*. […] The very chairs and tables, cabinets and even musical instruments, where practicable, are *of* the building itself, never fixtures upon it."
—Wasmuth Portfolio ("Ausgeführte Bauten und Entwürfe von Frank Lloyd Wright"), 1910

Annunciation Greek Orthodox Church, Wauwatosa, Wisconsin, 1956–1961

29. Balance the whole

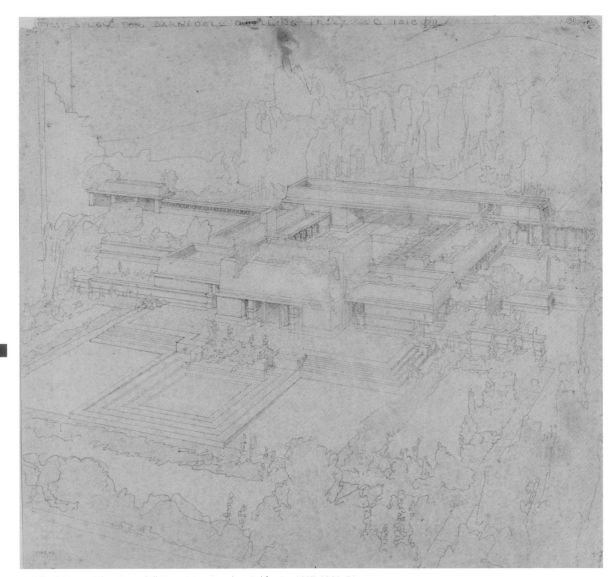

Hollyhock House (Aline Barnsdall House), Los Angeles, California, 1917–1921. FA

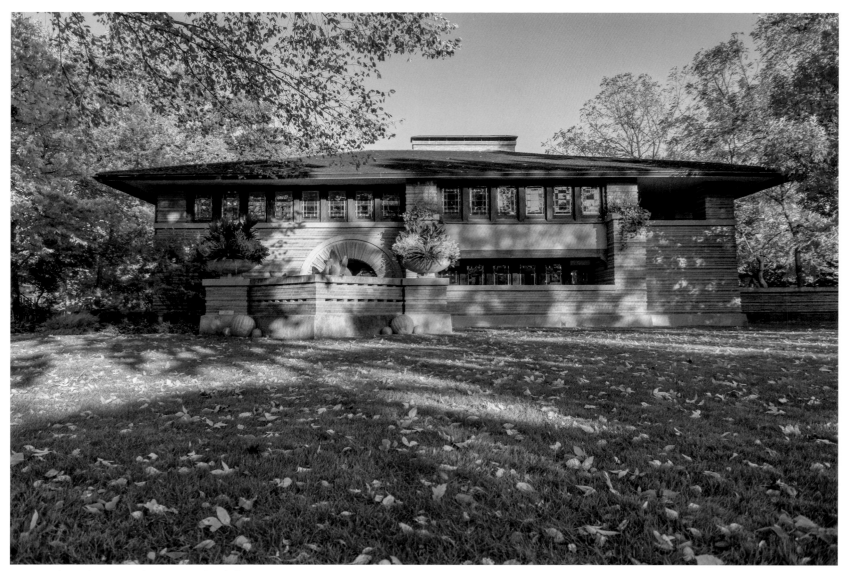

Arthur and Grace Heurtley House, Oak Park, Illinois, 1902

With a cut and a slice, you can open up space. Frank Lloyd Wright used diagonals mainly for three reasons. First, he wanted spaces to open as you moved through them. When you walk in a door and a room expands at a diagonal, or if you can see into another room at an angle, you get the sense of the place expanding and drawing you out. Second, extending this principle to the broader landscape, especially in the desert, he used sharp angles and diagonal lines to make the building appear to reach out toward the horizon. And third, he used angles to fit buildings comfortably into sites that are not rectangular or not flat. Nestling into the angles of a hill or of a boulevard means fixing the building on the site and making rooms that are more or less what we expect, then rotating parts of the overall composition to acknowledge the particularities of where the building is located. Wright typically preferred 30- and 60-degree angles, which let him slip and slide his forms to create alternating moments of contraction and expansion. Later in life, he also used 45-degree angles. He could rotate the square, as at Taliesin West, to define the territory made and inhabited by humans, crisscrossed by paths of movement. The jutting angles point outward, but at the same time they emphasize the opening or meeting space within. Angles appear in many of Wright's ornamental details, too. The angle is there to show the power of geometry as the underlying basis of all things natural and human-made.

30. Activate the angle

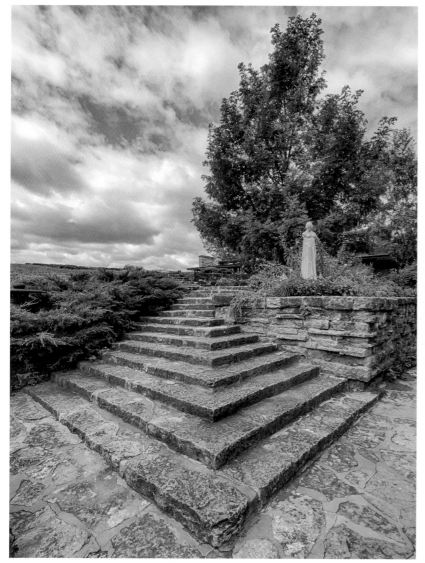

Taliesin III, Spring Green, Wisconsin, 1925–1959

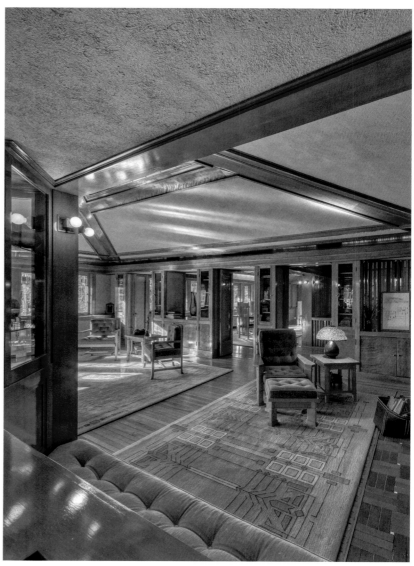

Arthur and Grace Heurtley House, Oak Park, Illinois, 1902

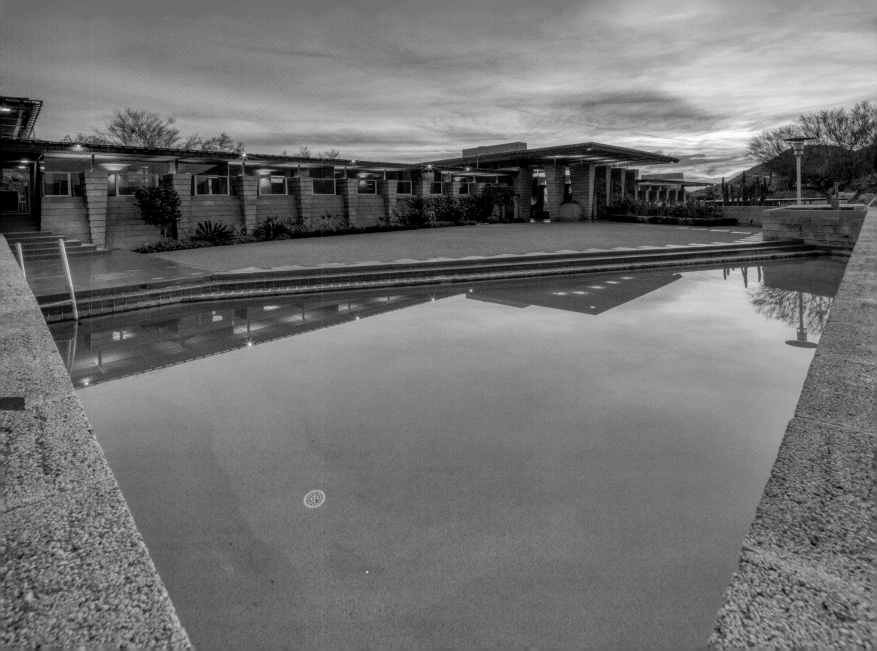

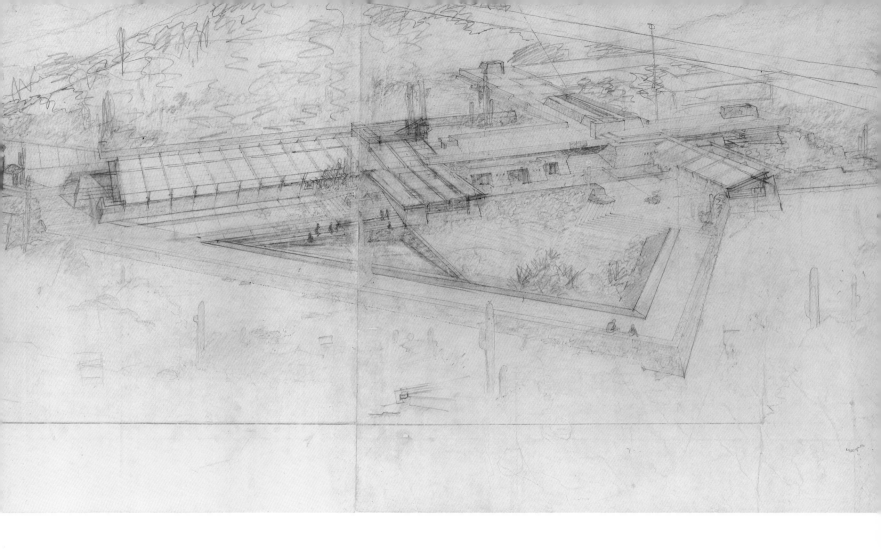

< Harold C. Price, Sr. House, Paradise Valley, Arizona, 1954–1955

Taliesin West, Scottsdale, Arizona, 1937–1959. FA

Together with the idea of marking the center of a structure with a vertical element, Frank Lloyd Wright spun the composition out with rotating geometries. This rotation is visible both from the outside of such buildings and when you look at them in plan. The idea is to establish a central square either at the experiential center (which is not always the geometric center) of the lot or site. This might be the living room of a house or the main ceremonial space of an office building or church. Wright frequently emphasized this space by making it taller than the other parts of the building, and by placing it at an angle to the overall site or approach. In that way, you realize that this is a distinct and human-made figure — a realm all its own. The views from there slice through the landscape with long lines or at an angle, so that they give you a panorama of what is around you. Whatever spaces are needed to support and connect the main gathering space to the rhythms of daily life, such as the bedroom and kitchen wings, the offices or the carport, then extend out in several directions, but often at a different angle from the square. Often, these wings also follow either natural contours or the approach you take to arrive at the building, and thus "lock" the central rotated square back into place. Wright further accentuated the importance of the center by giving it a pronounced and exaggerated roof that, also quite often, has at its center either a chimney or a spire that announces where the pivot point is exactly. In many of Wright's later projects, he dissolved the rotated square into spiraling ramps, bunched circles, or diamond-shaped rooms, which achieved the drama of the "turn and lock" with non-rectangular figures.

31. Rotate and lock

Henry N. Cooper House and Stable (unbuilt project), La Grange, Illinois, 1890. FA

FRONT ELEVATION OF COOPER BARN

COVERED
WAY TO BARN

DINING ROOM

D.W.

SERVICE.

VEST

HALL

MUSIC ROOM

LIBRARY

CARRIAGE ENTRANCE.

DOWN TO
CARRIAGE ENTRANCE

VEST

FAMILY SITTING
ROOM

BED ROOM

UP TO BED ROOMS.

BATH CLO.

GARDEN

PAVILION

GED TO BE
LINOIS
RIE AT REAR
AL ROOF
ORNER OF
SLOPE.

TERS

ENTRANCE WAY.

Richard Quittenton, *Rotate and Lock*, 2020

> Taliesin West, Scottsdale, Arizona,
1937–1959

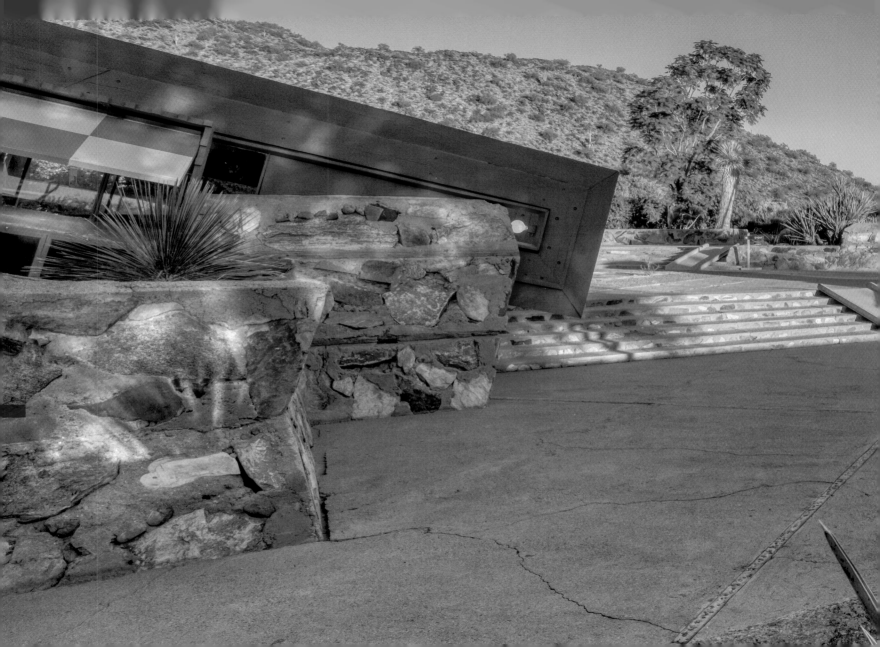

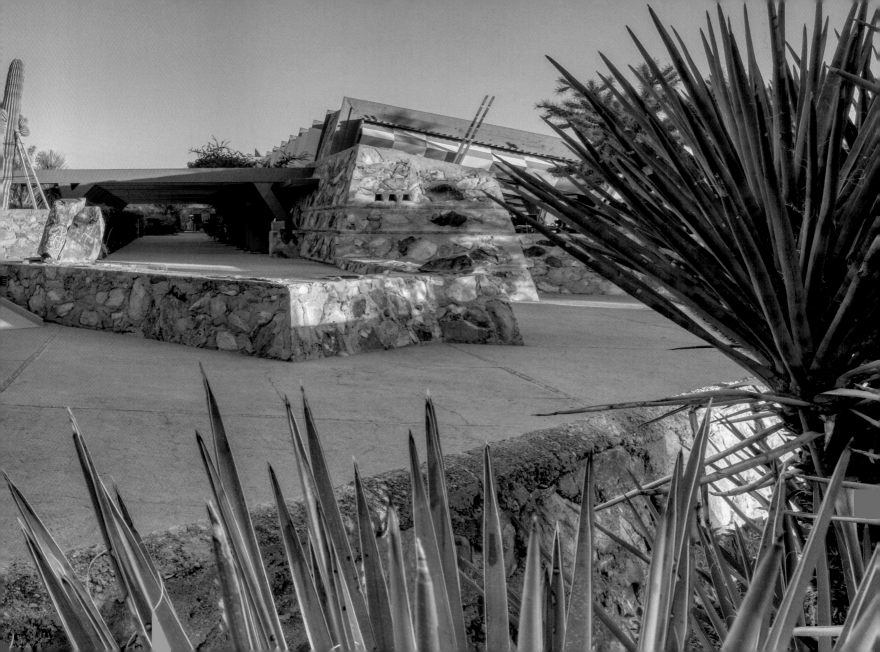

There is a method to the seemingly natural, yet confident way that Frank Lloyd Wright's best buildings fit onto their sites. Many of Wright's plans have at their core an "X" that figuratively anchors the building to the landscape. The heart of that figure, in turn, is usually a massive chimney and hearth around which the house gathers or, in the case of institutional buildings, a monumental element such as a stair and elevator tower from which you can access the whole building. That vertical structure connects earth and sky through the house, and pins the whole composition to the site. From there, Wright develops rooms and spaces in linear extensions, angled composition, or circular spirals—what he called "zones." The spaces may step up and down, or stack up into many floors, but they always tie back into the physical and metaphorical core. From the outside, the 'X' element is visible from afar as a spindle around which the building turns—a sign of its inner organization and a marker of its presence in the landscape. Especially in Wright's house designs, the chimney tells you that there is a place of belonging and gathering deep inside a structure whose lines move out along and above the landscape to welcome you in. The private recesses of the house may be dark, pulling you subconsciously toward the open living spaces, and giving a sense of progressing out from the earth into the wider landscape. This is why Wright's habitable compositions seem to belong to their site, yet they do not merely try to fit in. Starting with the "X" element, the building claims a place for itself in a natural and fitting way.

"At the center of four zones forming a cross, stands a spacious wigwam of a living room. A tall central brick chimney stack with five fireplaces on four sides divides this large vertical central living space into four areas for the various domestic functions: entrance, family living, library, and dining room. Extending from this lofty central wigwam are four wings.
—*An Autobiography*, 1943

^ Wingspread (Herbert F. Johnson House),
Wind Point, Wisconsin, 1937–1939. FA
> Richard Quittenton, *X Marks the Spot*, 2020
>> Hollyhock House (Aline Barnsdall House),
Los Angeles, California, 1917–1921

32. Let "X" mark the spot

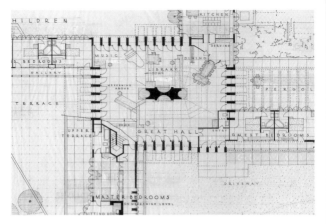

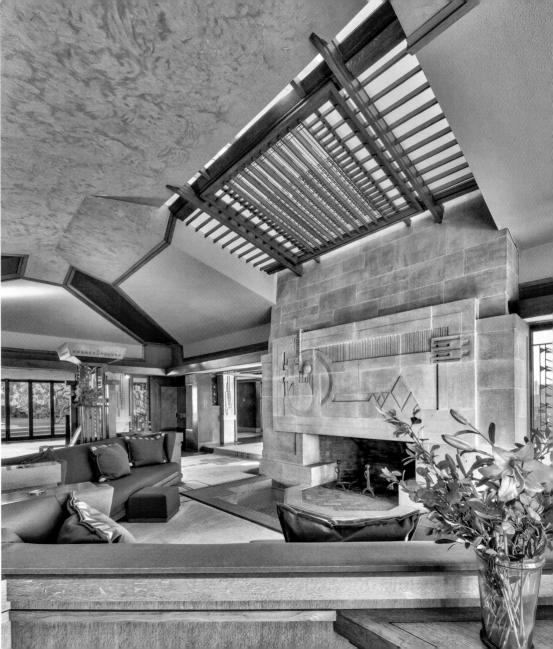

Frank Lloyd Wright almost never let you enter straight into a room. That would be too anticlimactic. To heighten your awareness of the space you were entering, he would make you turn and turn again. An extreme example is the elaborate entrance sequence to the Garden Room, the social heart of the community he built at Taliesin West. When you walk towards the building from the rest of the complex, the door is hidden, forcing you to double back to find it. When you then enter the building, you face a wall in a very low-ceilinged space. This breaks your momentum, refocuses your attention, and compels you to keep going. Turn again, and you glimpse part of the space. Take a few steps and turn once more, and finally you are in the high-ceilinged, luminous space of gathering. Not all of the entries to Wright's spaces are that complex, but he often heightened the drama of his architecture by delaying the gratification you feel upon entering the central rooms of his buildings. The entrance in this way becomes more than just a doorway. It becomes a zone of transition between the hurly-burly of the outside world and the interior scene that Wright controls completely. Within the building, the transitional areas also contain functional elements such as closets or bathrooms that, because they are tucked away there, preserve the simplicity and clarity of the main rooms. Those turns are also good feng shui. In classical Chinese architecture, you would never enter a room directly, but always would have to go through several turns to confuse any ghosts that might have followed you in. On a more prosaic level, the delays also serve to control both the temperature and the light of the space. But, above all else, turning and turning again just makes you fully aware that you have arrived at the spiritual heart of Wright's architecture: the space within.

33. Turn and turn again

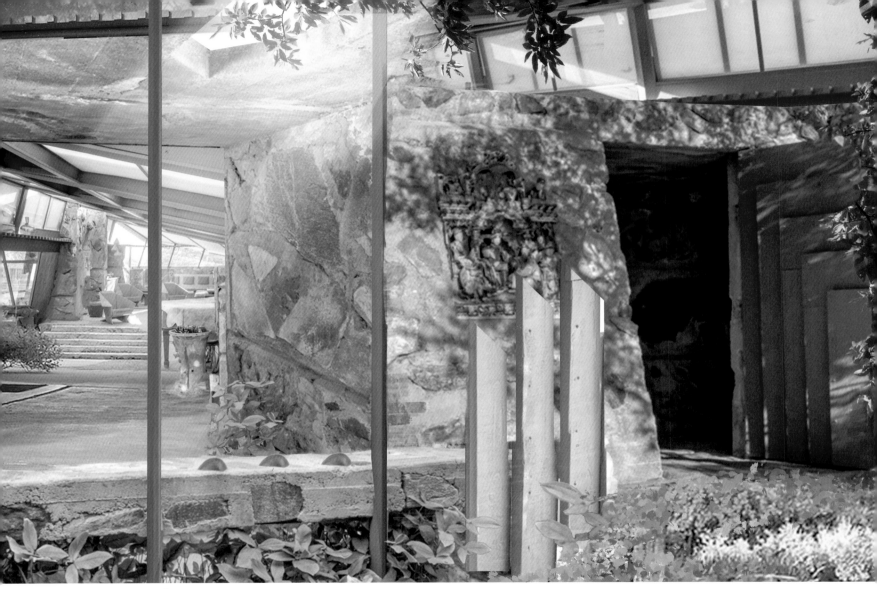

Richard Quittenton, *Turn and Turn Again*, 2020

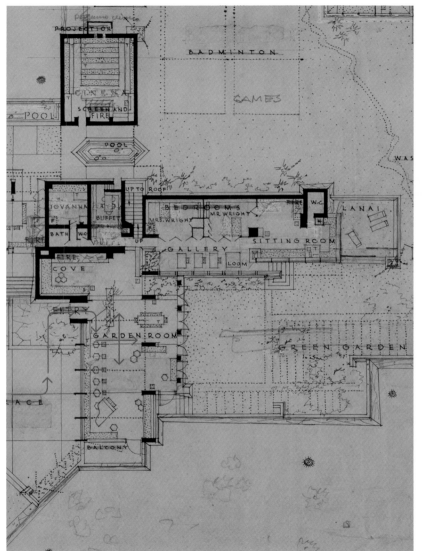

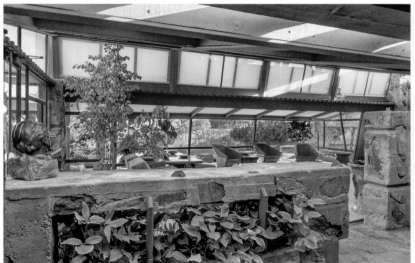

Taliesin West, Scottsdale, Arizona, 1937–1959, plan detail. FA

Taliesin West, Scottsdale, Arizona, 1937–1959 (top, above, and opposite)

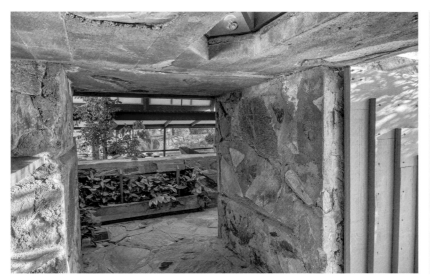
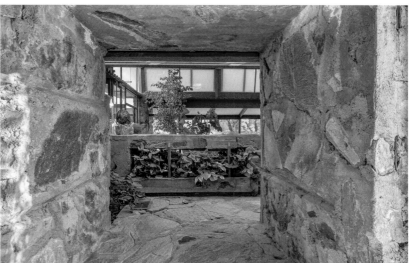
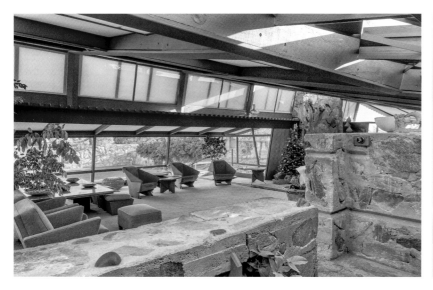
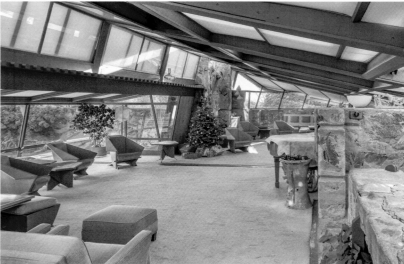

When Frank Lloyd Wright spoke of "plasticity," he generally wasn't talking about polycarbonate (plastic) materials, but about smooth architectural forms and surfaces that flow into one another. He recognized that new materials and technologies made it possible to create more expressive forms and seamless spaces. In some cases, notably in the Johnson Wax Company Headquarters (see p. 76 and following pages) and the Marin County Civic Center (see pp. 84–85), he literally streamlined his buildings with rounded edges both inside and outside, and turned structural design into an expressive motif. The walls and the roofs seem to flow around and with the movement of the work and workers inside, while also offering fluid versions of the context—the hills of Marin and the factories of Racine—around them. In Wright's later buildings, he paired curvilinear forms with pliable materials like sheet metal, plastic, and spray-on concrete to create a sense of smooth and continuous movement through space. His own bathroom at the otherwise rustic Taliesin West became the equivalent of an Airstream trailer, sheathed all in smooth metal surfaces under a skylight. Even in his earlier work, though, Frank Lloyd Wright pushed and pulled at traditional building materials to make his spaces more plastic—seemingly part of each other, not just next to each other. He used bands of windows and clerestories to obscure the edges of structures, and wanted his buildings to appear monolithic (of one piece) even when built of many different parts. As Wright became more uninhibited about expressive forms and new materials, he sought always to relate them to something other than their machine nature: he saw in his arcs, circles, and dancing diagonals forming open shapes as the embodiment of natural forms that human beings were now only able to approach more closely. Plastic architecture doesn't have to be made out of synthetic materials, and it doesn't have to look cheap. You can make your buildings plastic in the sense of flowing movement that expresses an underlying reality.

"The folded plane enters here with the merging lines, walls and ceilings made one. Let walls, ceilings, floors now become not only party to each other but part of each other, reacting upon and within one another; continuity in all…"
—*The Natural House*, 1954

"To further illustrate this magic simplifier we call 'plasticity': see it as flexibility similar to that of your own hand. What makes your hand expressive. Flowing continuous line and continuous surfaces seen continually mobile, of the articulated structure of the hand as a whole."
—*An Autobiography*, 1943

34. Make it flow

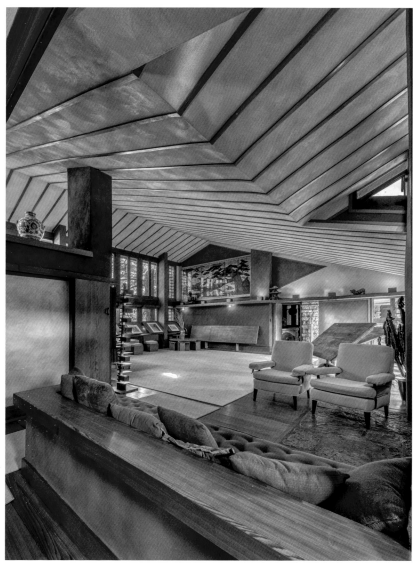

Taliesin III, Spring Green, Wisconsin, 1925–1959

Marin County Civic Center, San Rafael, California, 1957–1962

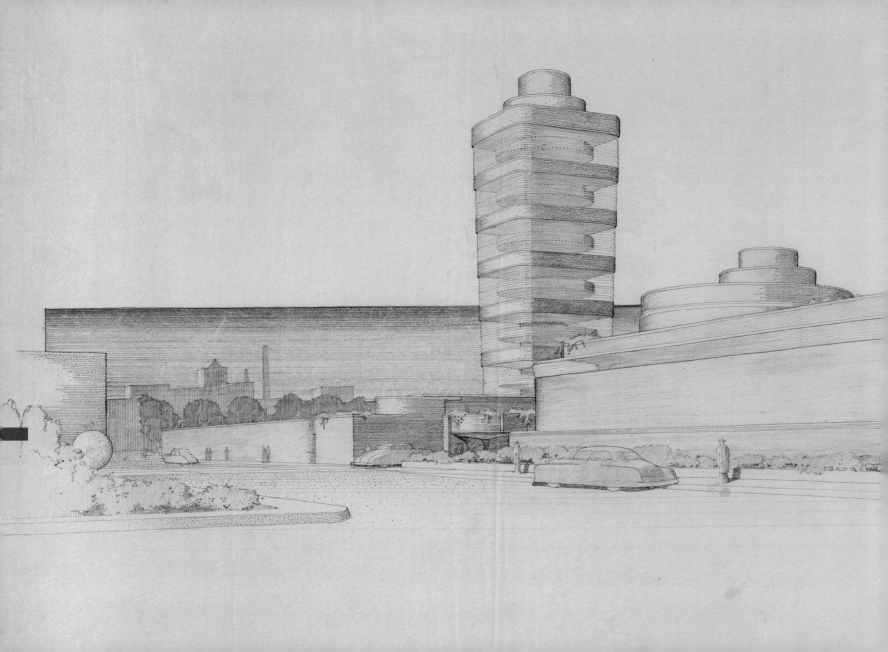

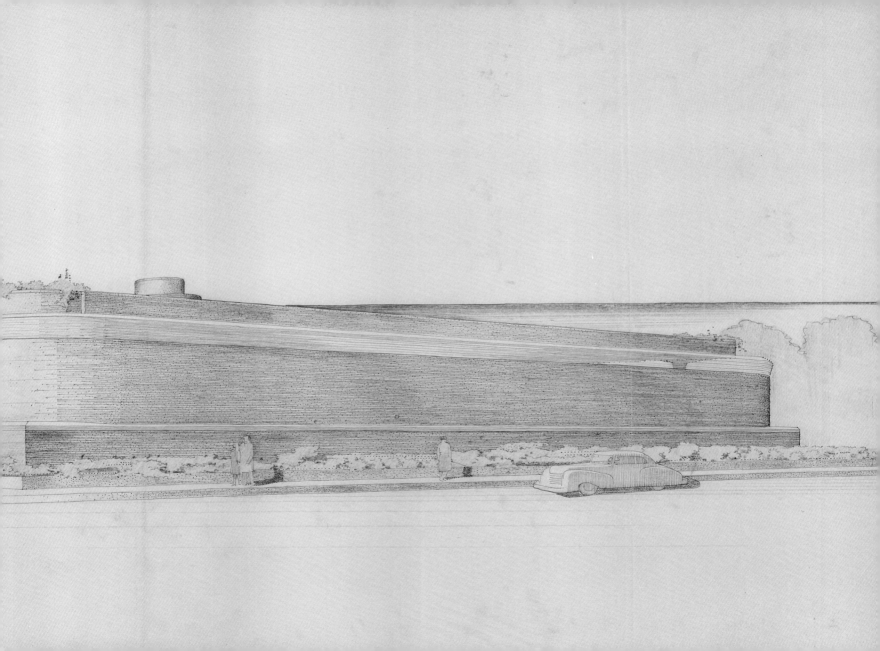

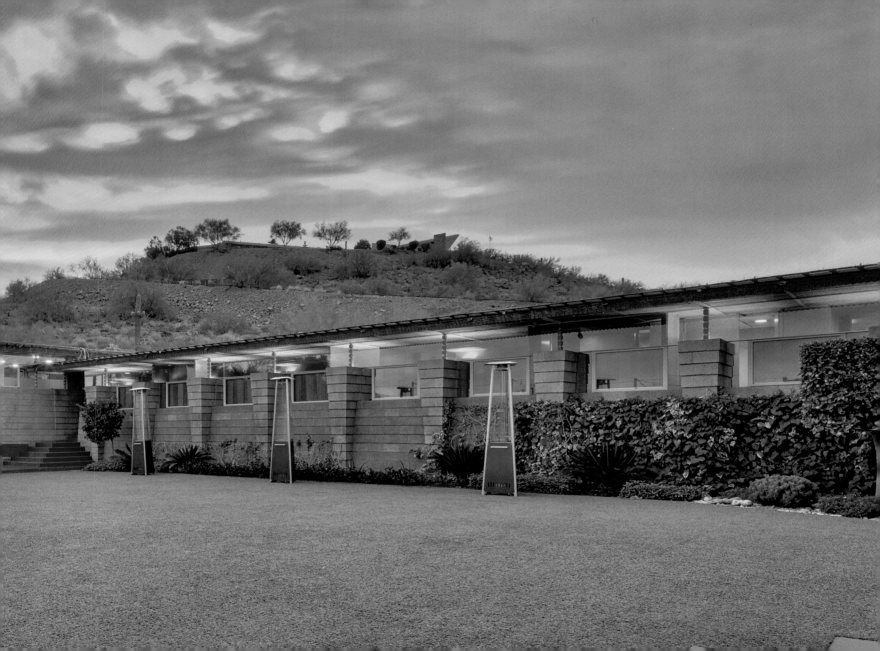

In many of Wright's homes, the private area spins out into a line of bedrooms that culminates in the larger, master bedroom. This "train" of sleeping spaces extends the lines of the house out from the central core, often rubbing up against the edge of the lot. But the bedrooms were modest and the windows small. For Frank Lloyd Wright, the place where you slept was of little importance. In fact, he wanted you to spend as little time there as possible, as he believed that the most important aspect of the home was its communal life. The overall function of the house was to make its inhabitants come together to eat, learn, make music, socialize, or just be together. The kitchen was merely a place of production, and was thus often labeled "galley" on his plans. The bathrooms were nuisances to be hidden away. The bedrooms were monks' cells, outfitted with small beds and minimal storage. They did not have the best views, nor a great deal of light. The idea was that you would go there just before sleep, and leave as soon as you woke up to re-enter family life. The master bedroom at the end of the hall was only slightly larger. Wright recognized that the two adults who were the head of the standard nuclear family for which he usually designed might have more clothes to store, and that they would want or deserve a bit more privacy. This efficient "head-and-cabins" arrangement of bedrooms typifies the way Wright treated private spaces as secondary to the fluid, extensive, and open space of the community of whatever size he was sheltering. Together the cells of bedrooms supported family life by taking care of that annoying time when you could not be a conscious member of your community.

<< S. C. Johnson Research Tower, Racine, Wisconsin, 1944–1950. FA

< Harold C. Price, Sr. House, Paradise Valley, Arizona, 1954–1955

35. Bring the household together

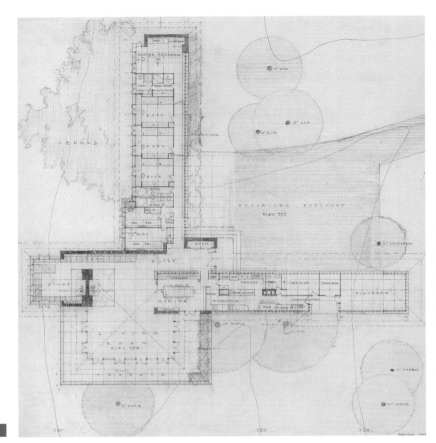

William Boswell House, Cincinnati, Ohio, 1956–1961, scheme 2, plan. FA

Samuel Eppstein House, Galesburg, Michigan, 1948–1949

Samuel Eppstein House, Galesburg, Michigan, 1948–1949

Frank Lloyd Wright did not want you to see how things or people worked. He wanted you to see the poetry of your environment, not its mechanics. Wright almost never showed any of the parts of the buildings that made them work. He hid electric conduits and appliances out of sight, and did the same with air and heating ducts, as well as plumbing. "I've always hated radiators," he wrote, so he promoted radiant floor heating ("gravity heating," as he called it), as a means to eliminate them. When you walk into a Frank Lloyd Wright building, you have no sense of its complex systems. That does not mean that Wright disliked modern materials or gadgets. He used metal, glass block and even plastics when he thought they were appropriate. He also loved radios, record players, movie projectors and, late in his life, rheostats. He just didn't want you to see them. So he encased them in boxes or put them somewhere where they would not interfere with the experience of space that he so carefully choreographed. It was this approach to technology, more than anything else, that put Frank Lloyd Wright at odds with those of his peers who saw the embrace and consciousness of technology as at the core of modern architecture. While European avant-gardes of the early twentieth century embraced the image as well as the function of the machine, most of the architecture profession still hewed to historical styles, covering modern industrial components with neoclassical or gothic skins. Wright rejected both of these approaches as he strived to invent his own style—exploring the potential of new technology and materials, informed by historic precedents, but abstracting all of them to emphasize the flow of space and what Wright called "the nature of materials." Wright's critics alternately called him either too radical or too old-fashioned, but his admirers recognized in his architecture something comfortingly familiar yet compellingly modern. Wright himself called upon artists to "breathe the thrill of ideality" into the raw power of the machine. This meant concealing the work of the machine in favor of its results, filtered through the veil of artistic ideals.

"While you are making such a fuss over sewer, gas, ventilation, and good nickel-plated plumbing, why not ventilate the more vital atmosphere of your children's house a little and give them a chance to recognize the true and the beautiful when they see it?"
—"The Architect and the Machine," 1894

"Appliances or fixtures as such are undesirable. Assimilate them together with all appurtenances into the design of the structure."
—"In the Cause of Architecture," 1908

> Taliesin West, Scottsdale, Arizona, 1937–1959

>> Romeo and Juliet Windmill Tower, Hillside Home School, Spring Green, Wisconsin, 1896

36. Celebrate work—sometimes

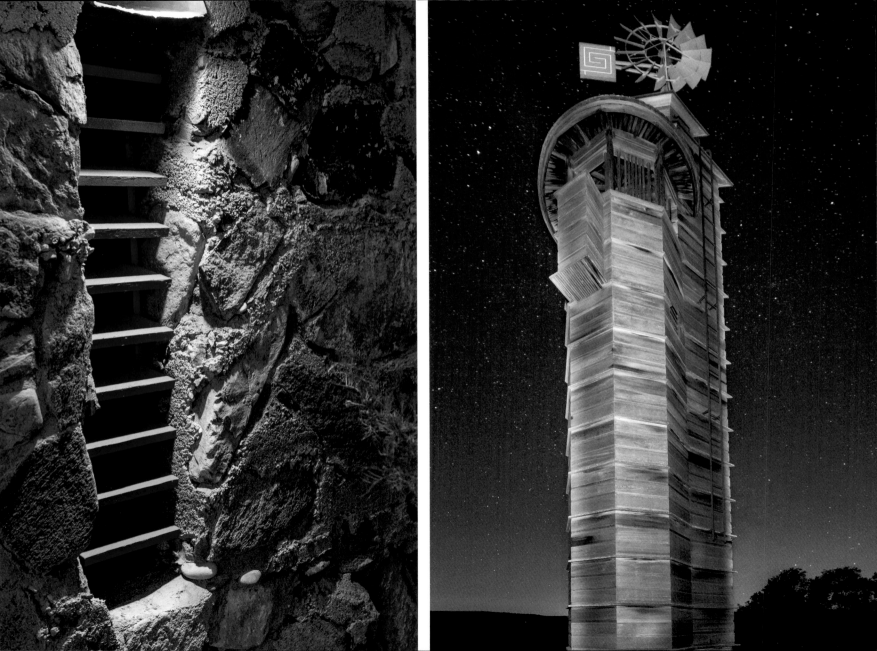

Frank Lloyd Wright believed in using the right materials for the right setting. That did not necessarily mean the most expensive ones. He sought to express the true nature of whatever materials he worked with—plywood as well as hardwood, concrete as well as stone, canvas flaps as well as glass, and sheet metal as well as terra cotta panels. Sometimes he juxtaposed refined and economical materials, as in the doorway between the dining room and the kitchen of a house he designed in Batavia, Illinois: halfway across the jamb, the white oak changes to the yellow pine he used in the area where the servants worked. Expensive materials were to be used where they mattered, either because your eye would focus on them, or because your hand would touch them. In designing homes of moderate cost, Wright championed the humble beauty of unvarnished wood and exposed concrete blocks, to be ennobled by a sense of "integral" ornament. His studios at Taliesin and Taliesin West, built on meager budgets, are essays in doing more with less. His ideas about the correct way to use materials combined technical, aesthetic, environmental, economic, and even moral aspects. He wanted to use as little steel reinforcing in his concrete structures as possible, as he felt the concrete should be strong enough by itself. Where possible, he wanted to make that material out of the sand and stone on-site, which he believed would save costs and make the building fit in better with its surroundings. Still, Wright's buildings were not cheaper to construct than those of his peers. He used whatever resources he saved (or thought he saved) to create more ornament, make larger living spaces, and push the structure to perform in more dramatic ways.

"The machine, by its wonderful cutting, shaping, smoothing, and repetitive capacity, has made it possible to so use it without waste that the poor as well as the rich may enjoy today beautiful surface treatments of clean, strong forms that the branch veneers of Sheraton and Chippendale only hinted at, with dire extravagance, and which the Middle Ages utterly ignored."
—"The Art and Craft of the Machine," 1901

"A simple, cheap material everywhere available, the common stuff of the community—here made rare and exquisite by the Imagination."
—"In the Cause of Architecture IV: Fabrication and Imagination," 1927

37. Embrace simple materials

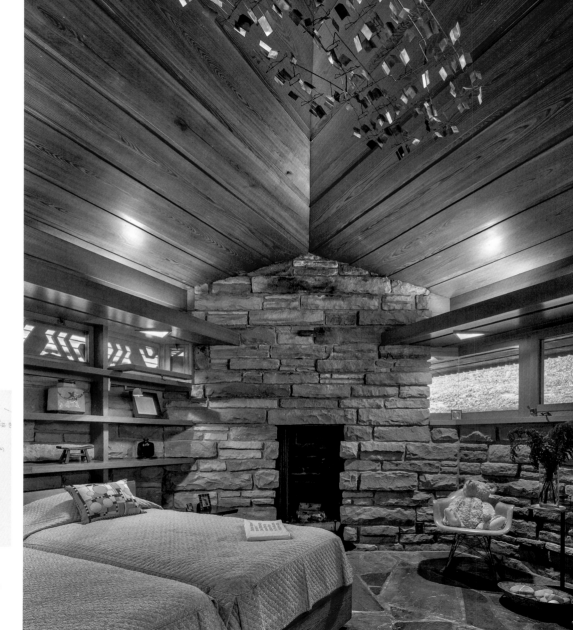

Frank Bott House, Kansas City, Missouri, 1956–1963. FA

> Kentuck Knob (I. N. Hagan House), Chalkhill, Pennsylvania, 1954–1956

One of Frank Lloyd Wright's most remarkable inventions was the textile-block system. He had long sought a way to weave together structure and ornament into a single, flexible system that would simultaneously make his designs affordable, use mass production and standardization, and let his structures fit into their varied sites. In 1924 he perfected a system by which mundane concrete blocks, "the gutter rats of construction," as he called them, could be cast on-site, using sand and aggregate from the immediate area, thus giving them a color and texture close to the local landscape. He then proposed that each block have a built-in pattern whose geometry, when repeated throughout a building, would create a rhythmic texture across the whole composition. He designed slots and grooves so that steel reinforcing bars could join the blocks both horizontally and vertically. As a result, a mason with no special training (or even a determined amateur, Wright believed), could cast the blocks, slot them through the metal rods, and tie them together with more rods running horizontally. They could even use the blocks to create reinforced-concrete roofs. Four textile-block houses were realized in Southern California during the 1920s, and the architect continued to experiment with and use the system in later decades. Although the system turned out to be more cumbersome, difficult to construct, and costly than Wright had hoped, architects today are trying to apply new computer-aided technology and concrete hybrids to allow the method to fulfill its potential. Someday Wright's rescue operation on what we often think of as the ugliest part of modern construction might indeed lead to the affordable beauty of which the architect dreamed.

"A building for the first time in the world may be lightly fabricated, complete, of mono-material—literally woven into a pattern or design as was the oriental rug ... fabrication as infinite in color, texture, and variety as in that rug. A certain simple technique larger in organization but no more complex in execution than that or the rug-weaving, *builds* the building."
—"In the Cause of Architecture, IV: Fabrication and Imagination," 1927

38. Make concrete beautiful

Charles Ennis House, Los Angeles, California, 1923–1924

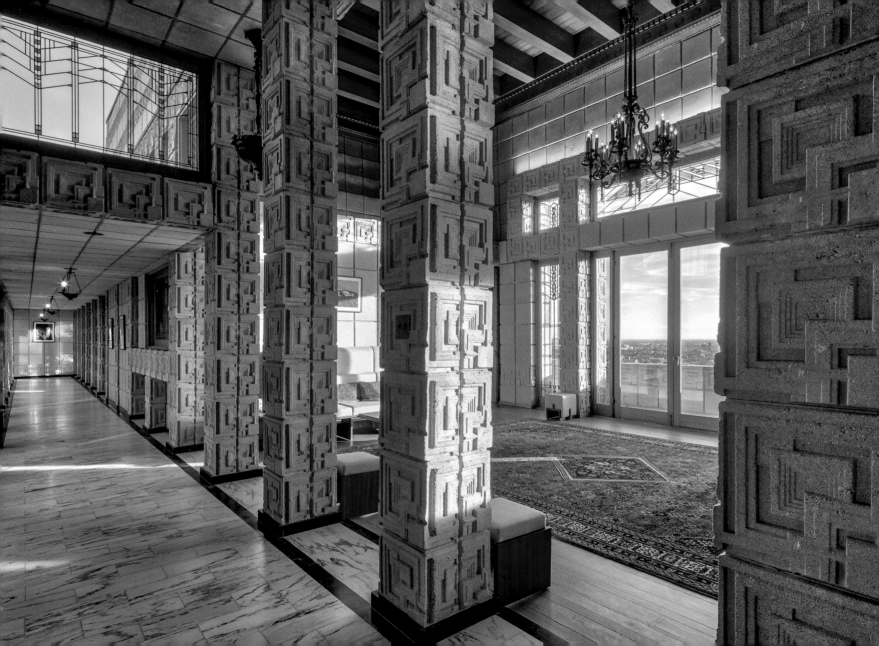

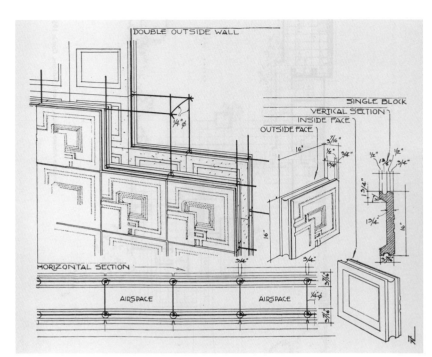

Textile block design, patent study, 1921. FA

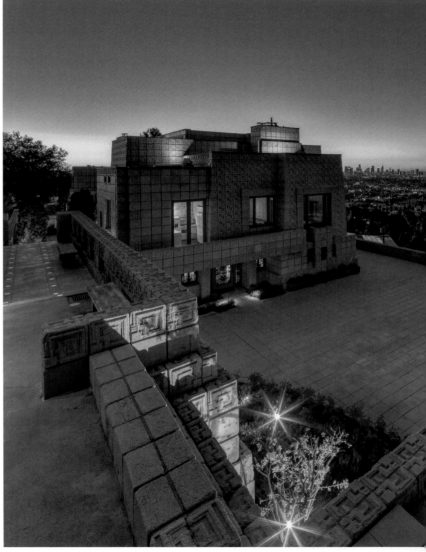

Charles Ennis House, Los Angeles, California, 1923–1924

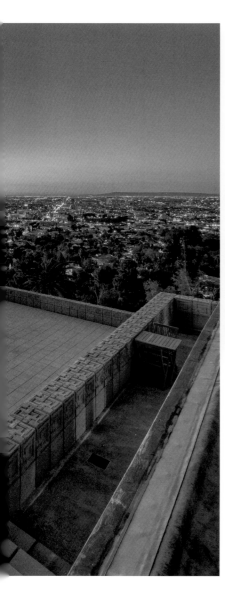

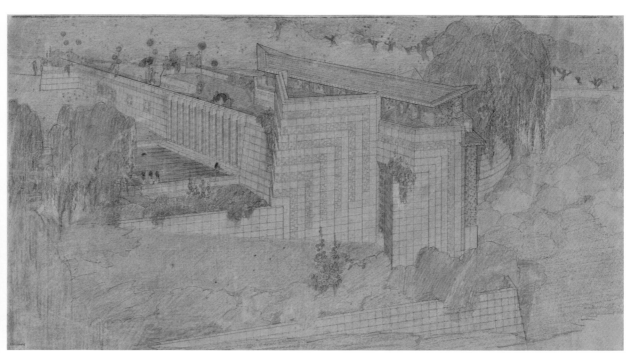

Aline Barnsdall "Little Dipper" kindergarten, Los Angeles, California, 1921–1923. FA

> Charles Ennis House, Los Angeles, California, 1923–1924

>> Seth Peterson Cottage, Mirror Lake, Wisconsin, 1958

>>> David and Gladys Wright House, Phoenix, Arizona, 1950–1953

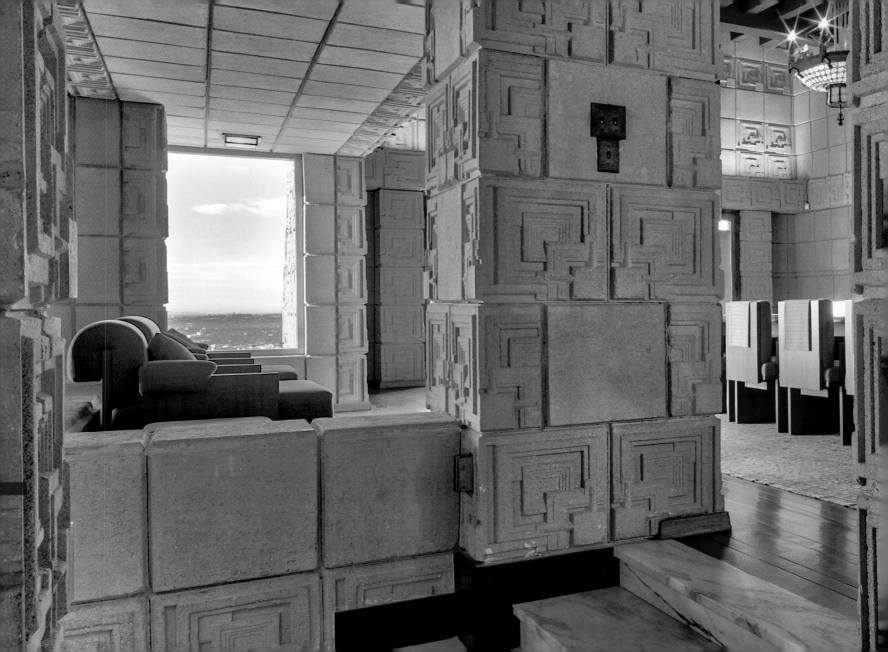

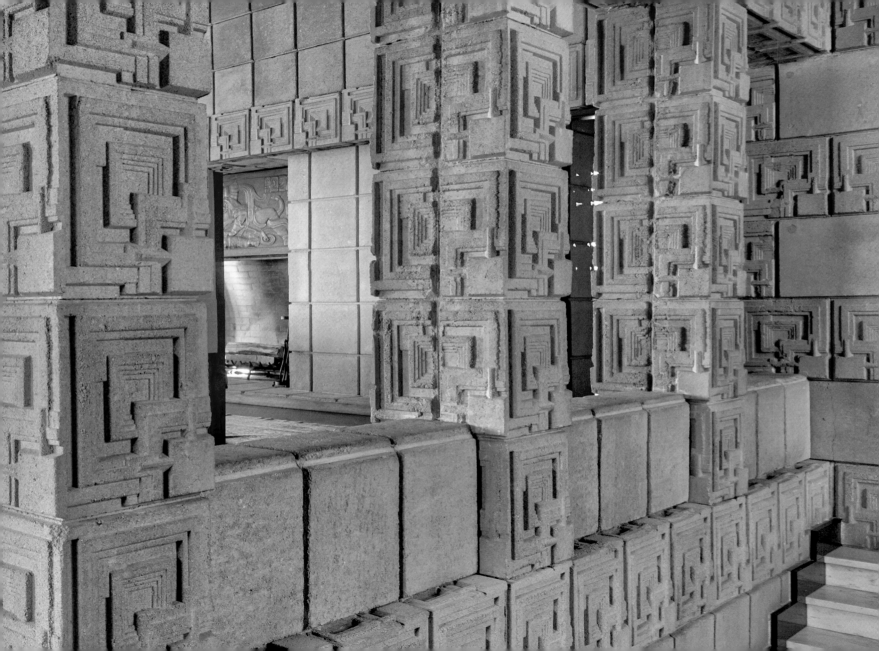

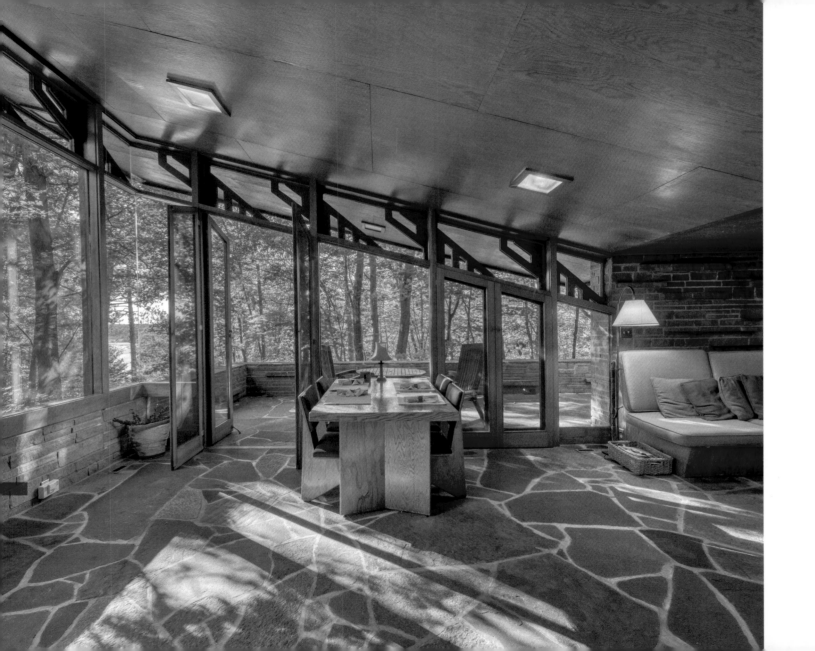

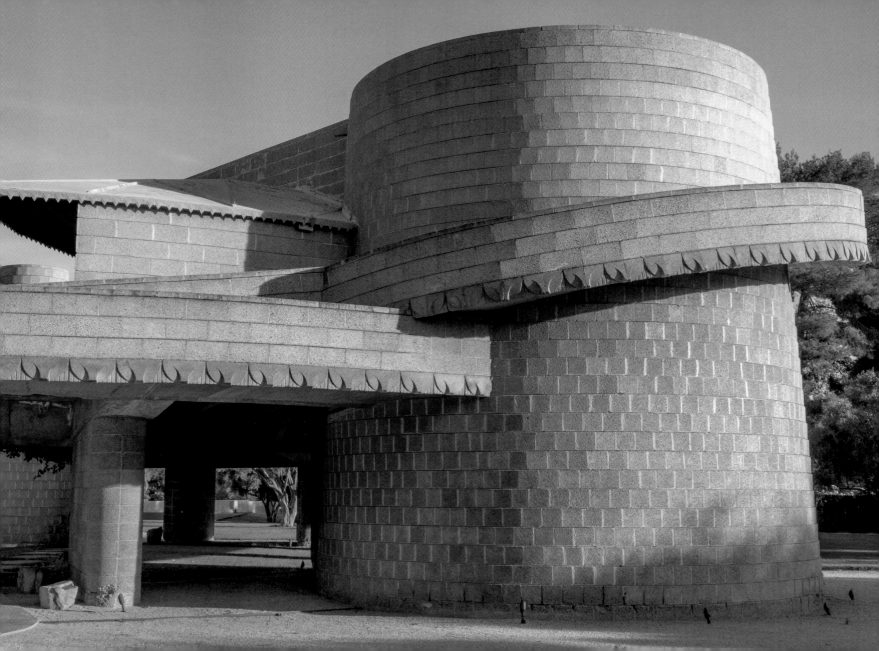

39. Express the inner rhythm

40. Make the room glow

41. Form a room with furniture

42. Direct the human body

43. Embroider rooms with textiles

44. Mirror your world

45. Accentuate with red

46. Take care of the luxuries in life

BUILDING and BODY

The man Frank Lloyd Wright called his "dear master," the architect Louis Sullivan, wrote a book called *A System of Architectural Ornament*. In his words and in his startlingly vibrant drawings, he argued for the artistic use of natural forms, especially those of leaves, plants, and flowers, combined with waves and other water shapes, interlocked with human-made geometries. The aim was to find and express the hidden order of things. Wright took his master's precepts one step further, developing ways to express natural forms in more abstract ways so that they became fused with geometry in the overall structure and plan of a building. Throughout his life, he sought to make the rectangles and squares, the angles and the diagonals, and the circles, ovals, and curves that were the basis of his architecture, become one with the hidden order or growth principle of leaves, flowers, trees, shells, and other organic forms. This interweaving of geometry and a "conventionalization" or abstraction of natural forms was the recipe he used in designing his site-specific rugs and wall hangings, his screens and room dividers, his art-glass windows, and his embellishments in stone and steel. He even went so far as to give his floor plans what he felt was an innately organic geometry. In his early buildings, Wright followed Sullivan in locating much of his ornament at the capitals of columns, as friezes where roofs met ceilings and roofs, or at ledges where horizonal supports met vertical elements. He then went further by creating globes and blocks that he placed on top of finials at various scale as summations of the geometries inherent in the buildings below them. Later on, Wright eliminated most ornament from the body of his buildings, though he would occasionally elaborate a frieze with a rhythm of elements that would recall classical models. Instead, he shaped his structural supports into expressive elements. Ultimately, he completely merged form, structure, and space in the spirals of his last buildings. Here, Wright created an experience that was like inhabiting the overlapping curves and angles of which Sullivan had dreamed almost a century earlier.

"Integral ornament is simply structure-pattern made visibly articulate … It is the expression of inner rhythm of form."
—*An Autobiography*, 1943

"In the main ornamentation is wrought in the warp and woof of the structure. It is constitutional in the best sense and is felt in the conception of the ground plan. […] to me it is the most fascinating phase of the work, involving the true poetry of conception."
—"In the Cause of Architecture," 1908

39. Express the inner rhythm

A. D. German Warehouse, Richland Center, Wisconsin, 1915–1921

> Charles Ennis House, Los Angeles, California, 1923–1924

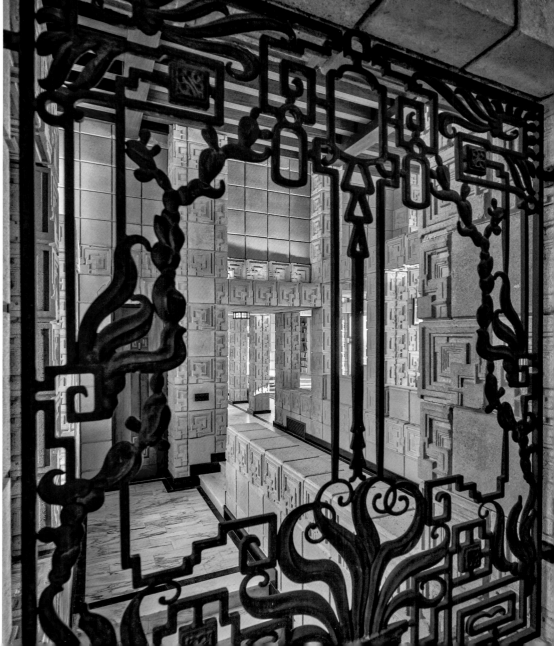

Imperial Hotel, Tokyo, Japan, 1915–1923, Oya capital detail. Private collection, FLWF

Twin cantilevered bridge (unbuilt project), Pittsburgh, Pennsylvania, 1948, south elevation. FA

Hollyhock House (Aline Barnsdall House), Los Angeles, California, 1917–1921, design for stone mantel above living room fireplace. LC

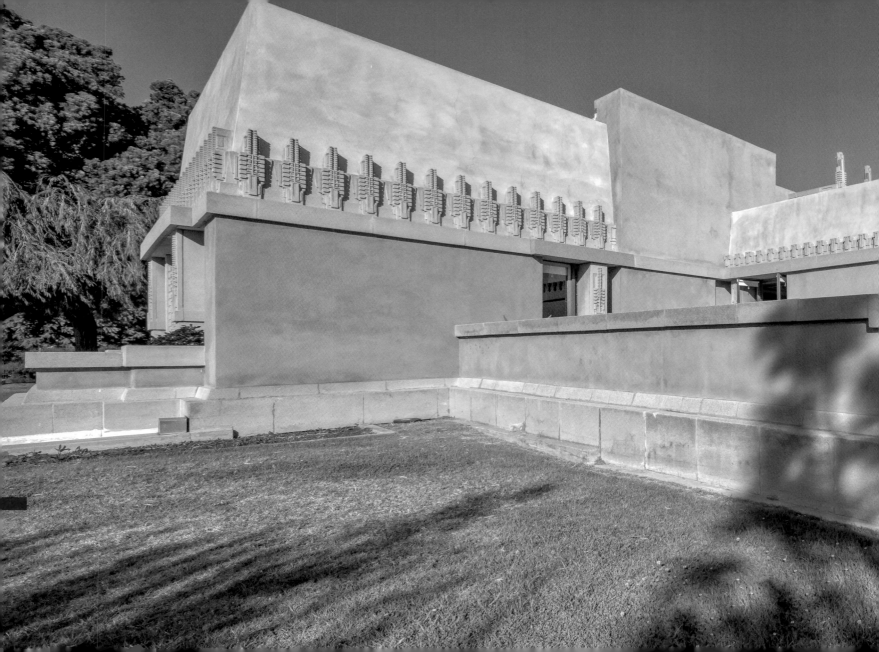

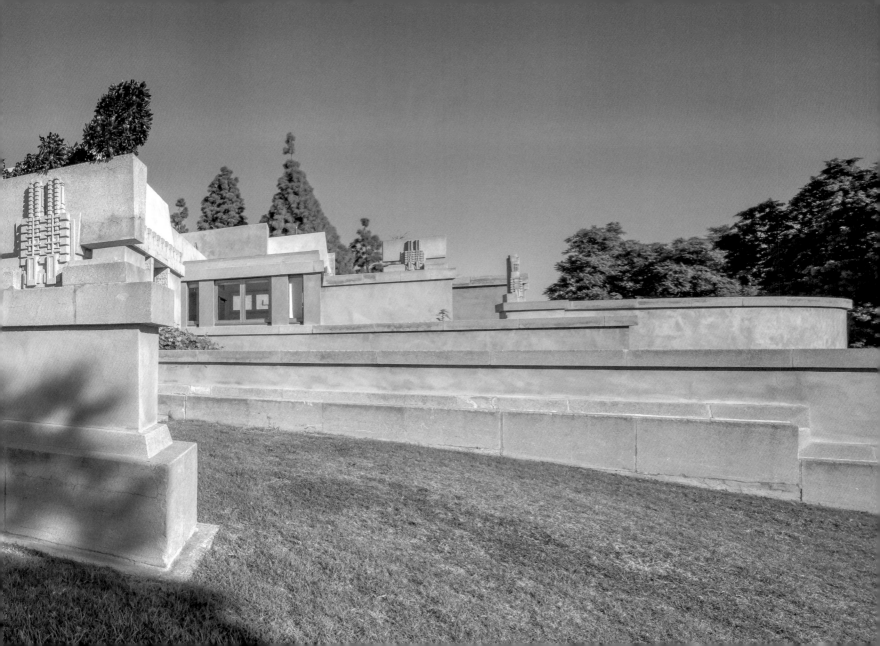

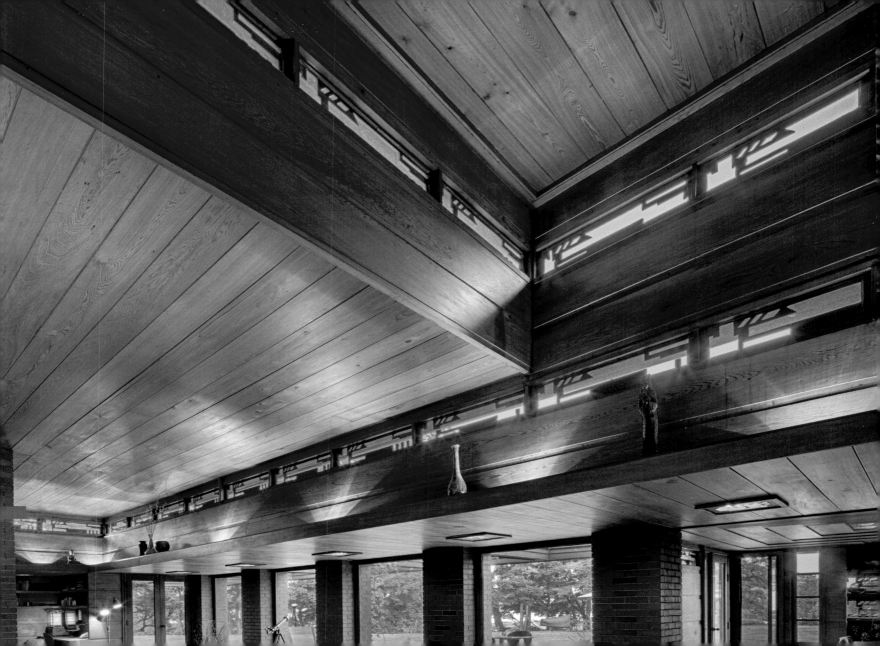

At first glance, clerestories seem to be a waste of good glass. They are above eye level, so you cannot see out through them. Unlike skylights, they often don't even give you a sense of the sky above. Instead, they let light in without showing you the source, and wash a room with a diffuse glow. Clerestories are an emblem of restraint, giving light but denying a view, focusing your attention inward. They also draw your attention upward toward the ceiling as your eye follows the glow up to its source. Frank Lloyd Wright loved using clerestories for all those reasons, but also because they separate walls and ceilings into independent planes that each have their own edges, their own definition, and their own purpose, but that never come together to contain us. The ceiling plane, floating above the walls along a line of clerestories, can then shoot out past the walls as an overhanging roof, providing an added sense of shelter. The structure holding up this roof then becomes visible. The walls below are equally brushed by light from the clerestory, which, in the evening, glows from within. The band of light is a separator, a pause in the structure that lets you see the parts all around it. For Wright, the clerestory is neither window nor blank, neither structure, nor opening, but the hovering void, just out of touch and sight, that lets you see and understand the architecture woven around you.

"Sunlight otherwise impossible may be got into the house through the attic by way of what we call a lantern or clerestory. And that should also give you the sense of lift and beauty that comes in so many of our plans at this time."
— *The Natural House*, 1954

Still Bend (Bernard Schwartz House), Two Rivers, Wisconsin, 1939–1940

40. Make the room glow

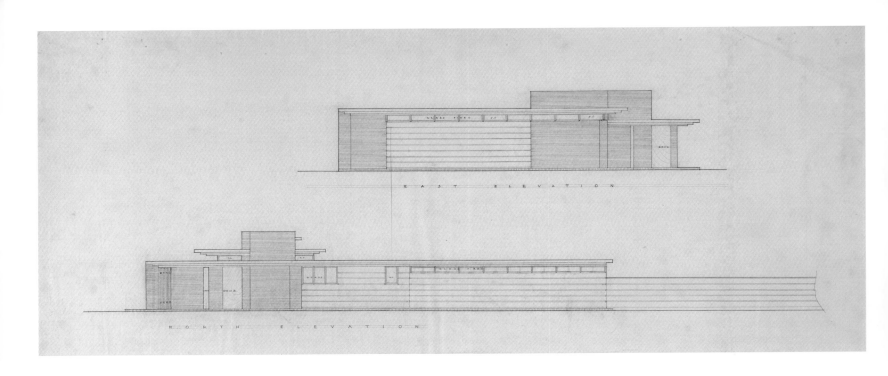

Jacobs I (Katherine and Herbert A. Jacobs House), Madison, Wisconsin, 1936–1937. FA

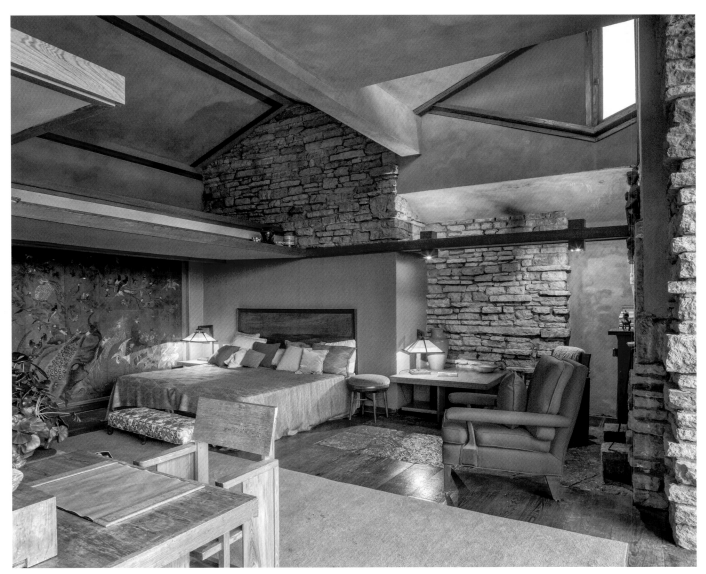

Taliesin III, Spring Green, Wisconsin, 1925–1959

Like many architects, Frank Lloyd Wright wanted to design everything in and around his buildings, down to the furniture and furnishings. To him, the chairs, tables, and chests with which he filled his designs represented the same principles as the larger structures, but they also had their own rules and aims. The most striking of his furniture designs, and the object to which he most frequently turned his attention, were dining room chairs. Especially in his early houses, Wright designed heavy, high-backed chairs to create an intimate room within a room around the table. The ring of chairs with their straight backs, extending above the top of most people's heads, together create an implied rectangle of communal space. It is a place of focus around which the room can disappear into shadows. The furniture's decoration, which usually takes the form of stylized flowers, mirrors what would have been the floral centerpieces. He also designed massive chests, sideboards, mantels, and other furniture, and decorated them with plant motifs, without the references to history more common in furniture at the time. He believed a sense of contemporary belonging came from your own family and from nature, not from borrowing the styles befitting former kings, queens, or aristocrats. Wright's later furniture was lighter and more open, echoing the angles and circles he used in his mid-twentieth-century buildings, so that some of his best chair designs seem to spin naturally into the eddy of overall room. Wright had definite ideas about how you should sit and use furniture. Having dinner, you should sit up straight, but when you were watching a performance, you should cross your legs and look sideways. The result was that his furniture did not put comfort first. The human body conforms to the chair, the table, or the other objects of use because these are implements that connect you to the shared rituals of eating, listening to music, working, or joining in conversation.

"Now we see that [the] furniture is 'built in' in complete harmony, nothing to arrange, nothing to disturb; room and furniture 'an entity.' No glaring fixtures, there, but light, incorporated in the wall, which sifts from behind its surface opening appropriately in tremulous pattern, as sunlight sifts through the leaves in the trees; and underfoot this thick soft rug of dignified weave provided for in thickness of the flooring. All so permanently organized, seeming to fit so well, we feel somehow that it is right we should be there."
—"Architect, Architecture and the Client," 1896

"So far as possible all furniture was to be designed in place as part of the architecture. Hangings, rugs, carpets—all came into the same category."
—"Two Lectures on Architecture," 1931

41. Form a room with furniture

Taliesin III, Spring Green, Wisconsin, 1925–1959

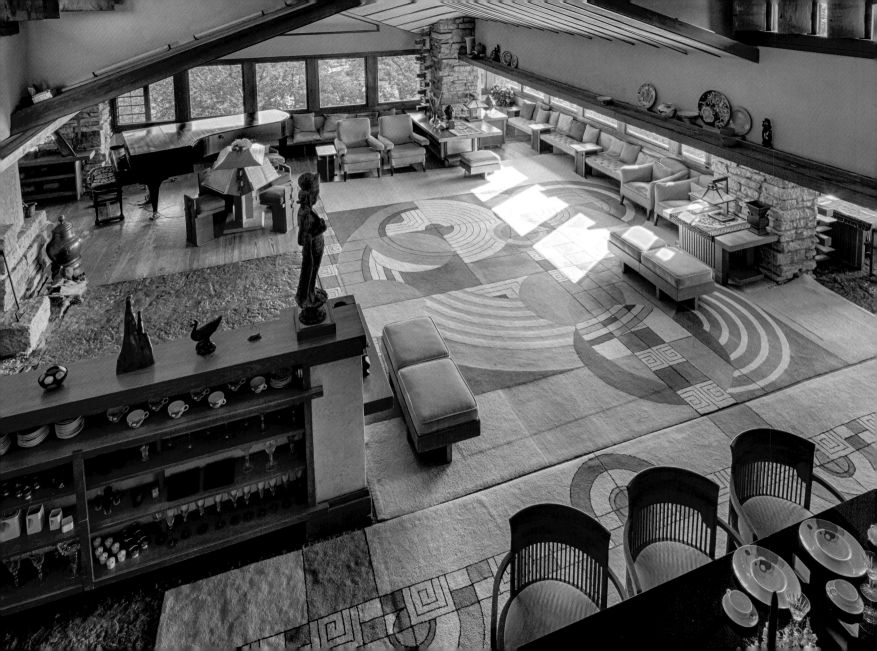

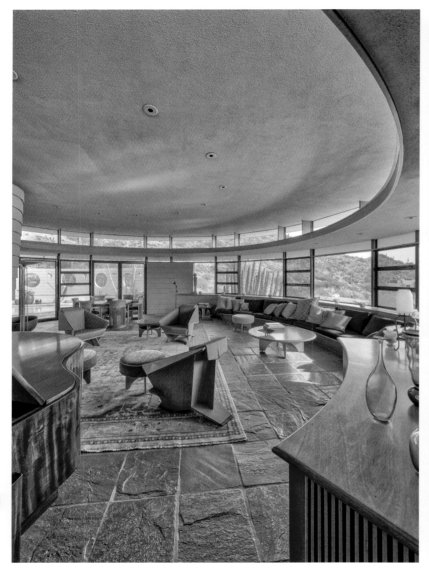

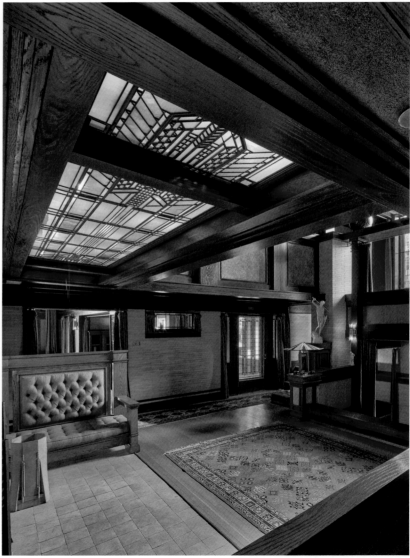

Norman and Aimee Lykes House (completed by John Rattenbury), Phoenix, Arizona, 1959–1968

Susan Lawrence Dana House, Springfield, Illinois, 1900–1902

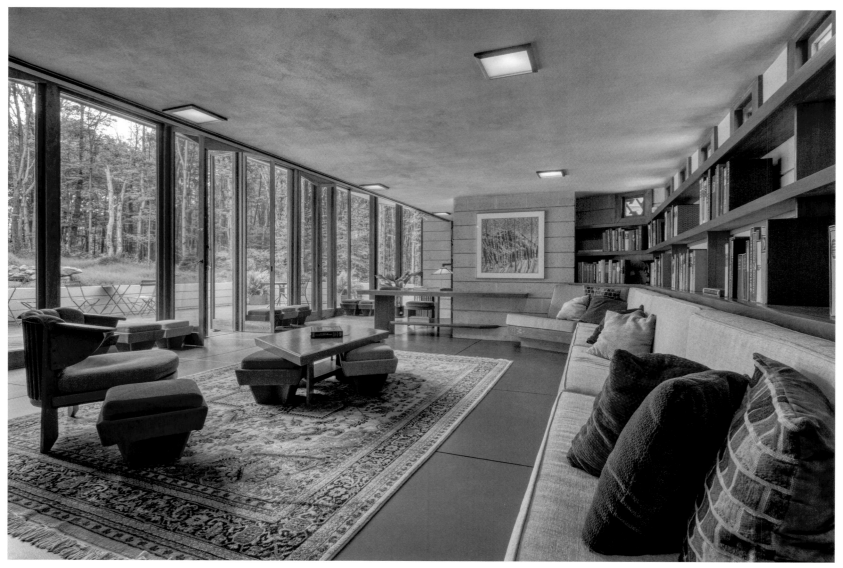

Mäntylä (R. W. Lindholm House), Cloquet, Minnesota, 1952, moved to Polymath Park, Pennsylvania, 2016–2019 > C. Thaxter Shaw House, renovation (unbuilt project), Montreal, Canada, 1906

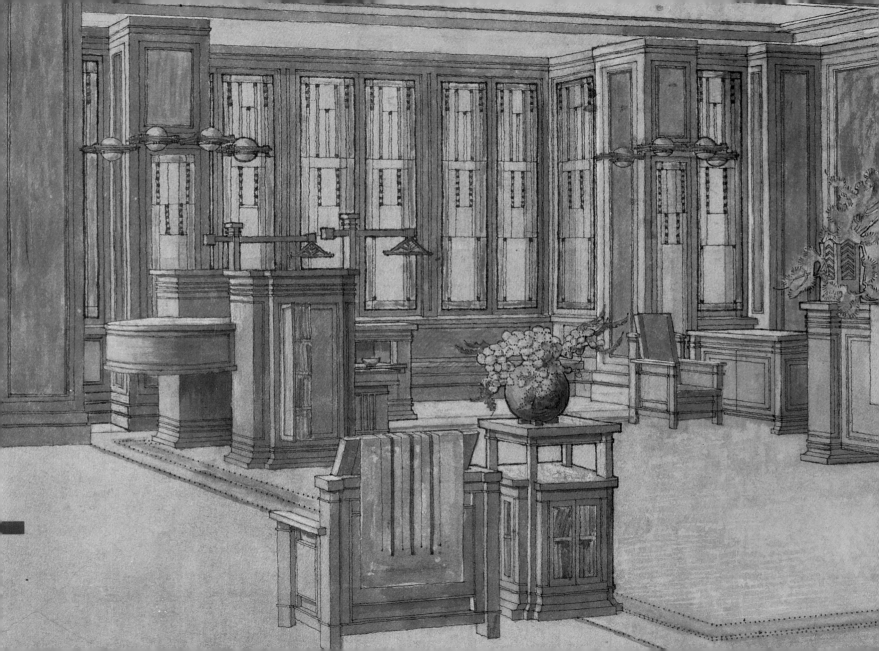

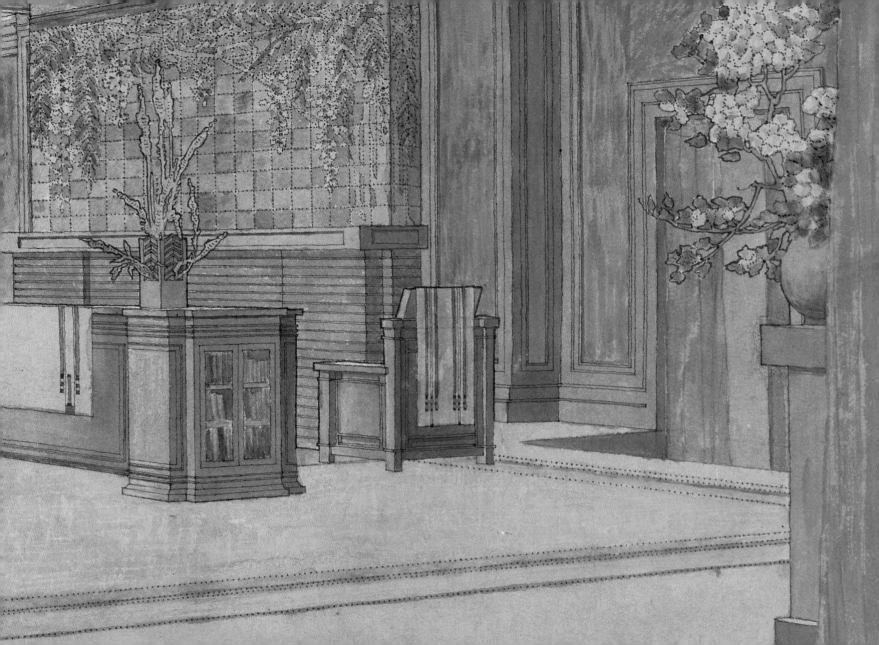

Ignoring the needs and realities of human bodies appears to be a recurring problem in Frank Lloyd Wright's architecture. He seems to have been more interested in the idea or abstraction of who we are as corporeal beings than he was in physical comfort or sensible use. With the exception of a few projects such as the Laurent House, which he designed for a disabled veteran, his architecture was one of discipline and transformation, not of acceptance and accommodation. That does not mean he ignored the human body. Like many architects, he just had an idea of what it should be rather than accepting what it was. He thought of himself as the measure of all things, and he was 5'6" tall (although he claimed to be taller and wore platform shoes). Since he thought architecture should both form a cocoon around its occupants and connect them to a wider world, he preferred many of his spaces, at least the private or non-communal areas, to be very low. He is reported to have said that "anything over six feet is a waste of material," causing even his closest apprentices and family members to have to duck to avoid bumping their head. He focused on views and acoustics more than on comfort. The result was buildings and spaces that confront you with their beauty—and their limitations. At times, those restrictions are calculated to heighten your awareness of your body in space, as when Wright placed rows of windows low in a room, so that you would enjoy the view most fully when you were sitting down, or when he placed seats at an angle in his theaters, to force you to turn and focus. Yet some of the choices he made were purely aesthetic, as when he placed doorknobs so close against the door jamb that you have to be careful not to skin your knuckles when turning that knob. More important than comfort, convenience, or even safety, for Wright, was to make you aware of where you are and to place you within the order he has made.

"The lovely human figure might come into the scheme but come in only to respect the architecture, dominated by a proper sense of the whole. The human figure should be there but humbly, to heighten the whole effect."
—*An Autobiography*, 1943

"Taking the human being for my scale, I brought the whole house down in height to fit a normal man; believing in no other scale, I broadened the mass out, all I possibly could, as I brought it down into spaciousness. It has been said that were I three inches taller (I am 5'8½" tall), all my houses would have been quite different in proportion. Perhaps."
—"Modern Architecture" (The Kahn Lectures), 1931

> Hillside Theater (Taliesin playhouse), Spring Green, Wisconsin, 1952–1955, seating plan. FA

>> Hillside Theater (Taliesin playhouse), Spring Green, Wisconsin, 1952–1955

42. Direct the human body

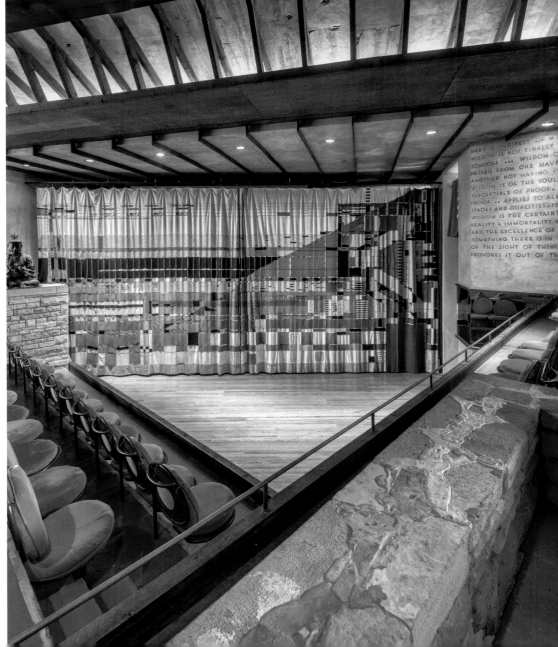

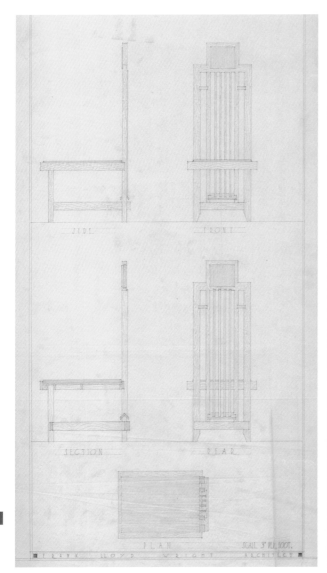

Dining chair, Henry & Elsie Allen House, Wichita, Kansas, 1916–1917. FA

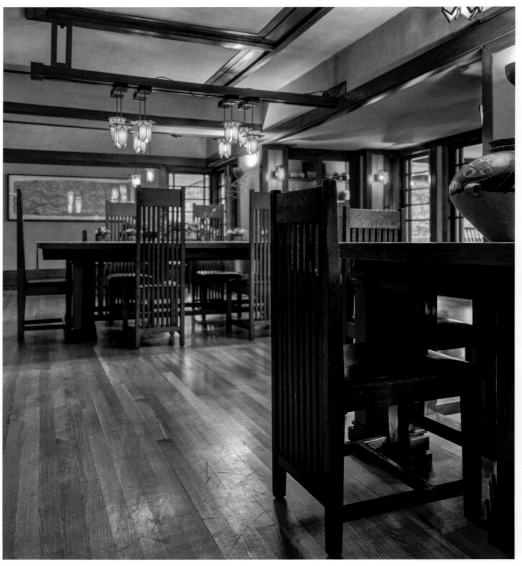

Emma and Peter Beachy House, Oak Park, Illinois, 1906

202

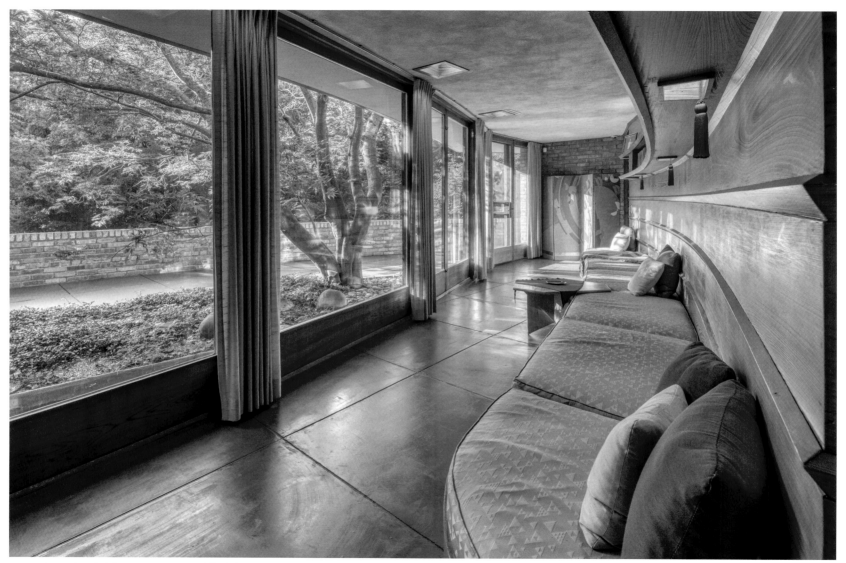

Kenneth and Phyllis Laurent House, Rockford, Illinois, 1949–1951

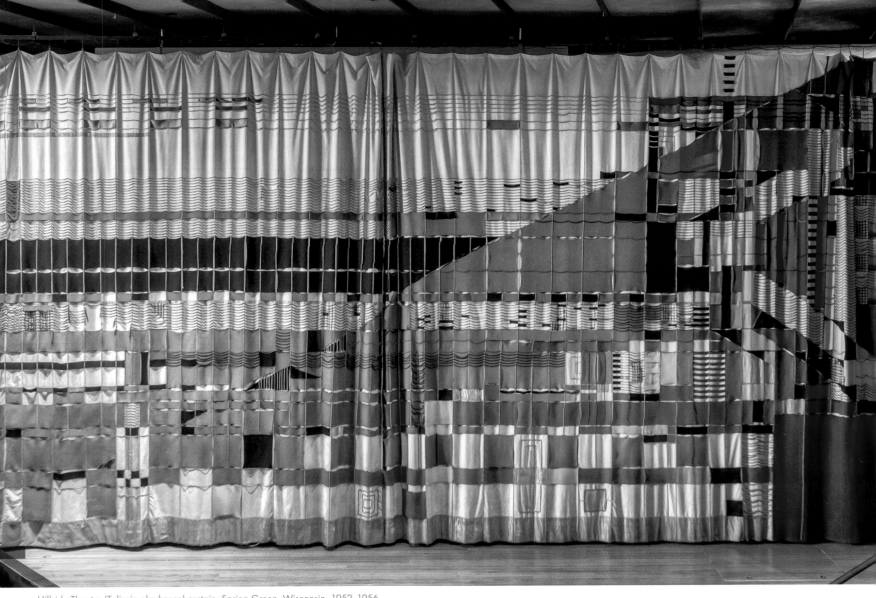

Hillside Theater (Taliesin playhouse) curtain, Spring Green, Wisconsin, 1952–1956

Frank Lloyd Wright loved textiles, both in reality and as an ideal. In his writing, he often spoke of architecture as that which weaves us together, and also that which will weave a new spirit into our surroundings. He also wrote of architecture as a veil or skein that he draped over the activities of daily life, both to protect them and to let them see their surroundings in the best light. In a concrete sense, he understood the importance of carpets and wall hangings, as well as window curtains and screen partitions, in creating livable interiors. He also dabbled in fabric roof canopies for hot, dry climates. Wright worked with talented collaborators throughout his career to devise these textiles. They were for him a prime location for decorative motifs that would sum up and abstract the geometries of the building in which they appeared, or that would highlight a particular thematic motif, such as the hollyhock flower in the house of that name in Los Angeles. The textiles never had representations of actual flora or fauna, however, nor of any building elements. Rather, he was interested in how the logic of the weft and weave of any such carpet or drapery could develop into thin, drawn-out lines and dancing blocks of color that would lead your eye past them and make them part of the overall design of the room. His most dazzling textile set pieces were his stage curtains, such as the one in the theater at Taliesin. There, he not only emblazoned the geometries of which he was fond, but wove them through abstract allusions to the local landscape. The best textiles in Wright's buildings are maps to the architecture in its context. They also soften the contours of the space and provide some sense of privacy, both between rooms and from the outside.

"Good colors, soft textures, living materials, the beauty of the materials [...] these are the means of decoration considered purely as such. And it is quite impossible to consider the building one thing and its furnishings another, its setting and environment still another.... Floor coverings and hangings are as much a part of the house as the plaster on the walls or the tiles on the roof."
—Wasmuth Portfolio ("Ausgeführte Bauten und Entwürfe von Frank Lloyd Wright"), 1910

"Color has a tremendous influence on our moods and cannot be too carefully considered. Use soft warm tones in preference to blues, grays, and cold pinks, for they are more wholesome to live with and better adapted in most cases to good decoration. To further decoration [beyond furnishings], never have any unless you understand it thoroughly and are satisfied that it means something good in the scheme as a whole."
— "The Architect and the Machine," 1894

43. Embroider rooms with textiles

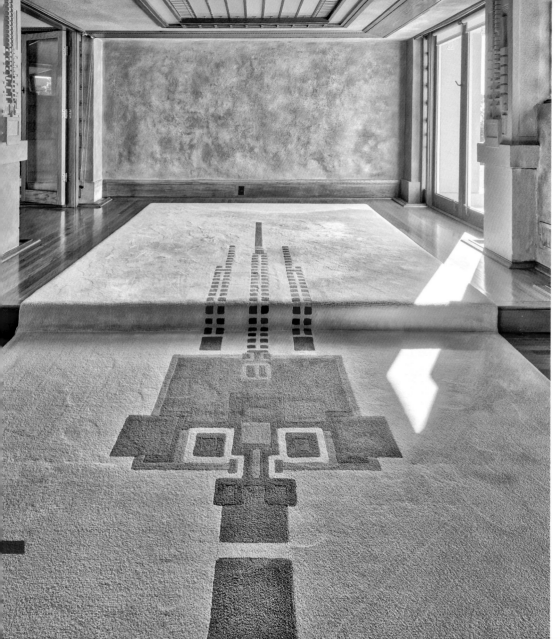

Hollyhock House (Aline Barnsdall House), Los Angeles, California, 1917–1921

> David and Gladys Wright House, Phoenix, Arizona, 1950–1953

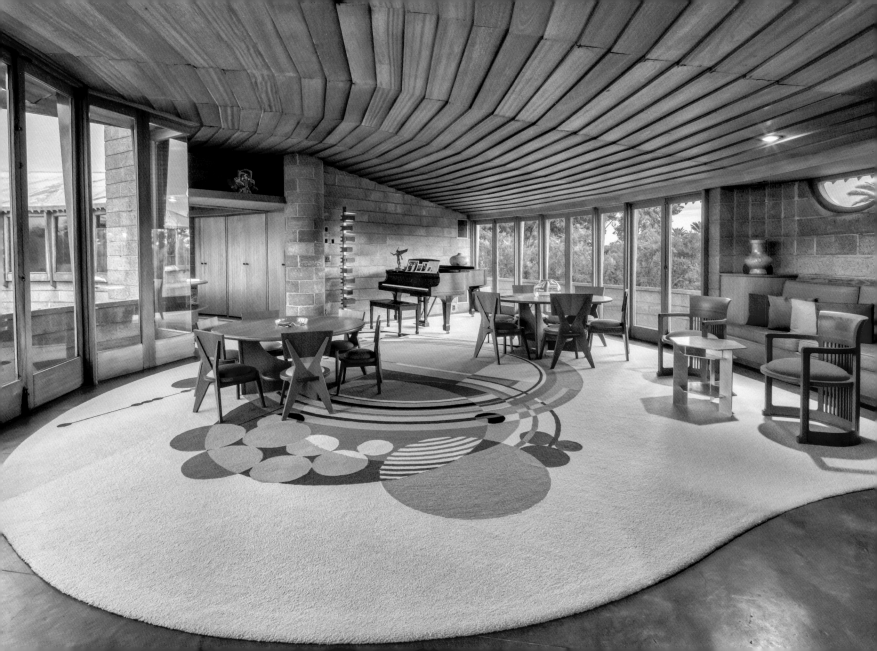

In a clerestory above the desk where Frank Lloyd Wright worked for much of the last years of his life, he used a trick you would not expect from an architect who preached honesty in all things. He created an overhead light source that consists of a little roof that pops up above the main, very low covering over the study he added onto the house. It has windows on all four sides—or at least that is how it appeared in Wright's time. If you looked closely, you would have noticed that one of the sides had mirrors, since removed, covering the structure that made this particular clerestory work. Wright was not averse to using such subterfuge in his buildings. When he wanted to create the illusion of more space, or when he wanted to bring in light or a vista into one particular part of a room, he would use mirrors. These were never large, but were inserted strategically, like the little red accents with which he leavened his buildings. He also almost never used reflective or even shiny materials on large surfaces. His willingness to use mirrors, though, points to a larger truth about (his) architecture: to tell the truth in buildings, you often have to tell a lie. Even if you want your users to understand how the space they are occupying or viewing is put together, you can never show all the bits and pieces of wood, steel, concrete, stucco, and whatever else makes for a complete and sheltering building. And, even if you want to make a building a whole, organic and complete in itself, as Wright did, then you still will inevitably wind up with bits and pieces that contradict each other. So you give the illusion of space with mirrors. You hide lights in coves. You extend ceiling planes to both hide what is above and accentuate the horizontal line. And you bury unsightly aspects of technology inside your walls. This, for Frank Lloyd Wright, was the best way for architecture to mirror nature: by fleshing out space, not exposing the carcass and organs.

"But to extend the vista, complete the form, multiply a unit where repetition would be a pleasure, lend illusion and brilliance in connection with light effects—all these are good uses to which the architect may put the mirror."
—"In the Cause of Architecture, VI: The Meaning of Materials—Glass," 1928

44. Mirror your world

Richard Quittenton, *Mirror Your World*, 2020

> Taliesin III, Spring Green, Wisconsin, 1925–1959

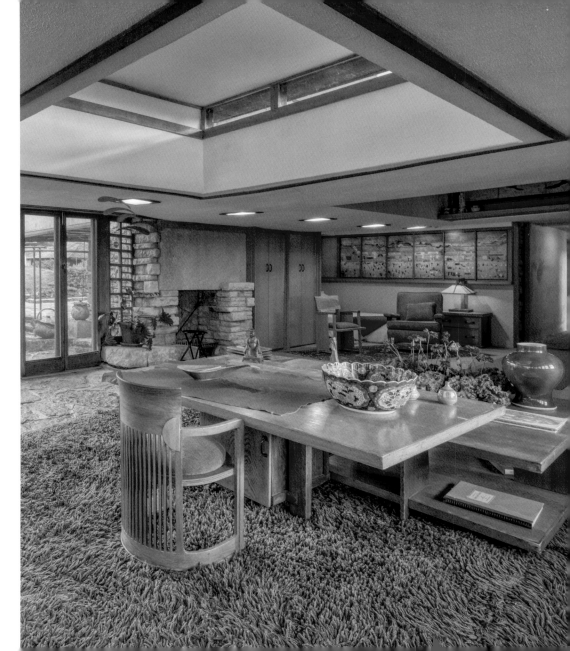

Let the other modern architects try to be as white or transparent as possible: Frank Lloyd Wright made his mark with red. In fact, he used many different reds. He used a deep, saturated red to accentuate a wall or color the end of a beam to catch your eye as it swept across the expanse of the horizontal lines he preferred. That bit of red would form a punctuation, and could also become a line that wove through the glass and textiles he (or his talented collaborators) designed. Then there was the earthy "Cherokee Red" that became one of his design signatures later in his life. Though he might have been inspired by Native American sources, Wright formulated or selected this hue—in fact, a family of hues ranging from red-brown to dusty orange—depending on the context and the material. Cherokee Red was dark and saturated, evocative of the rocks and soil of the desert Southwest, compared with the brighter "Chinese" reds that he used on the title blocks of his drawings and elsewhere. Wright also painted some of his favorite objects and even his cars red. It was the color of his name on prints and the underlining on his letterhead. Those who worked with Wright say he specified brighter reds for signs, lighter reds for pavement, and various forms of a burnt and almost brownish red when he wanted to be subtle or blend with the earth. It seems red was a baseline for Frank Lloyd Wright: a note that he used to give rhythm and continuity to his structures.

"We will paint the canvas triangles in the eccentric gables, scarlet. This red triangular form in the treatment is why we called the camp Ocatilla. Candle flame."
—An Autobiography, 1932

"Top edges of 2x4s might be left red."
—Letter to Oscar Stonorov, Feb. 8, 1951

45. Accentuate with red

David and Gladys Wright House, Phoenix, Arizona,
1950–1953

> Taliesin III, Spring Green, Wisconsin, 1925–1959

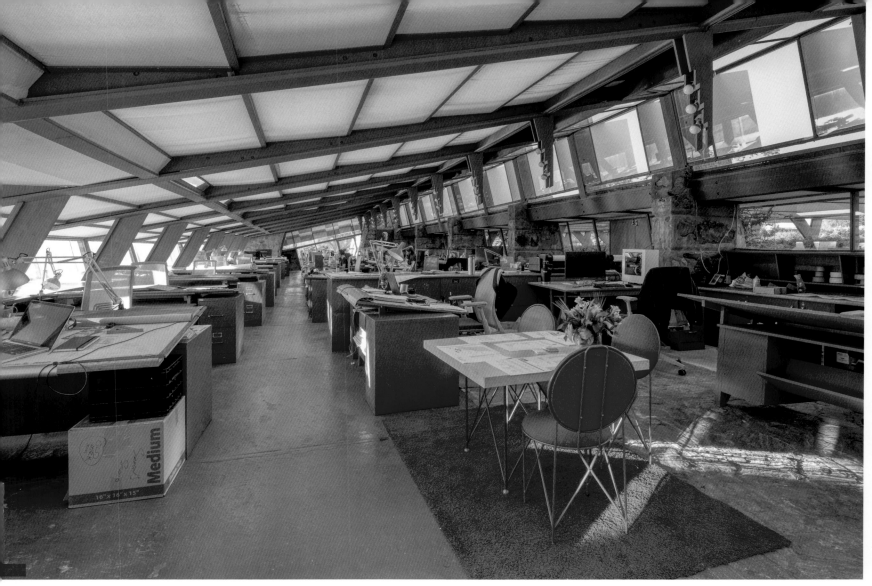

Taliesin West, Scottsdale, Arizona, 1937–1959

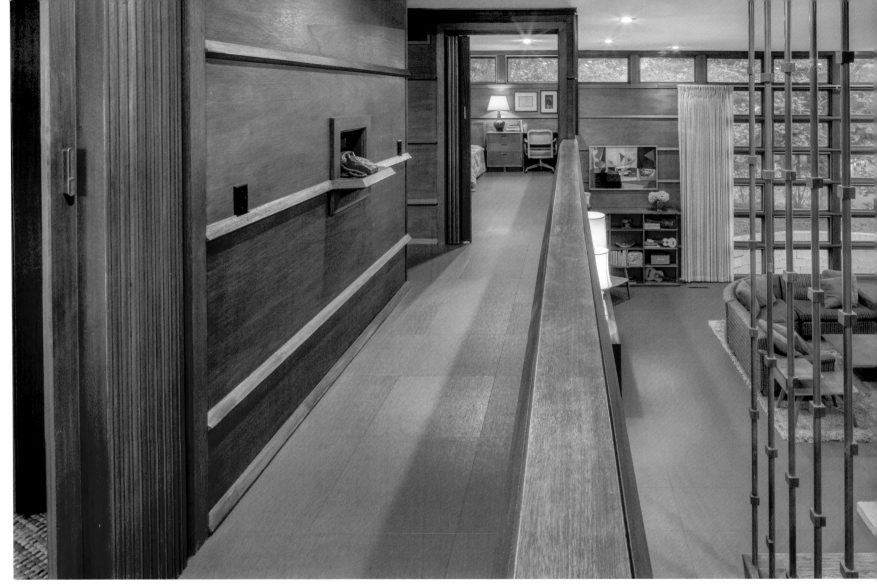

Walter and Mary Ellen Rudin House (prefabricated house #2 for Erdman Homes), Madison, Wisconsin, 1957–1959

Frank Lloyd Wright's buildings often combine bare-bones materials with luxurious appointments. That was how the architect lived and believed we should all live, work, and play: close to nature, but with modern conveniences and original Chinese paintings; in structures of plywood and concrete, but with gold-leaf and teak accents; in rambling buildings with small, cellular private spaces, but with luxuriously expansive shared spaces for the community. Wright's love of luxury may have been the result of both his penurious upbringing in a small town in the Midwest, and of his immersion in the Chicago of the last quarter of the nineteenth century that was ablaze with activity and ostentatious displays of wealth. Perhaps more crucially, Wright believed in the sensual nature of the world. He saw beautiful forms, colors, patterns, and spaces in nature, and he wanted to echo this sensuality in the human-made world. He lavished attention on those parts of the building that were specific to site and function, where your body, your hand, or your eye would rest, or that they became the ceremonial focal point of a room. There, the building would blossom—often quite literally, as he loved abstractions of floral forms—with ornament, expensive materials, and materials manipulated to respond to touch and sight. Luxury was a responsiveness to the human body, as in clothes. It was the concentrated investment of human effort, love, and ingenuity that made an object or work of art beautiful. Luxury was also, truth be told, the sign of achievement, marking the ability of a good citizen to amass such precious objects—and as such served also as a kind of bank, on which Frank Lloyd Wright drew several times when he was close to insolvency and sold his collections of art. In commissioning Wright, you bought luxury: a handmade building that would fit you like a glove, amaze you and your friends with its luster, and remain an object of beauty even as you or the uses to which you put it changed.

"So long as we had the luxuries the necessities could pretty well take care of themselves so far as we were concerned. We were seldom without our season tickets to the Symphony."
—*An Autobiography*, 1932

"Remember that we can own only what we can assimilate and appreciate, no more. Many wealthy people are little more than the janitors of their possessions for the benefit of those who more truly own them."
—"Architect, Architecture, and the Client," 1896

46. Take care of the luxuries in life

> Susan Lawrence Dana House, Springfield, Illinois, 1900–1902

>> Arthur and Grace Heurtley House, Oak Park, Illinois, 1902

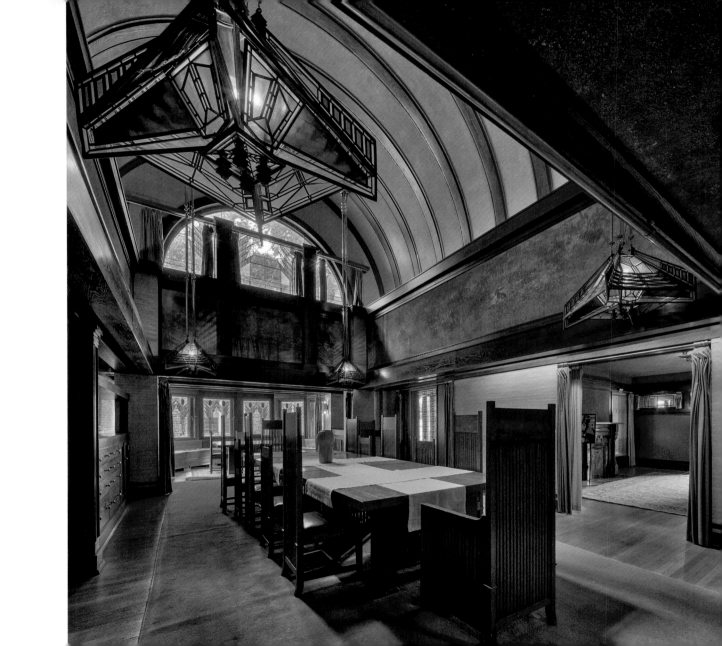

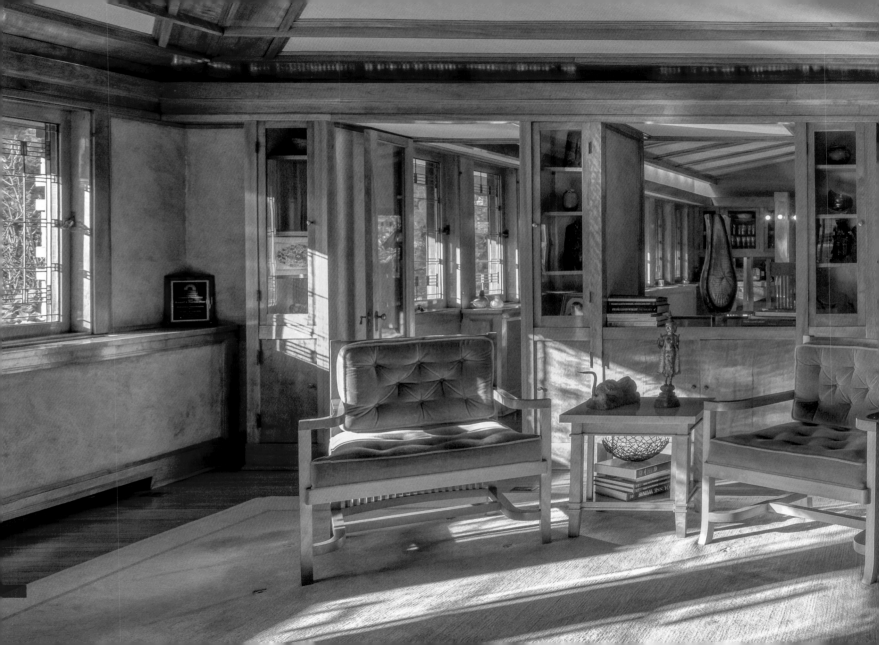

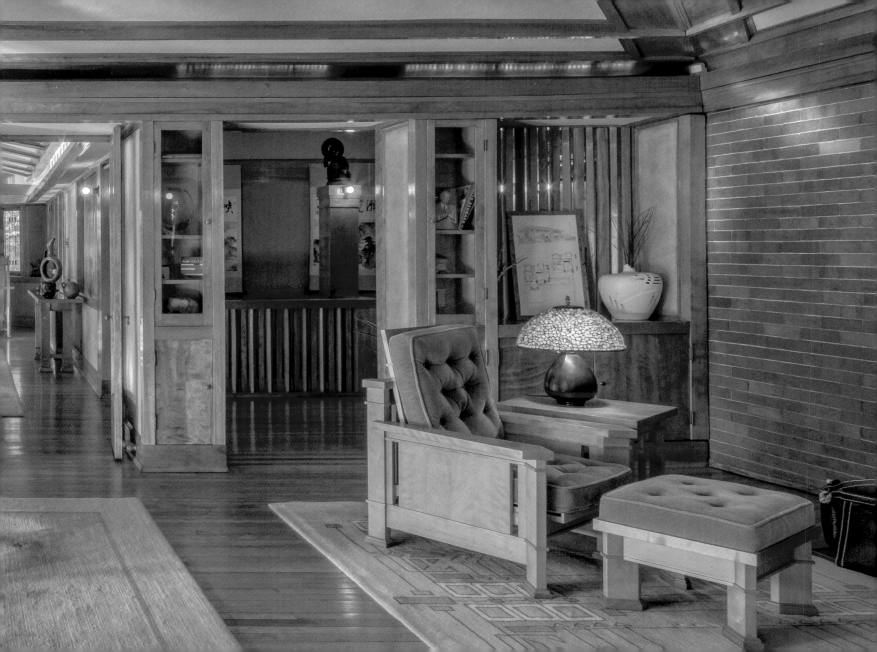

47. Circle the cosmos

48. Spiral to heaven

49. Connect with the sky

50. Be true to oneself

ABSTRACTION and COSMOS

As Frank Lloyd Wright matured as an architect, he began to use more and more circles. Rounded shapes are largely absent from his early designs, unless they are urns placed within otherwise rectangular rooms or bay windows and corresponding terraces that merge the room with the surrounding landscapes. However, his long-running interest in breaking down corners to create a continuous sense of movement, as seen in early projects such as Unity Temple, foreshadows his later embrace of circles. As he began to work in more suburban and rural settings, and even to create urban plans outside of the United States (such as that for Baghdad right before his death), he turned to circles to organize space. Some of his masterpieces of the 1950s, ranging from the house he designed for his son, David Wright, in Phoenix, to the Guggenheim Museum, are nothing more than a circle or series of circles that he made inhabitable. In three dimensions, the circle becomes a spiral defined by a ramp, but Wright also began to echo the overall form of his plans with bubbles that became rooms spinning off the main space, or with patterns on rugs and curtains that used to weave the spaces together. Wright thought that circles and other geometric forms had cosmic significance. The circles became like the Buddhist mandalas, maps of the whole world that you can grasp and see. It is also worth noting that many artists, late in life, tend to use more curvilinear forms—whether because of a desire to escape from the rigidity of everyday life, to connect to larger forces before they pass, or merely because they are skilled enough to control these difficult shapes, we do not know. What is clear is that Wright's circles, because they appeared late in his life, became his last signature, and one that his apprentices brought with them when they continued his practice after his death. Wright's circles are his most forceful, expressive, and most difficult-to-inhabit-and-manage forms. The reality of having to hang a painting or bring rectangular pieces such as bricks or wood beams together in a curvilinear shape often undermined his aims. The circles are gestures and lines of desire more than practical form-givers.

"Various geometrical forms (circular, especially) in planning structure become more economical than the square of the box."
—A Testament, 1957

47. Circle the cosmos

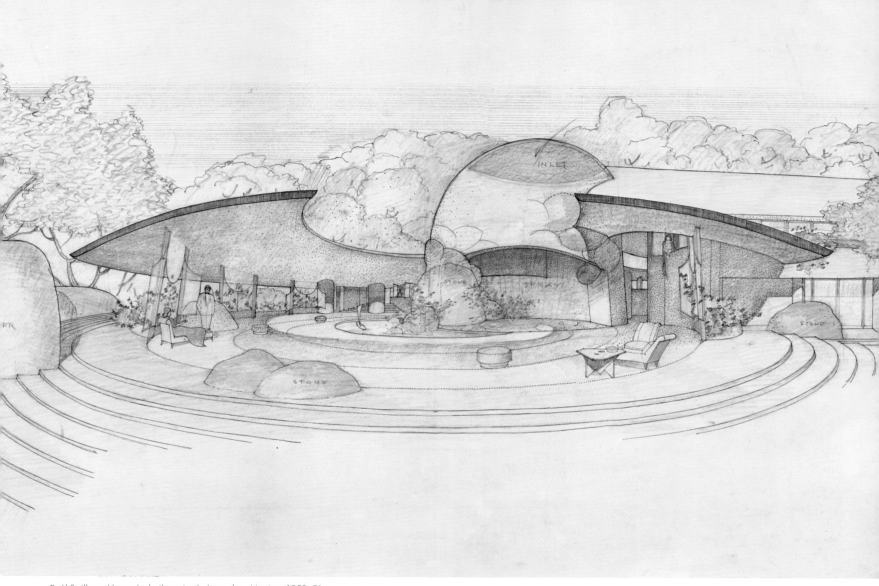

Raúl Bailleres House (unbuilt project), Acapulco, Mexico, 1952. FA

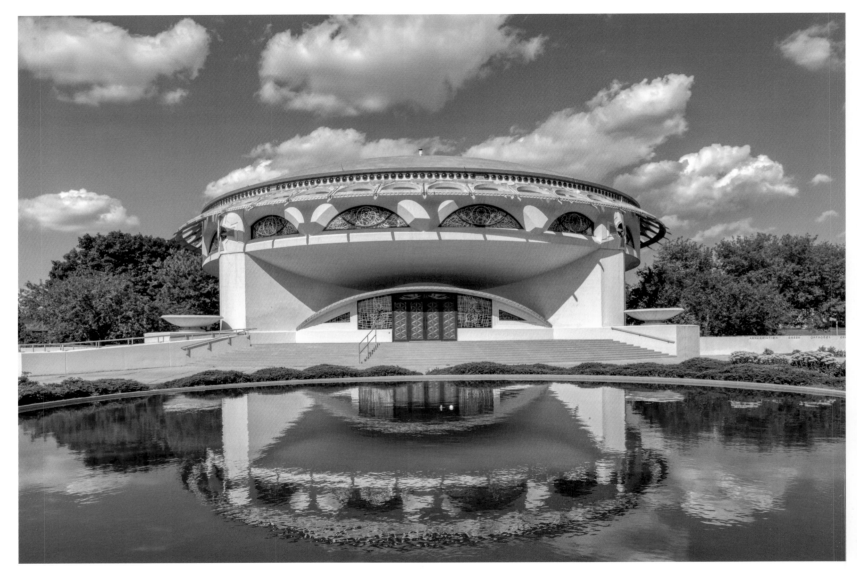

Annunciation Greek Orthodox Church, Wauwatosa, Wisconsin, 1956–1961

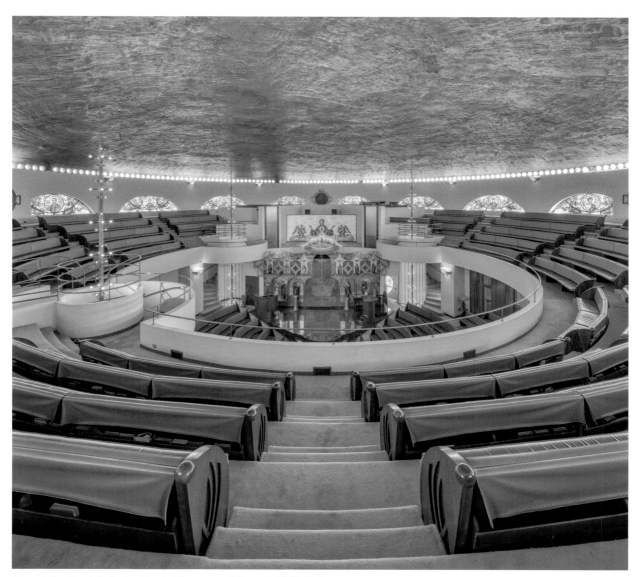

Annunciation Greek Orthodox Church, Wauwatosa, Wisconsin, 1956–1961

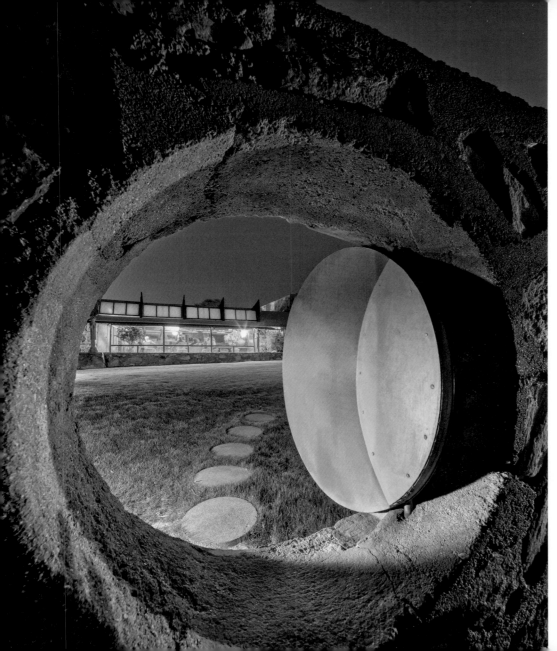

Taliesin West, Scottsdale, Arizona, 1937–1959

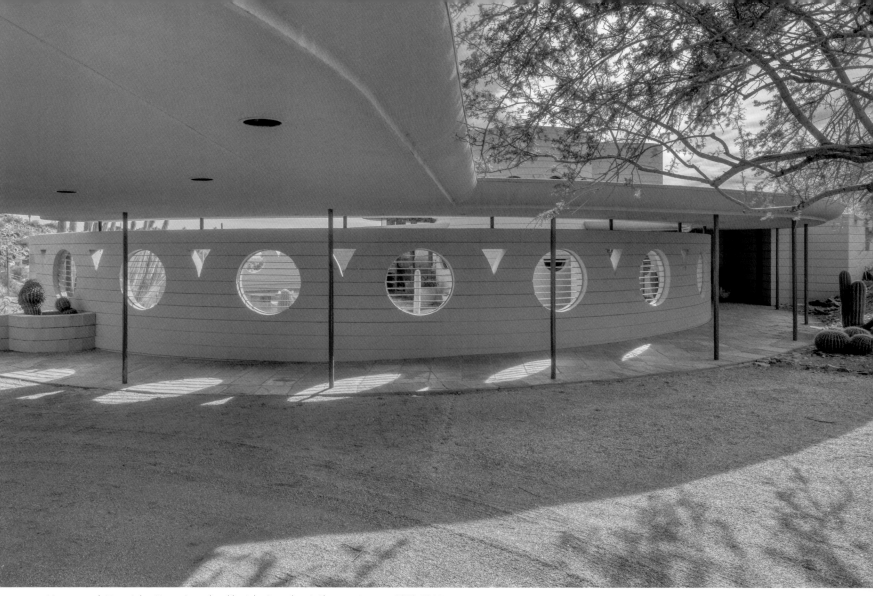

Norman and Aimee Lykes House (completed by John Rattenbury), Phoenix, Arizona, 1959–1968

The spiral or helix combines the circle, which we usually think of as closed and perfect, with the energy of growth. It is also a way to bring together different scales in a continuous looping movement. Spirals have shown up in architecture for millennia as ornament, sometimes representing the cyclical motion of waves, but also as dizzyingly complex mazes. Frank Lloyd Wright came to use spirals literally in the final decades of his career. He found the motif in the work of Native American artists and artisans, and adopted it into his signature, the "whirling arrow." The spiral is also the basis of the plan of many of his later designs, the most famous of which is the Solomon R. Guggenheim Museum in New York. His spirals usually take you up and out, from the ground to the sky, through a set of experiences and spaces that have no borders between them. The architecture becomes a way of connecting heaven and earth while achieving the three-dimensional continuity of spaces that Wright had long sought to achieve. Finally, the spiral, as an expression of the mathematical Fibonacci sequence, serves to align small and large pieces in a continuum of scales. In Wright's work, the spiral connects the body to the community in the building and then to a larger universe beyond.

"Certain geometric forms have come to symbolize for us and potently to suggest certain human ideas, moods, and sentiments—as for instance: the circle, infinity; the triangle, structural unity; the spire, aspiration; the spiral, organic progress; the square, integrity."
—"The Japanese Print: An Interpretation," 1912

48. Spiral to heaven

Gordon Strong Automobile Objective (unbuilt project), Sugarloaf Mountain, Maryland, 1924. FA

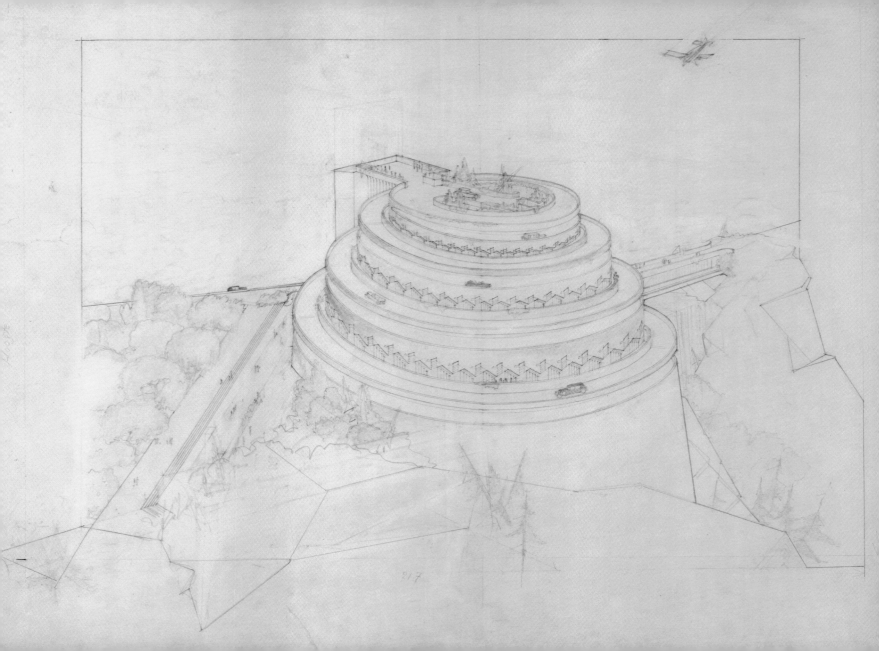

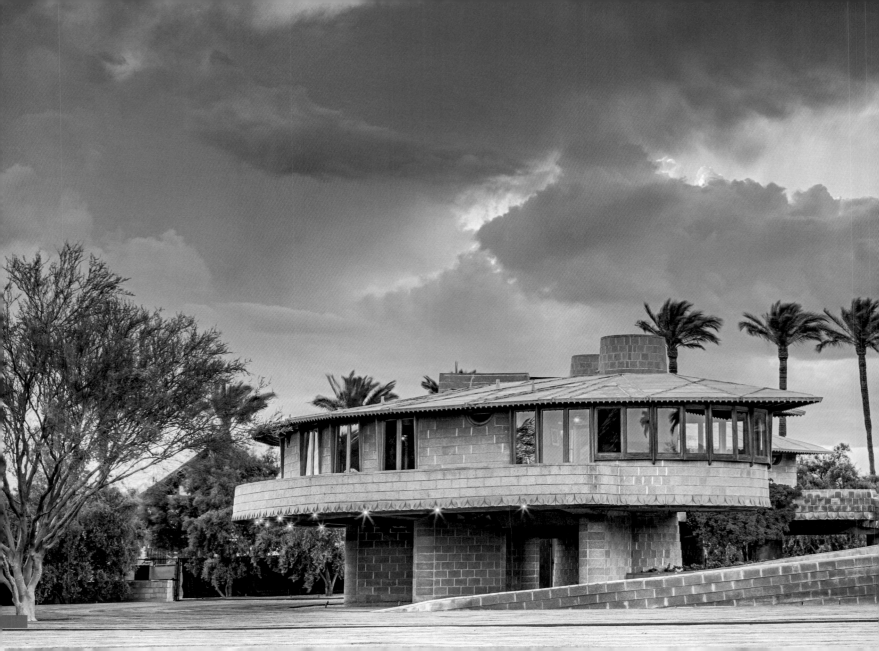

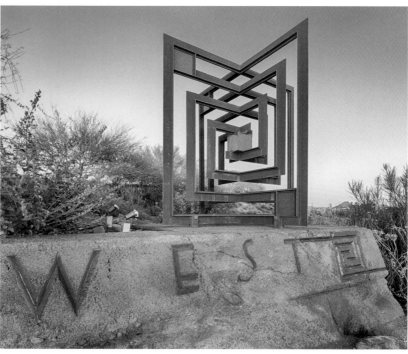

< David and Gladys Wright House, Phoenix, Arizona, 1950–1953

Taliesin West, Scottsdale, Arizona, 1937–1959

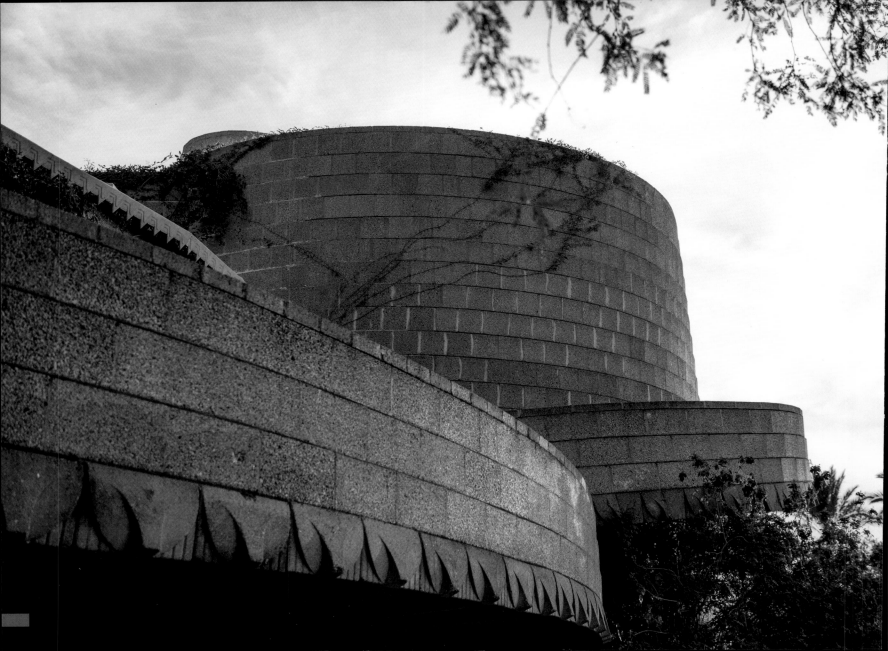

David and Gladys Wright House, Phoenix, Arizona,
1950–1953 (opposite and right)

> Solomon R. Guggenheim Museum, New York, New York,
 1943–1959. FA

>> Solomon R. Guggenheim Museum, New York, New
 York, 1943–1959

>>> Solomon R. Guggenheim Museum, New York, New
 York, 1943–1959

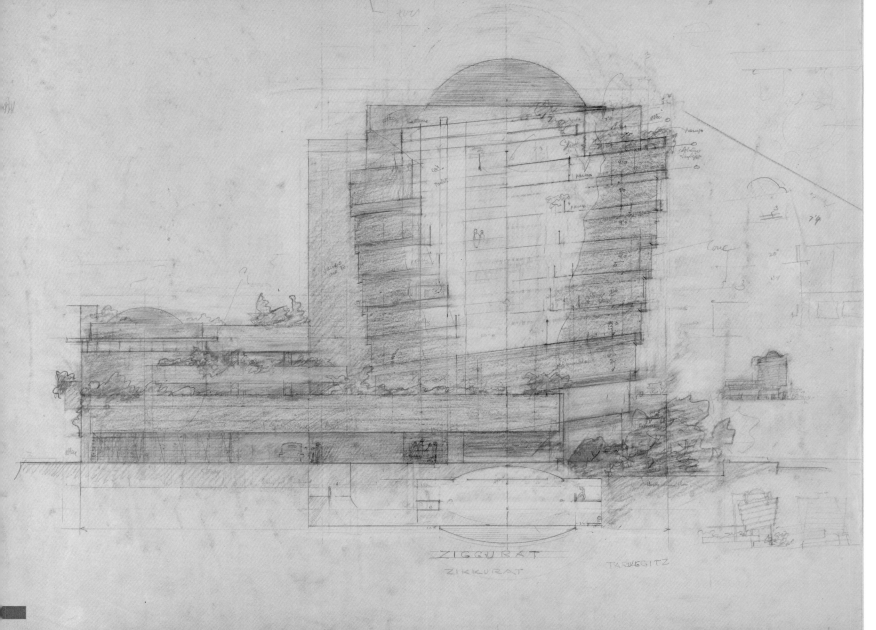

ZIGGURAT
ZIKKURAT TKRVGGITZ

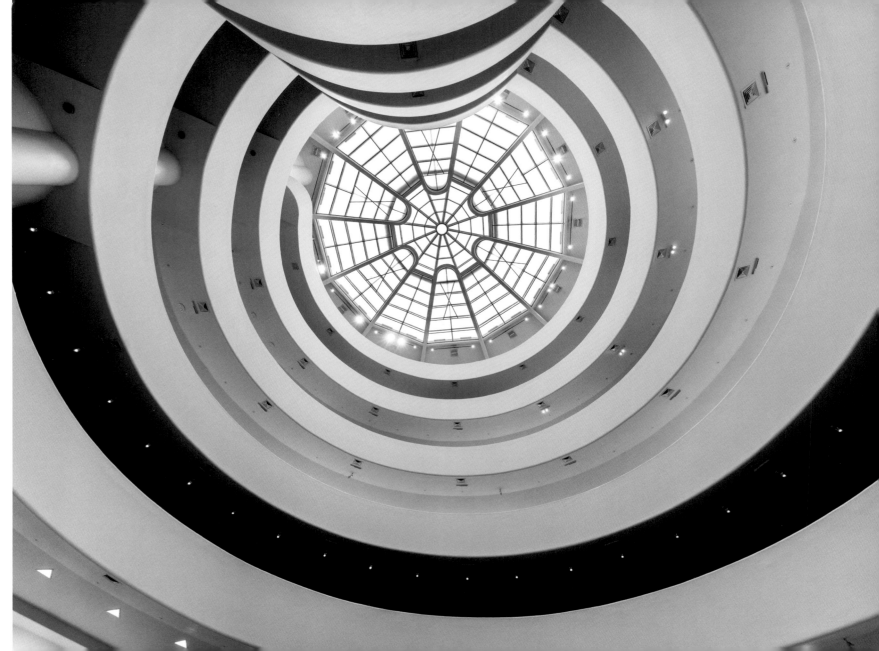

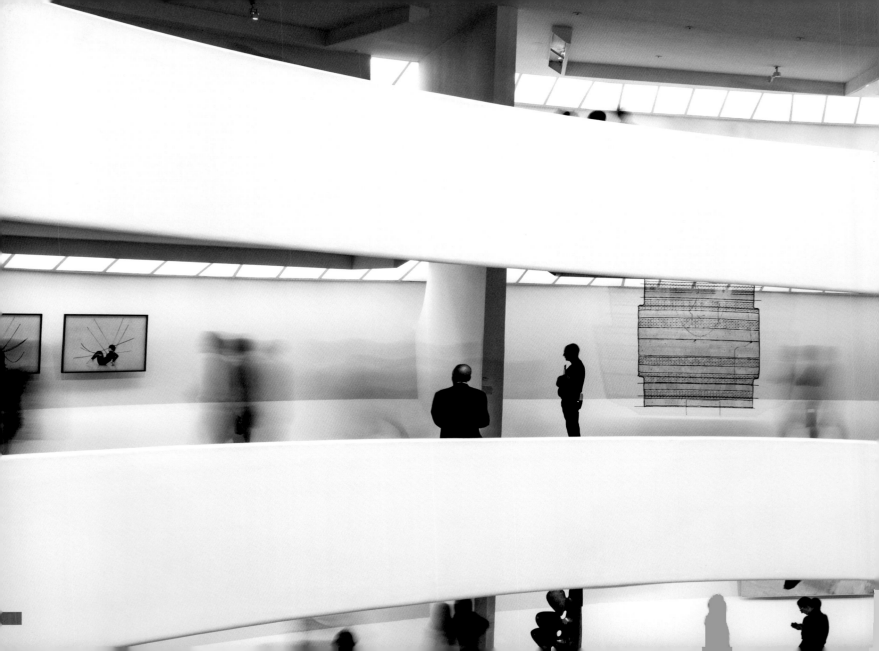

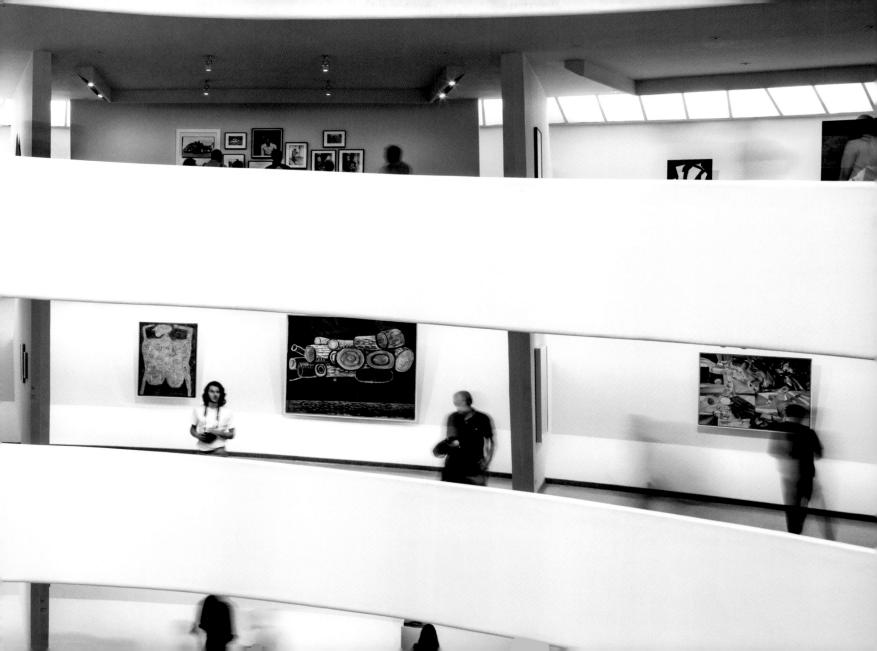

Even though Philip Johnson once mockingly called him (in the 1930s, when he was in the middle of his career) "the best architect of the nineteenth century," Frank Lloyd Wright actually loved the latest technology. He was fascinated by machinery of all sorts, from the electrical switches (he was intrigued by Johnson's rheostat at his so-called Glass House) to cars, to large turbines. He just did not feel that the machinery should be a visible part of the buildings he designed, and took pains to hide everything from mechanical ventilation systems to light switches as best he could. The one exception to that desire to hide technology was antennas. Starting in the 1920s, when radio towers spread across the United States, he started to incorporate them, either literally or by implication, in many of his designs. He seems to have loved the ways in which they expressed their structure in steel cross members, the manner in which they rose above all around the buildings and landscapes around them, and the fact that they were light and woven structures. In his designs, he emphasized the tapering most of them had, making the angles more evident so that you really felt them rise up above you. For Wright, antennas were new versions of the wind vanes, such as the one he had placed on top of the water tower at Taliesin (the Romeo and Juliet Windmill; see p. 171), and connected each site not to a natural force, but to the invisible web of culture and politics coursing through the ether on radio waves. The antennas were also ethereal versions of the chimneys that connected each building, as it spread out to be an unfolding of the landscape, to the sky and to such larger forces. Finally, the antennas also were reminiscent of the long extensions insects and some other animals send out to sense their surroundings and where thus organic. In the end, though, the antennas, for all they were meant to have a function and were meant to integrate technology into the structure, while serving as a symbol of connection, were above all else beacons. Like the steeples of churches or the silos next to farms, they served to signal the presence of the community or family inside the structure. In later years, Wright even proposed stand-alone towers, such as the one he imagined for the new Arizona State Capitol, that would have no ready function, but that were explicitly there to serve as the focal point and attractor for the whole composition. The antenna might have gathered information and been an element of the new integrated into the old, but it was also a sign of Wright's ambitions to announce his compositions to the world.

"The beacons from the top would reach adjoining states: the radio from the antennae lifting from the tower crown would be in touch with all the world."
—*An Autobiography*, 1943

"The 'movies,' through television, will soon be seen and heard better at home than in any hall. Symphony concerts, operas, and lectures will eventually be taken more easily to the home than the people there can be taken to the great halls in old style, and be heard more satisfactorily in congenial company."
—*Modern Architecture* (The Kahn Lectures), 1931

49. Connect with the sky

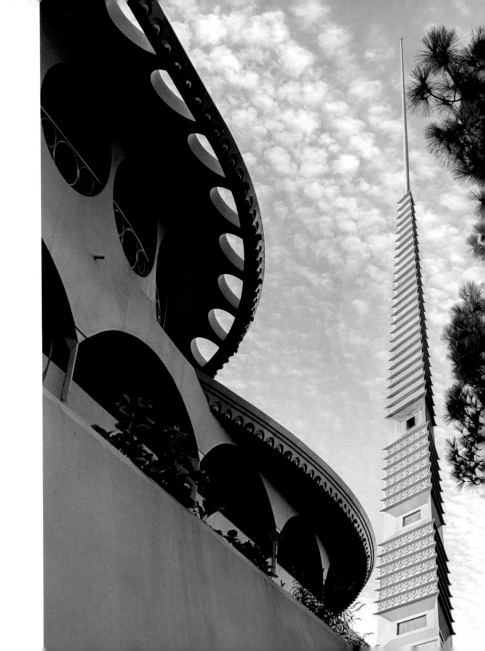

Marin County Civic Center, San Rafael, California, 1957–1962

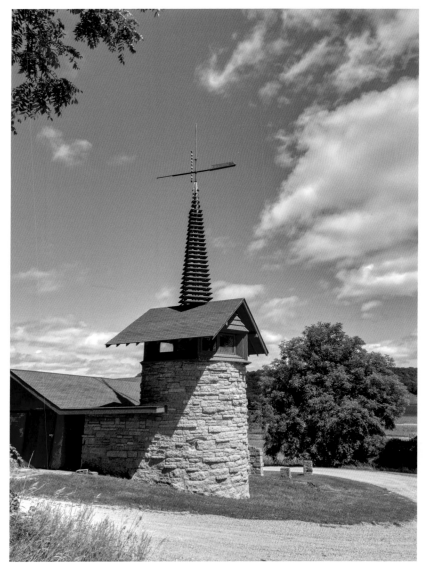

Midway barns, Taliesin Fellowship Complex, Spring Green, Wisconsin, 1938

University of Baghdad, plan for Greater Baghdad (unbuilt project), Baghdad, Iraq, 1957. FA

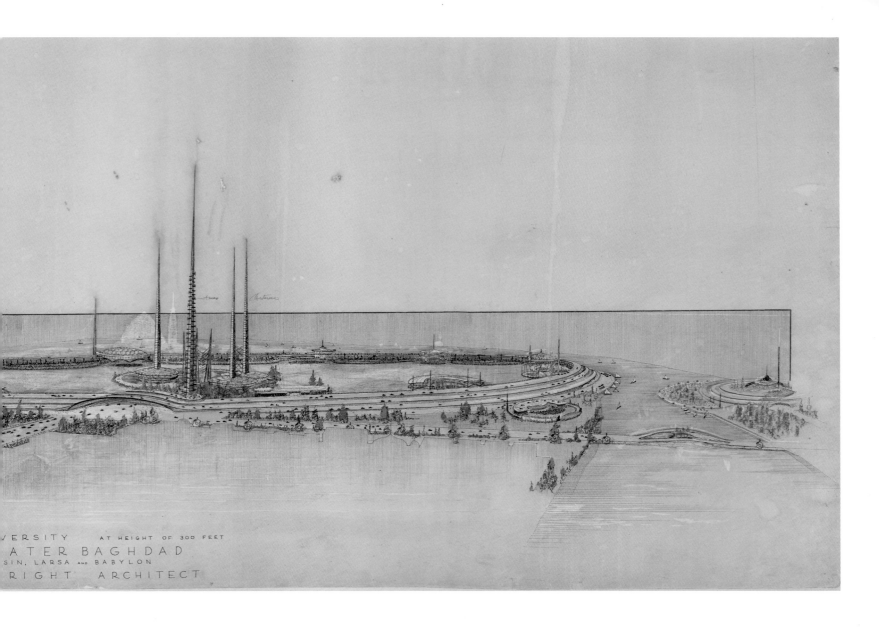

VERSITY AT HEIGHT OF 300 FEET

ATER BAGHDAD

SIN, LARSA AND BABYLON

RIGHT ARCHITECT

Frank Lloyd Wright believed in himself. His certainty about his abilities, his taste, and his confidence in the fact that he was the greatest American architect never wavered. He was so successful at establishing himself in the public eye that he became the model for the most popular book about architecture ever written, Ayn Rand's *The Fountainhead* (though he hated the depiction). His own autobiography was not far behind in its popularity, and remains the best-selling volume in the field to this day. You could say that Wright's greatest act of architecture was inventing and representing himself. He defined his designs in such a way that you could recognize them in an instant, and their imagery was so powerful that thousands of architects have tried and continue to try to imitate him. He was so successful in establishing himself in the popular imagination that he shows up in television shows and pop songs, not only through his buildings, which are used as evocative sets, but also by name as an enduring celebrity. Wright's image, by the time he was in his middle age, was that of a short man with a commanding presence who wore slightly eccentric and distinctive clothing: a porkpie hat, a cane, and a cape. It was also that of a bohemian, whose affairs were the subject of newspaper articles and gossip. He was a bon vivant, who spent whatever money he had on luxurious appointments and art. Wright was known as a cult leader, whose apprentices not only paid him to work for him, but also plowed his fields, built his homes and studios, cooked his food, and did his laundry. He was a mystic whose pronouncements evoked larger forces and truths in ways that were evocative, though rarely definite about how exactly they applied to architecture—that was a recipe only he seemed to have. He had little interest in comfort, whether it was that of his clients or his own (he slept on small cots for most of his life, even when his houses were huge), and felt that how a building looked, or rather what it meant, was more important than its function. The model he established, for better or for worse, is that of the heroic, nonconformist, charismatic architect who follows his own path and bends all to his vision.

"Proved by my own experience, I too can say with Liber Meister that 'every problem carries within itself its own solution,' a solution to be reached only by the intense inner concentration of a sincere devotion to Truth. I can say this out of a lively personal adventure in realizations that give true scheme, scheme line and color to all life, and, so far as Architecture goes, life to what otherwise would remain mere unrelated fact. Dust, even if stardust."
— *An Autobiography*, 1943

"May your own genius inspire and keep you as a blessing to your time and place."
— Letter to Andrew Devane, Mar. 27, 1956

50. Be true to oneself

Frank Lloyd Wright, Taliesin West, undated photo. FLWF

Learning from Frank Lloyd Wright does not always mean deferring to him. In immersing ourselves in his work and writings, it's also important to keep a critical perspective. There are flaws in his architecture, and, especially in later years, quite a few buildings that he seems to have raffled off in a hurry, although such lapses are more than outweighed by the beauty of his body of work as a whole. More deeply problematic, however, is Wright's sweeping view of the architect's authority.

In his zeal to design a better world, Wright sought to control every aspect of what you see and do in the places he designed. His architecture and interiors, conceived in the spirit of the *Gesamtkunstwerk*, or total work of art, are exceedingly wilful impositions of form, image, and space on human activities. He choreographed it all, from the moment of arrival to the rituals of everyday life, worship, work, or play. While he enjoyed continually altering and improving upon his own environments at Taliesin and Taliesin West, he expected his clients to more or less accept what he gave them, though some of them pushed back. The danger of learning from Frank Lloyd Wright, then, is learning submission to a particular kind of self-proclaimed genius. Because of the cult he and his architecture created, we still have countless imitators of both his mode of operating and of his work, none of whom come close to being as effective as Wright. When they replicate Wright's overreach, the results can be all the more painful.

Learning from Wright is not easy, even for those who knew him. Most of the talented collaborators with whom Wright worked throughout his career, and without whom he could not have achieved any of his buildings, did not achieve comparable success on their own. As members of Wright's Taliesin Fellowship community, their lives were quite often reshaped, not always for the better, as historians have shown, by the dictates of Wright and his third wife, Olgivanna. The historical record also shows

Afterword: What not to learn from Frank Lloyd Wright

that Wright often spoke or acted in sexist and racist ways. Finally, Wright proposed a totalizing model of development that, despite its egalitarian and pastoral appeal, threatened to undermine the city and homogenize much of the landscape. We still have much to learn from what Wright did, even as we must continue to question and reject some of his actions and tenets. We must learn, in other words, how exactly not to be like Frank Lloyd Wright, even as we appreciate his many great works and study the splendid design tools and tricks, the moves and masterpieces of spatial composition that he left us.

Acknowledgments

Our first debt of gratitude is to Frank Lloyd Wright and his skilled collaborators for designing the spaces that inspired both the photography and writing of this book. We also wish to thank the scholars, such as Sidney Robinson and Neil Levine, whose insights have critically informed our view of Wright's work. On a more immediate level, we appreciate the support of the Frank Lloyd Wright Foundation. Librarians Margo Stipe and Elizabeth Dawsari, working from Taliesin West, shared their knowledge of precious archival collections. We also received crucial guidance and assistance from librarians at Avery Architectural & Fine Arts Library, Columbia University, including Mathieu Pomerleau, Katherine Prater, and Margaret Smithglass. We thank the owners and stewards of historic Frank Lloyd Wright properties who granted access for photography. We are also excited to include a series of interpretive diagrams by Richard Quittenton, which he produced specifically for this book. Finally, we appreciate the support of Rizzoli publisher Charles Miers, editor Douglas Curran, and graphic designer Luke Bulman in bringing this book to fruition.

Aaron Betsky
Gideon Fink Shapiro
Andrew Pielage

Selected Writings by Frank Lloyd Wright

A Testament. New York: Horizon Press, 1957.

Address to the Junior Chapter of the American Institute of Architects, New York City, 1952. In *Writings and Buildings*.

An American Architecture. Edited by Edgar Kaufmann. New York: Horizon Press, 1955.

An Autobiography (2nd edition). New York: Duell, Sloan and Pearce, 1943.

"Architect, Architecture and the Client," 1896. In *Frank Lloyd Wright Collected Writings*, Volume 1.

"Ausgeführte Bauten und Entwürfe Von Frank Lloyd Wright." Berlin: Ernst Wasmuth, 1910.

Frank Lloyd Wright Collected Writings, Volume 1. Edited by Bruce Brooks Pfeiffer. New York: Rizzoli, 1992.

"In the Cause of Architecture." *The Architectural Record* Vol. 23, No. 3 (March 1908): 155–165.

"In the Cause of Architecture. Second Paper." *The Architectural Record*, Vol. 35, No. 5 (May 1914): 405–413.

"In the Cause of Architecture, I: The Logic of the Plan." *The Architectural Record*, Vol. 63, No. 1 (January 1928): 49–57.

"In the Cause of Architecture, II: What 'Styles' Mean to the Architect," *The Architectural Record*, Vol. 63, No. 2 (February 1928): 145–151.

"In the Cause of Architecture, IV: Fabrication and Imagination." *The Architectural Record*, Vol. 62, No. 4 (October 1927), 319-322.

"In the Cause of Architecture, VI: The Meaning of Materials—Glass." *The Architectural Record*, Vol. 64, No. 1 (July 1928): 10–16.

"In the Cause of Architecture, VIII: Sheet Metal and a Modern Instance." *The Architectural Record*, Vol. 64, No. 4 (October 1928): 334–342.

Letters to Architects. Edited by Bruce Brooks Pfeiffer. Fresno, Calif.: California State University Press, 1984.

Letters to Apprentices. Edited by Bruce Brooks Pfeiffer. Fresno, Calif.: California State University Press, 1982.

"Modern Architecture: Being the Kahn Lectures," 1931. In *The Essential Frank Lloyd Wright*.

"The Architect and the Machine," 1894. In *Collected Writings*, Volume 1, 20–26.

"The Art and Craft of the Machine." Chicago: Chicago Architectural Club, 1901.

The Disappearing City. New York: William Farquhar Payson, 1932.

The Essential Frank Lloyd Wright: Critical Writings on Architecture. Edited by Bruce Brooks Pfeiffer. Princeton, N.J.: Princeton University Press, 2008.

The Japanese Print: An Interpretation. Chicago: Ralph Fletcher Seymour, 1912.

The Natural House. New York: Horizon Press, 1954.

The Architectural Forum, Vol. 68, No. 1 (January 1938): 1–101.

The Architectural Forum, Vol. 94, No. 1 (January 1951): 73–108.

"Two Lectures on Architecture." Chicago: The Art Institute of Chicago, 1931. In *The Essential Frank Lloyd Wright*.

Writings and Buildings. Selected by Edgar Kaufmann and Ben Raeburn. New York: Meridian Books, 1960.

Sources of Frank Lloyd Wright quotations

Photography (unless otherwise noted) © 2021 Andrew Pielage

Abbreviations below (e.g. FA, LC.) refer to the nomenclature used in the image captions, with the full legal archive/source name spelled out here.

CHM Chicago History Museum
37 Concert at Taliesin, Spring Green, Wisconsin, 1937. HB-04414-1B2, Chicago History Museum, Hedrich-Blessing Collection.

FA Frank Lloyd Wright Foundation Archives (The Museum of Modern Art | Avery Architectural & Fine Arts Library, Columbia University, New York)
12 Cloverleaf Quadruple Houses (unbuilt project), Pittsfield, Massachusetts, 1942.
24 Drawing for Louis H. Sullivan (residential portfolio project), 1887.
31 Taliesin II, Spring Green, Wisconsin, 1914.
32 W. S. Spaulding Gallery for Japanese prints (unbuilt project), Boston, Massachusetts, 1919.
33 Thomas P. Hardy House, Racine, Wisconsin, 1905.
38–39, 136, 201 Hillside Theater (Taliesin playhouse), Spring Green, Wisconsin, 1952–1955.
45 Edward Schroeder House (unbuilt project), Milwaukee, Wisconsin, 1911.
50 Alexander Chandler House, (unbuilt project), Chandler, Arizona, 1928.
50–51 San Marcos-in-the-Desert resort for Alexander Chandler (unbuilt project), Chandler, Arizona, 1928–1929.
55 Cooperative Homesteads (unbuilt project), Detroit, Michigan, 1942.
57 Stonecrest (Robert Herberger House, unbuilt project), Maricopa County, Arizona, 1955.
62, 124 Fallingwater (Liliane and Edgar J. Kaufmann House), Mill Run, Pennsylvania, 1935–1938.
64–65, 157 Wingspread (Herbert F. Johnson house), Wind Point, Wisconsin, 1937–1939.
69 Imperial Hotel, Tokyo, Japan, 1915–1923.
71 Sherman Booth House, scheme 1 (unbuilt project), Glencoe, Illinois, 1911.
72–73 Doheny Ranch Resort (unbuilt project), Los Angeles, California, 1923.
78 Galesburg Country Homes master plan, Galesburg, Michigan, 1947–1948.
78–79, 120 Unity Temple, Oak Park, Illinois, 1904–1908.
83 Living City (unbuilt project), 1958.
88 National Life Insurance Company building (unbuilt project), Chicago, Illinois, 1924–1925.
91–92 Usonian Automatic housing for Walter Bimson (unbuilt project), Phoenix, Arizona, 1949.
96 Midway Gardens, Chicago, Illinois, 1913.
101 Jacobs I (Katherine and Herbert A. Jacobs House), Madison, Wisconsin, 1936–1937.
106–107 Isidore H. Heller House, Chicago, Illinois, 1896–1897.
113 Rubber Village (Fiberthin air houses), Mishawaka, Indiana, 1956.
113 Dinky Diner mobile kitchen unit (unbuilt project), 1939.
146 Hollyhock House (Aline BarnsdallHouse), Los Angeles, California, 1917–1921.
151, 160 Taliesin West, Scottsdale, Arizona, 1937–1959.
153 Henry N. Cooper House and Stable (unbuilt project), La Grange, Illinois, 1890.
164–165 S. C. Johnson Research Tower, Racine, Wisconsin, 1944–1950.
168 William Boswell House, Cincinnati, Ohio, 1956–1961.
173 Frank Bott house, Kansas City, Missouri, 1956–1963.
176 Textile-block design, patent study, 1921.
177 Aline Barnsdall "Little Dipper" kindergarten, Los Angeles, California, 1921–1923.
186 Twin cantilevered bridge (unbuilt project), Pittsburgh, Pennsylvania, 1948.
192 Jacobs I (Katherine and Herbert A. Jacobs House), Madison, Wisconsin, 1936–1937.
198–199 C. Thaxter Shaw House, renovation (unbuilt project), Montreal, Canada, 1906.
202 Dining chair, Henry and Elsie Allen House, Wichita, Kansas, 1916–1917.
221 Raúl Bailleres House (unbuilt project), Acapulco, Mexico, 1952.
227 Gordon Strong Automobile Objective (unbuilt project), Sugarloaf Mountain, Maryland, 1924.
232 Solomon R. Guggenheim Museum, New York, New York, 1943–1959.
239 University of Baghdad, plan for Greater Baghdad (unbuilt project), Baghdad, Iraq, 1957.

FLWF Frank Lloyd Wright Foundation
13 Frederick C. Robie House, Chicago, Illinois, 1908–1910. Private collection.
97 Midway Gardens, Chicago, Illinois, 1913. Private collection.
186 Imperial Hotel, Tokyo, Japan, 1915–1923. Private collection.
241 Frank Lloyd Wright, Taliesin West, undated photo.

LC Library of Congress
29 Frederick C. Bogk House, Milwaukee, Wisconsin, 1916–1917.
187 Hollyhock House (Aline Barnsdall House), Los Angeles, California, 1917–1921.

PD Public domain
66 Imperial Hotel, Tokyo, Japan, 1915–1923. Undated postcard.

Richard Quittenton
12 *Break the Box*
119 *Death and Resurrection*
153 *Rotate and Lock*
157 *X Marks the Spot*
159 *Turn and Turn Again*
209 *Mirror Your World*

WHS Wisconsin Historical Society
68 Imperial Hotel, Tokyo, Japan, 1915–1923. Archival photograph, 1923.

Image credits

First published in the United States of America in 2021 by
RIZZOLI INTERNATIONAL PUBLICATIONS, INC.
300 Park Avenue South, New York, NY 10010
www.rizzoliusa.com

© 2021 Rizzoli International Publications, Inc.
Text (except for excerpted Frank Lloyd Wright Quotations) © 2021 Aaron Betsky and Gideon Fink Shapiro
Photography (unless otherwise noted) © 2021 Andrew Pielage

Fallingwater (pp. 9, 17, 62, 123, 124, 131) is a property owned and operated by the Western Pennsylvania
Conservancy. Fallingwater ® is a trademark and a registered service mark of the Western Pennsylvania
Conservancy.

The name and image of the Solomon R. Guggenheim Museum are trademarks of
the Solomon R. Guggenheim Foundation. Used with permission.

Frank Lloyd Wright drawings (as detailed on p. 247) © 2021 The Frank Lloyd Wright Foundation, Scottsdale, AZ.
All rights reserved. The Frank Lloyd Wright Foundation Archives (The Museum of Modern Art | Avery Architectural &
Fine Arts Library, Columbia University, New York)

Frank Lloyd Wright archival photographs (as detailed on p. 247) © 2021 The Frank Lloyd Wright Foundation,
Scottsdale, AZ. All rights reserved.

Publisher: Charles Miers
Editor: Douglas Curran
Production Director: Maria Pia Gramaglia
Managing Editor: Lynn Scrabis

Design: Office of Luke Bulman

All rights reserved. No part of this publication may be reproduced, stored in a retrieval system, or transmitted in any
form or by any means, electronic, mechanical, photocopying, recording, or otherwise, without prior consent of the
publisher.

Printed and bound in Italy

2021 2022 2023 2024 2025 / 10 9 8 7 6 5 4 3 2 1

ISBN-13: 978-0-8478-6536-9
Library of Congress Control Number: 2020949531

Visit us online:
Facebook.com/RizzoliNewYork
Twitter: @Rizzoli_Books
Instagram.com/RizzoliBooks
Pinterest.com/RizzoliBooks
Youtube.com/user/RizzoliNY
Issuu.com/Rizzoli